500 POSES *for* Photographing Women

A VISUAL SOURCEBOOK FOR PORTRAIT PHOTOGRAPHERS

Michelle Perkins

AMHERST MEDIA, INC. ■ BUFFALO, NY

Front cover photographs by Tim Schooler.
Back cover photograph by Dan Brouillette.

Published by:
Amherst Media, Inc.
P.O. Box 586
Buffalo, N.Y. 14226
Fax: 716-874-4508
www.AmherstMedia.com

Publisher: Craig Alesse
Assistant Editor: Barbara A. Lynch-Johnt
Editorial Assistance: John S. Loder, Carey A. Maines

ISBN-13: 978-1-58428-249-5
Library of Congress Control Number: 2008926669

Printed in Korea.
10 9 8 7 6 5 4 3 2 1

About This Book

Determining the best way to pose your subject—a way that is flattering to the individual, appropriate to the setting and clothing, and visually appealing in the overall composition—can be one of the biggest challenges in creating a successful portrait. This is especially true when creating portraits of women, where the photographer may be called on to create anything from a very traditional head-and-shoulders pose to a more adventurous full-length look straight out of the pages of a fashion magazine. Quite simply, the variations are almost limitless.

This collection is a visual sourcebook designed to address exactly that problem. Filled with images by some of the world's most accomplished portrait, fashion, and commercial photographers, it provides a resource for photographers seeking inspiration for their own work. Stuck on what to do with a particular client or unsure how to use a given prop? Flip through the sample portraits, pick something you like, then adapt it as needed to suit your tastes. Looking to spice up your work with some new poses? Find a sample that appeals to you and look for ways to implement it (or some element of it) with one of your subjects.

For ease of use, the portraits are grouped according to how much of the subject is shown in the frame. Thus, the book begins with head-and-shoulders portraits, followed by portraits that introduce one or both hands into the head-and-shoulders look. Next are waist-up portraits, featuring images that include the head and shoulders, arms and hands, and at least some of the subject's torso. Moving on to three-quarter-length portraits, the examples feature subjects shown from the head down to mid-thigh or mid-calf. The balance of the book features full-length images—the most complex portraits to pose, because they include the entire body. Both the three-quarter- and full-length portraits are subdivided into poses for standing subjects, seated subjects, and reclining subjects.

It can be difficult to remain creative day after day, year after year, but sometimes all you need to break through a slump is a little spark. In this book, you'll find a plethora of images designed to provide just that.

Contents

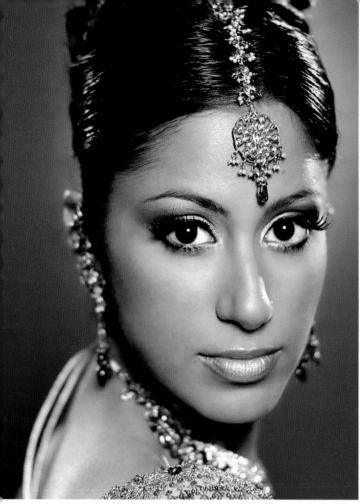

PLATE 1. PHOTOGRAPH BY CHERIE STEINBERG COTE.

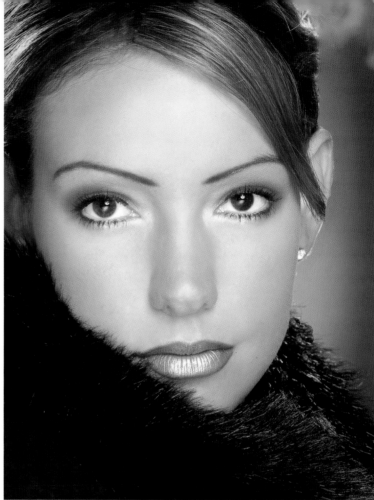

PLATE 2. PHOTOGRAPH BY BILLY PEGRAM.

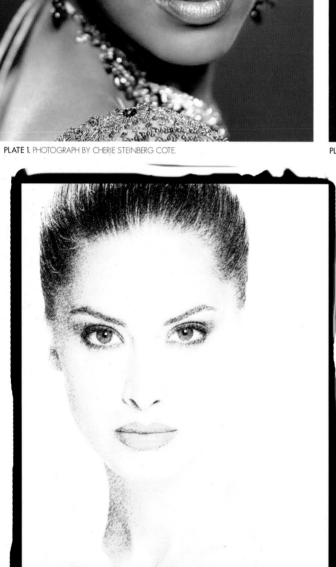

PLATE 3. PHOTOGRAPH BY BILLY PEGRAM.

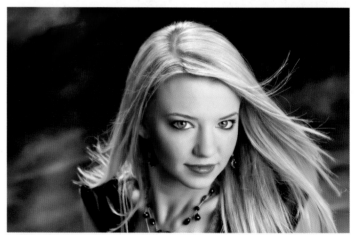

PLATE 4. PHOTOGRAPH BY TIM SCHOOLER.

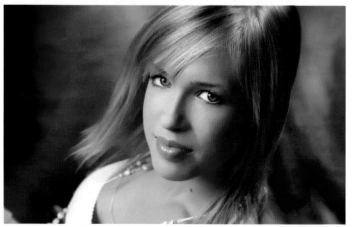

PLATE 5. PHOTOGRAPH BY TIM SCHOOLER.

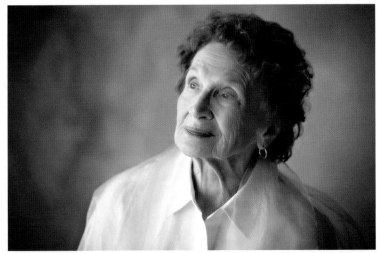

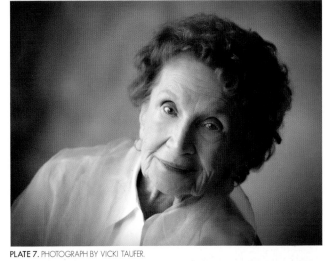

PLATE 6. PHOTOGRAPH BY VICKI TAUFER.

PLATE 7. PHOTOGRAPH BY VICKI TAUFER.

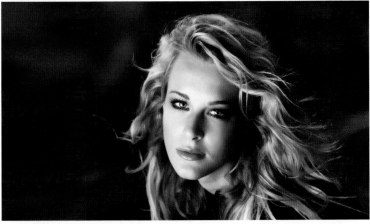

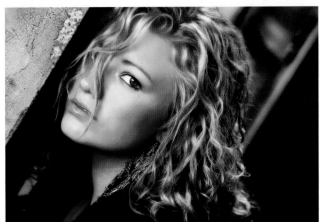

PLATE 8. PHOTOGRAPH BY TIM SCHOOLER.

PLATE 9. PHOTOGRAPH BY TIM SCHOOLER.

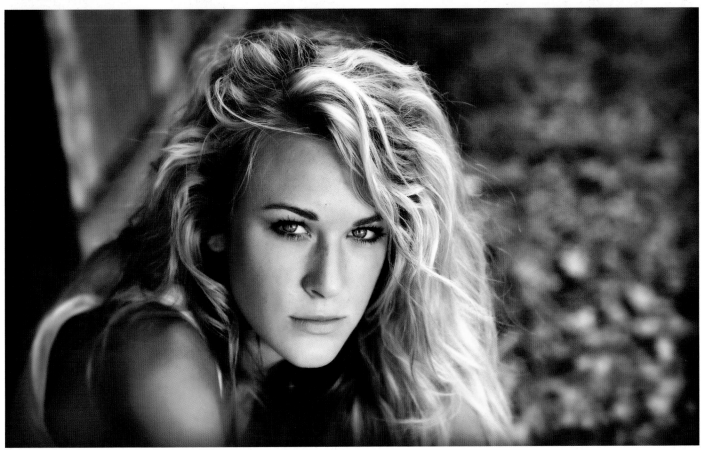

PLATE 10. PHOTOGRAPH BY TIM SCHOOLER.

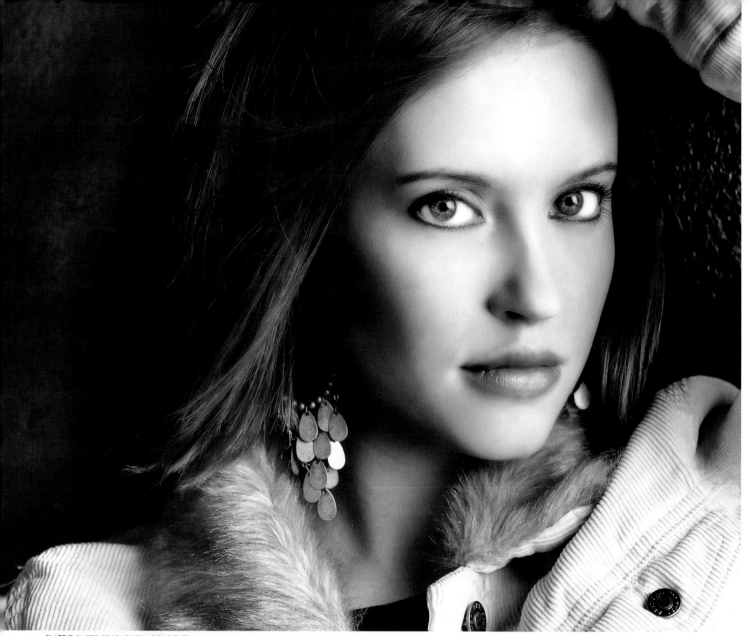

PLATE 11. PHOTOGRAPH BY TIM SCHOOLER.

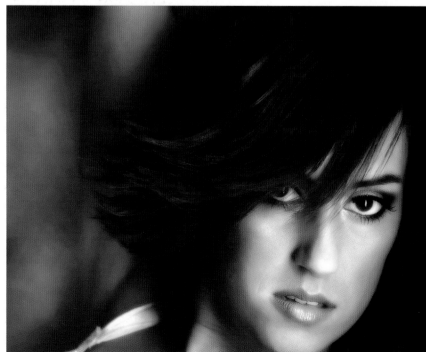

PLATE 12. PHOTOGRAPH BY TIM SCHOOLER.

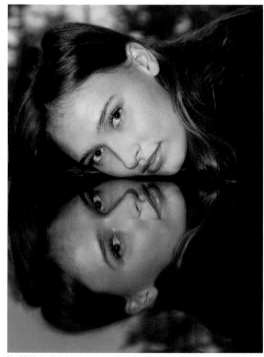

PLATE 13. PHOTOGRAPH BY STEVEN BEGLEITER.

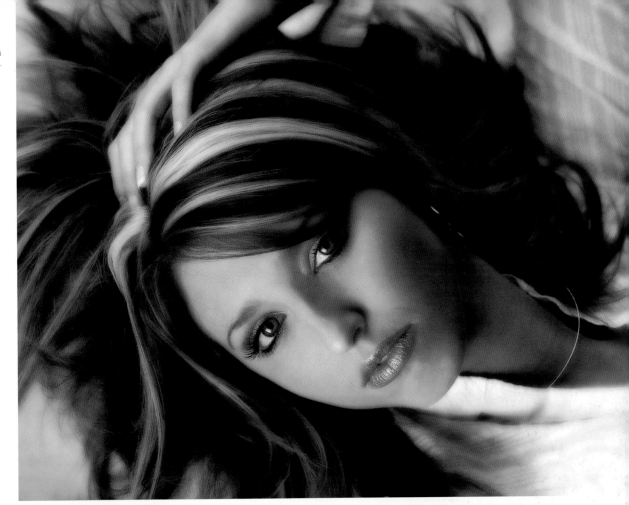

PLATE 14. PHOTOGRAPH BY TIM SCHOOLER.

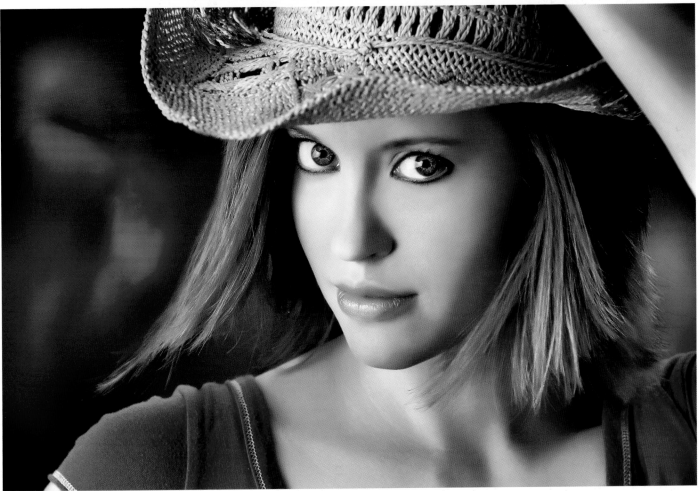

PLATE 15. PHOTOGRAPH BY TIM SCHOOLER.

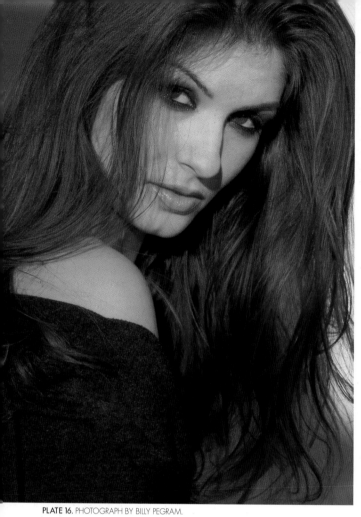

PLATE 16. PHOTOGRAPH BY BILLY PEGRAM.

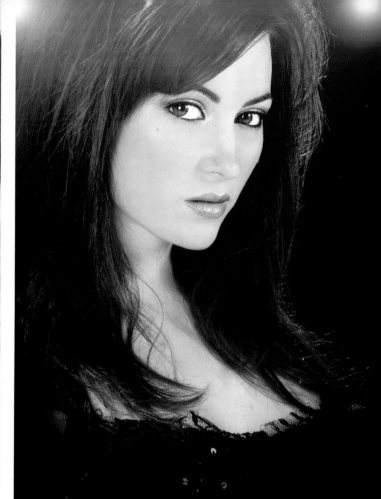

PLATE 17. PHOTOGRAPH BY BILLY PEGRAM.

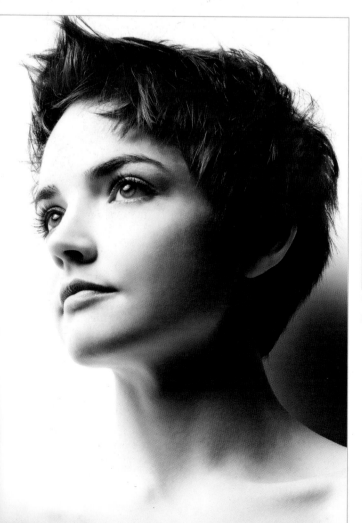

PLATE 18 (LEFT). PHOTOGRAPH BY WES KRONINGER.

PLATE 19 (ABOVE). PHOTOGRAPH BY WES KRONINGER.

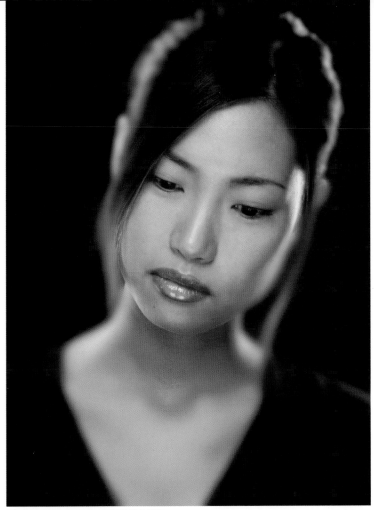

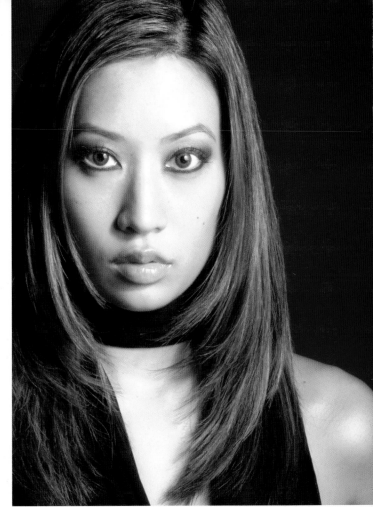

PLATE 20. PHOTOGRAPH BY STEPHEN DANTZIG.

PLATE 21. PHOTOGRAPH BY STEPHEN DANTZIG.

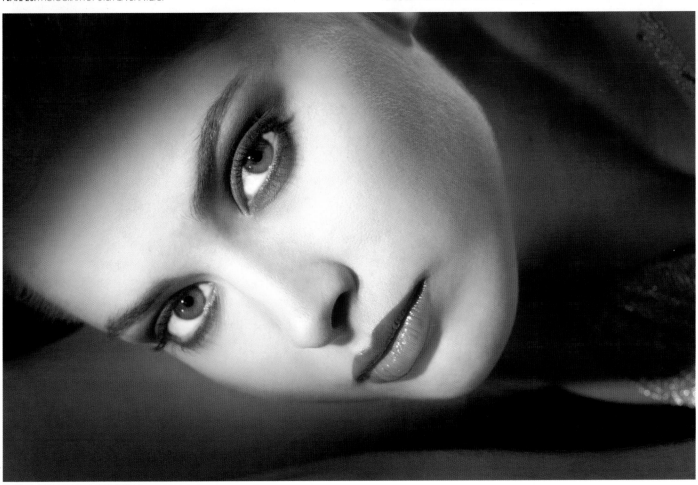

PLATE 22. PHOTOGRAPH BY BILLY PEGRAM.

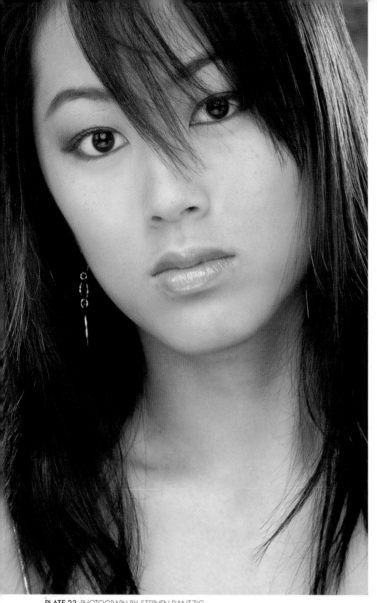

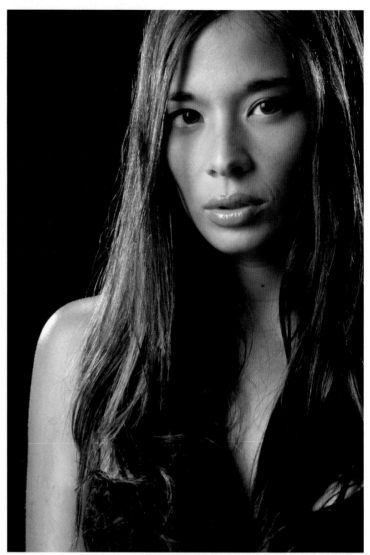

PLATE 23. PHOTOGRAPH BY STEPHEN DANTZIG.

PLATE 24. PHOTOGRAPH BY STEPHEN DANTZIG.

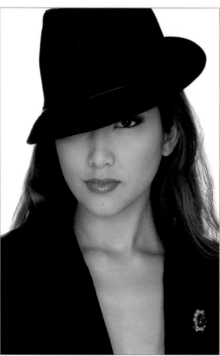

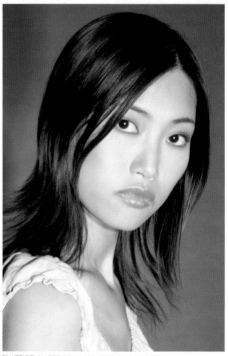

PLATE 25. PHOTOGRAPH BY STEPHEN DANTZIG.

PLATE 26. PHOTOGRAPH BY STEPHEN DANTZIG.

PLATE 27. PHOTOGRAPH BY STEPHEN DANTZIG.

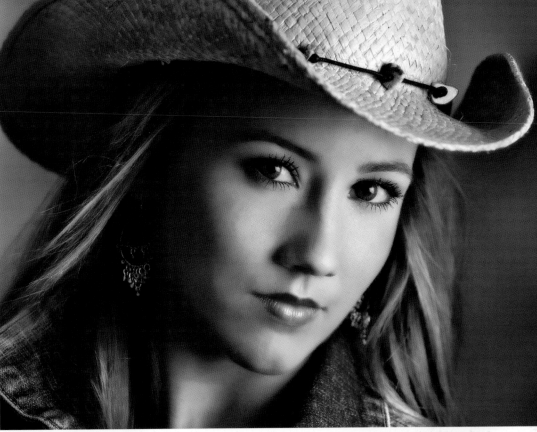

PLATE 28 (BELOW). PHOTOGRAPH BY TIM SCHOOLER.

PLATE 29 (RIGHT). PHOTOGRAPH BY TIM SCHOOLER.

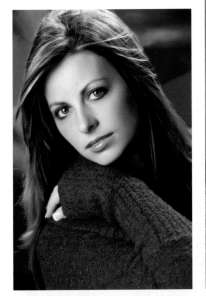

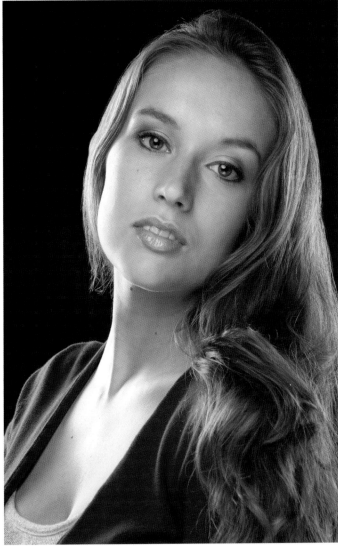

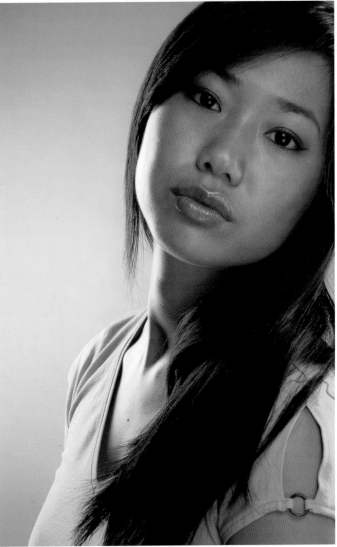

PLATE 30. PHOTOGRAPH BY STEPHEN DANTZIG.

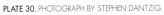

PLATE 31. PHOTOGRAPH BY STEPHEN DANTZIG.

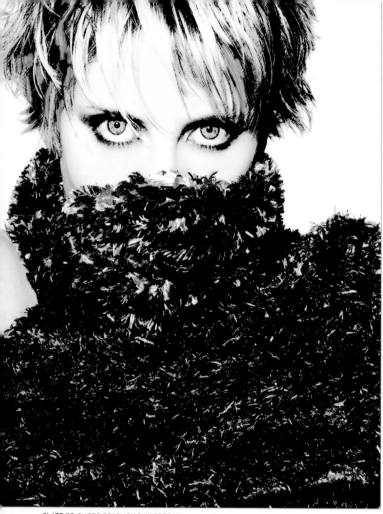

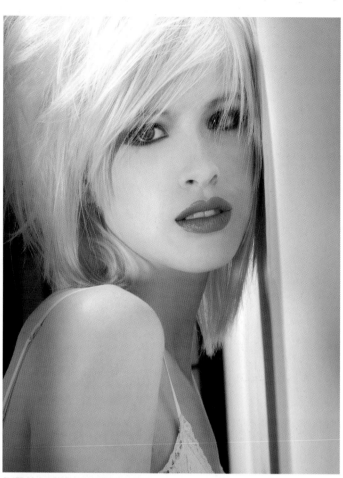

PLATE 32. PHOTOGRAPH BY BILLY PEGRAM.

PLATE 33. PHOTOGRAPH BY BILLY PEGRAM.

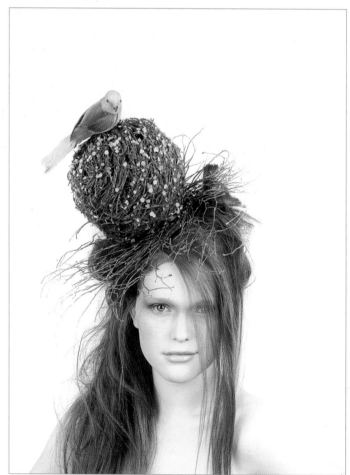

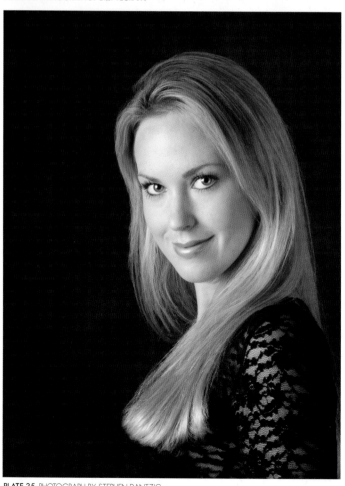

PLATE 34. PHOTOGRAPH BY CHERIE STEINBERG COTE.

PLATE 35. PHOTOGRAPH BY STEPHEN DANTZIG.

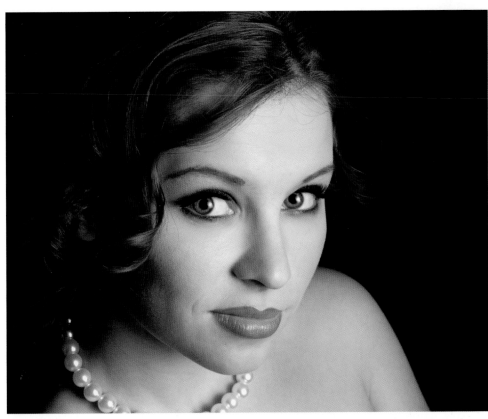

PLATE 36 (LEFT). PHOTOGRAPH BY ROLANDO GOMEZ.

PLATE 37 (BELOW). PHOTOGRAPH BY STEVEN BEGLEITER.

PLATE 38 (BOTTOM). PHOTOGRAPH BY CHERIE STEINBERG COTE.

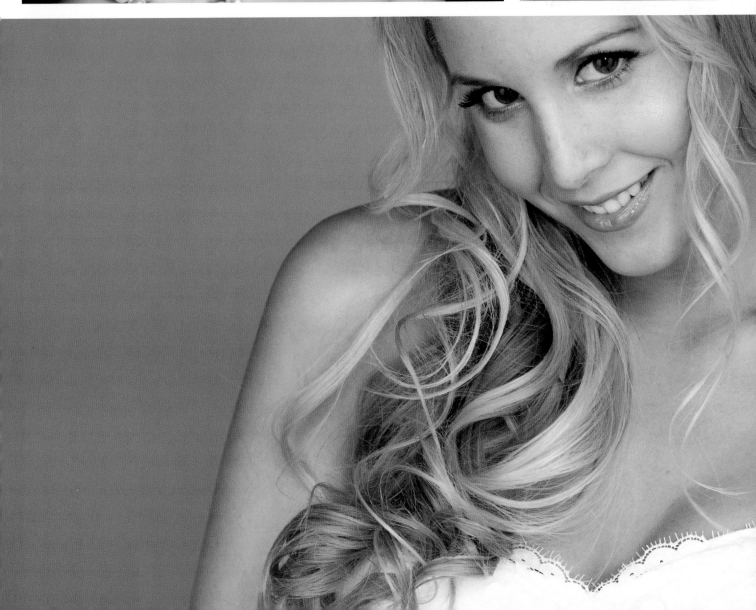

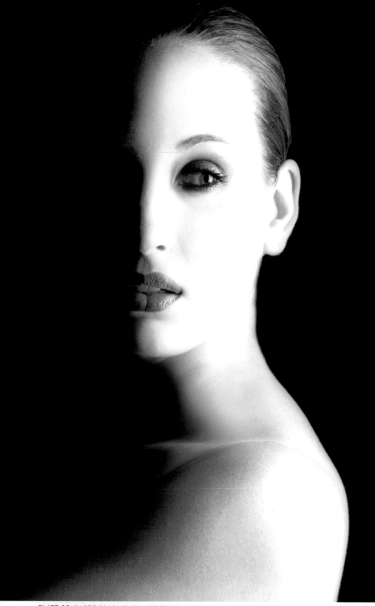

PLATE 39. PHOTOGRAPH BY BILLY PEGRAM.

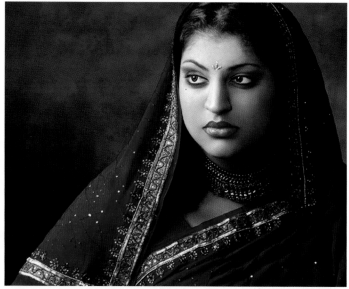

PLATE 40. PHOTOGRAPH BY DEBORAH LYNN FERRO.

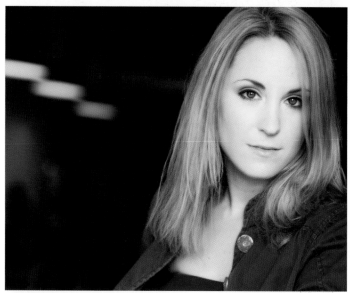

PLATE 41. PHOTOGRAPH BY JEFFREY AND JULIA WOODS.

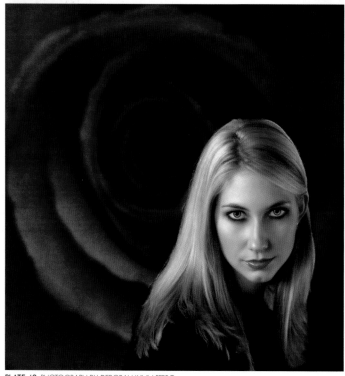

PLATE 42. PHOTOGRAPH BY DEBORAH LYNN FERRO.

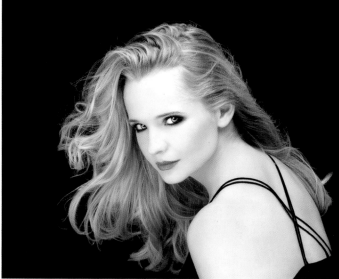

PLATE 43. PHOTOGRAPH BY DEBORAH LYNN FERRO.

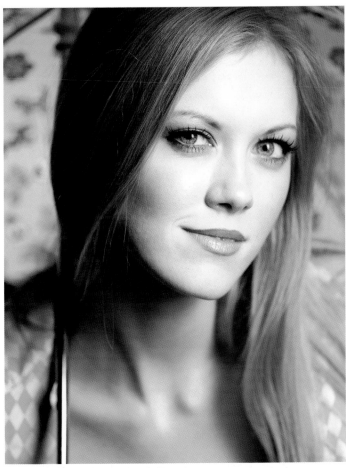

PLATE 44. PHOTOGRAPH BY ROLANDO GOMEZ.

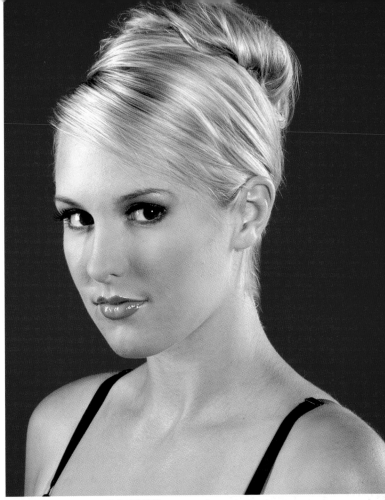

PLATE 45. PHOTOGRAPH BY STEVEN DANTZIG.

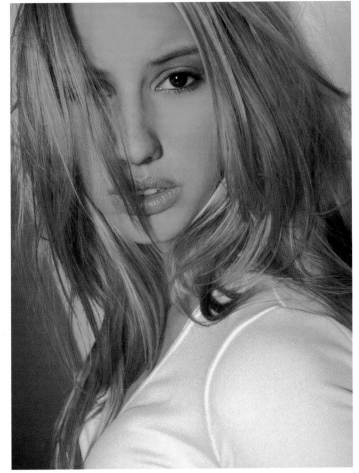

PLATE 46. PHOTOGRAPH BY BILLY PEGRAM.

PLATE 47. PHOTOGRAPH BY RICK FERRO.

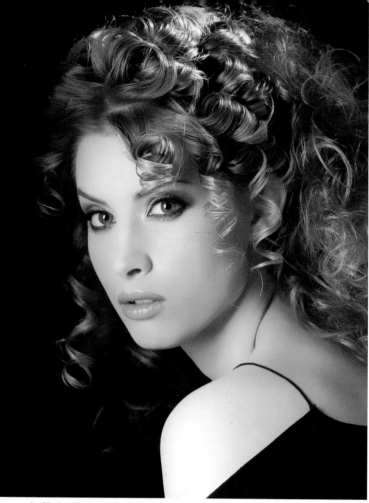

PLATE 48. PHOTOGRAPH BY BILLY PEGRAM.

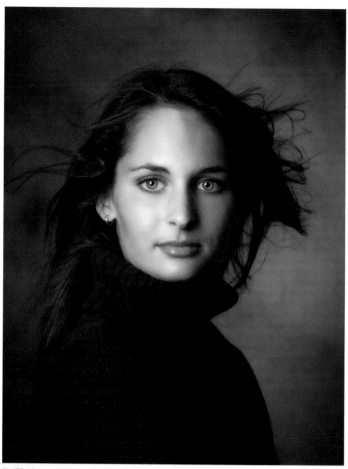

PLATE 49. PHOTOGRAPH BY VICKI TAUFER.

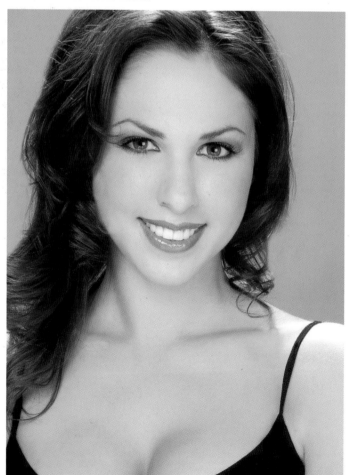

PLATE 50. PHOTOGRAPH BY BILLY PEGRAM.

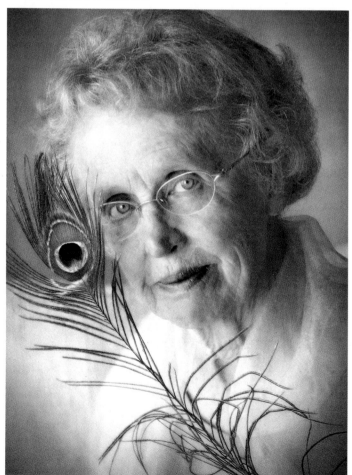

PLATE 51. PHOTOGRAPH BY VICKI TAUFER.

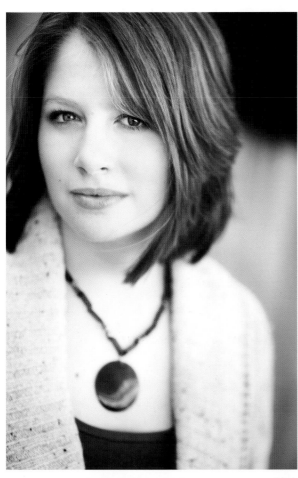

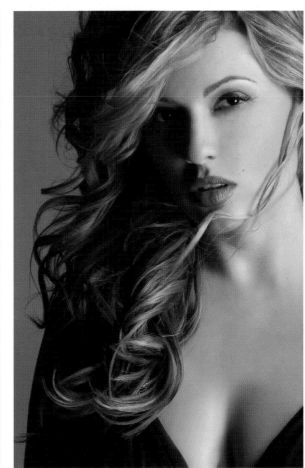

PLATE 52 (FAR LEFT).
PHOTOGRAPH BY
JEFFREY AND JULIA
WOODS.

PLATE 53 (LEFT).
PHOTOGRAPH BY
WES KRONINGER.

PLATE 54 (BELOW).
PHOTOGRAPH BY
WES KRONINGER.

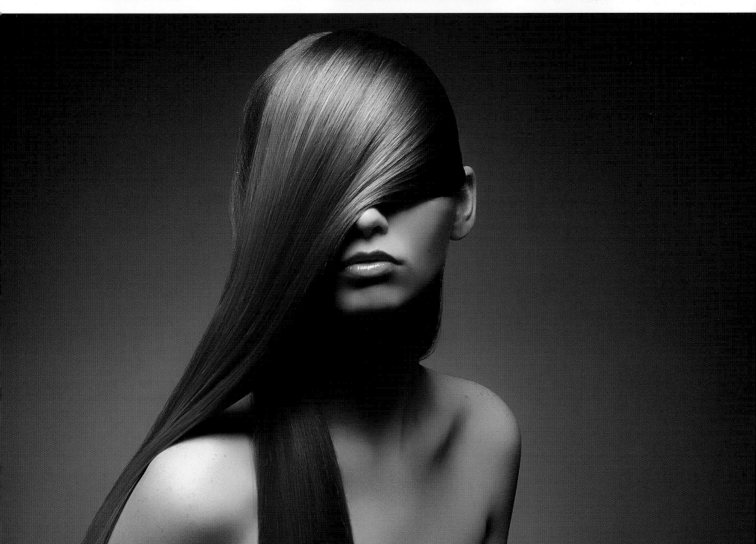

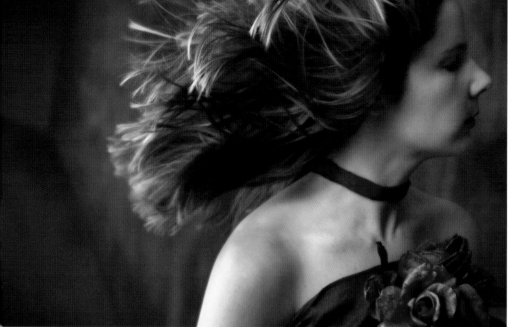

PLATE 55. PHOTOGRAPH BY VICKI TAUFER.

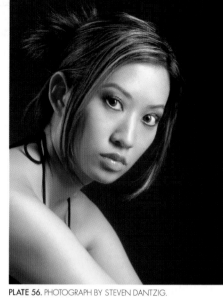

PLATE 56. PHOTOGRAPH BY STEVEN DANTZIG.

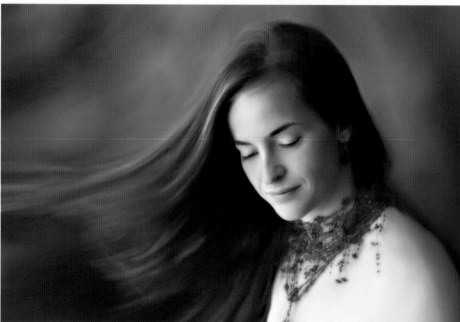

PLATE 57. PHOTOGRAPH BY VICKI TAUFER.

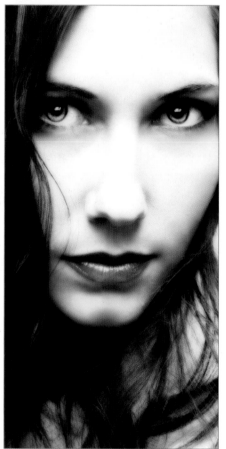

PLATE 58. PHOTOGRAPH BY RICK FERRO.

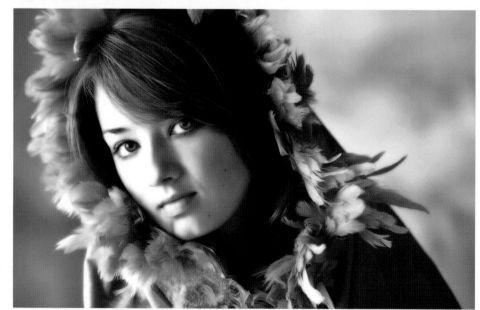

PLATE 59. PHOTOGRAPH BY VICKI TAUFER.

PLATE 60. PHOTOGRAPH BY DEBORAH LYNN FERRO.

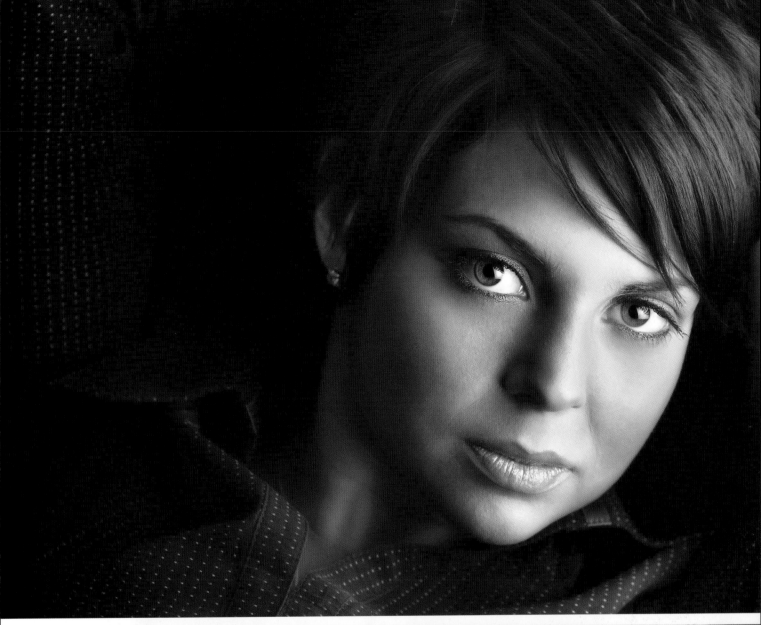

PLATE 61 (ABOVE).
PHOTOGRAPH BY
TIM SCHOOLER.

PLATE 62 (RIGHT).
PHOTOGRAPH BY
CHERIE STEINBERG COTE.

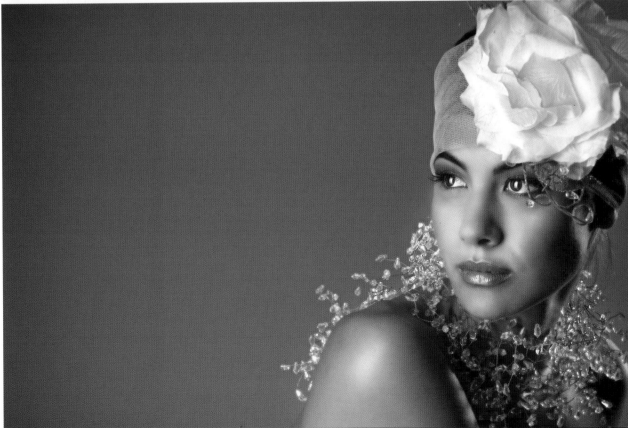

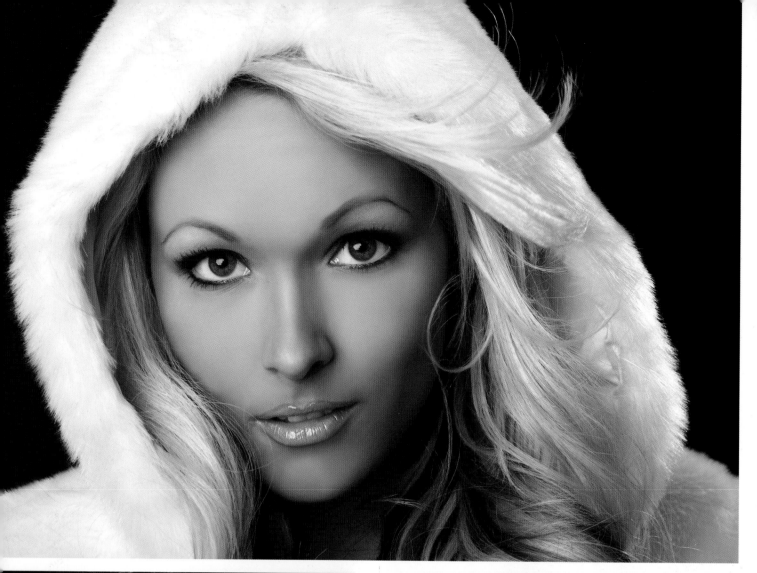

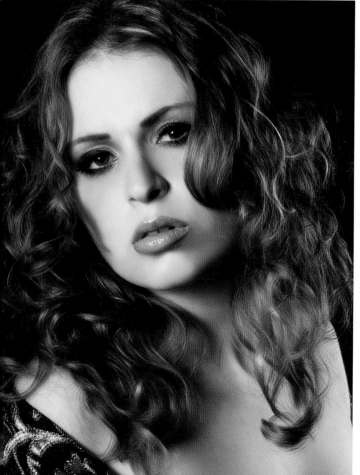

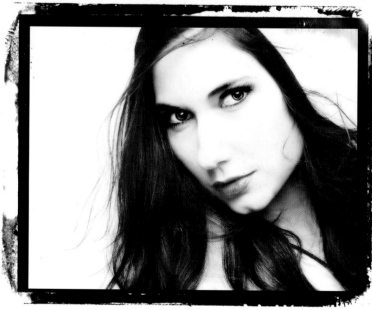

PLATE 63 (TOP). PHOTOGRAPH BY ROLANDO GOMEZ.

PLATE 64 (LEFT). PHOTOGRAPH BY ROLANDO GOMEZ.

PLATE 65 (ABOVE). PHOTOGRAPH BY RICK FERRO.

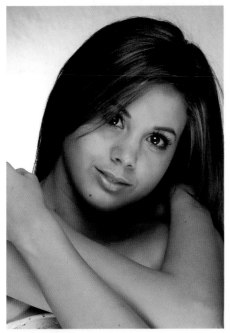

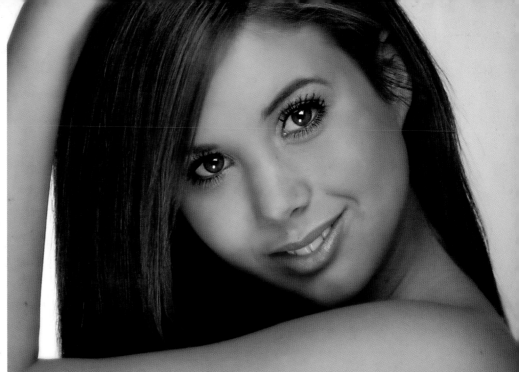

PLATE 66. PHOTOGRAPH BY JEFF SMITH.

PLATE 67. PHOTOGRAPH BY JEFF SMITH.

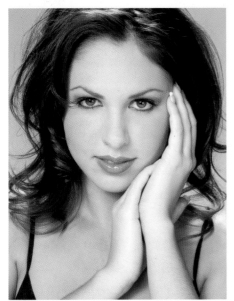

PLATE 68. PHOTOGRAPH BY BILLY PEGRAM.

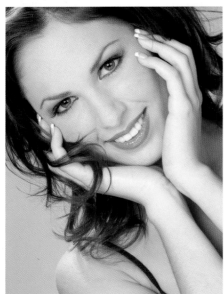

PLATE 69. PHOTOGRAPH BY BILLY PEGRAM.

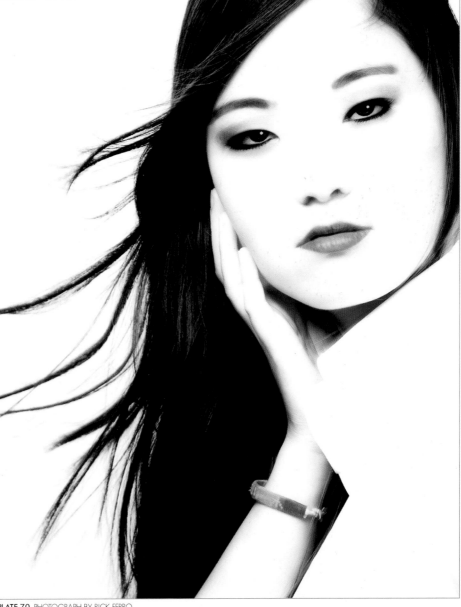

PLATE 70. PHOTOGRAPH BY RICK FERRO.

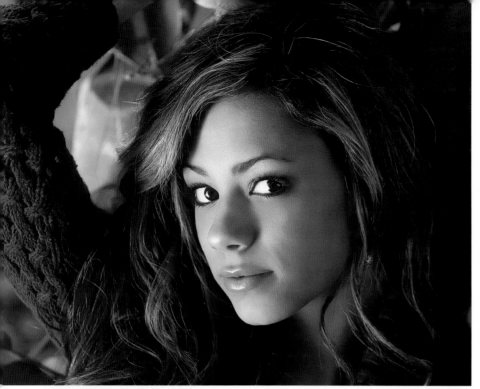

PLATE 71. PHOTOGRAPH BY TIM SCHOOLER.

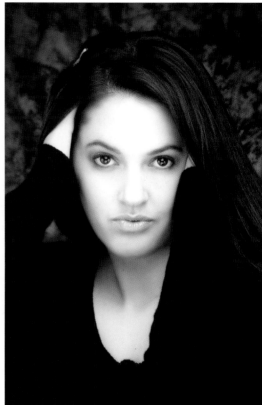

PLATE 72. PHOTOGRAPH BY JEFF SMITH.

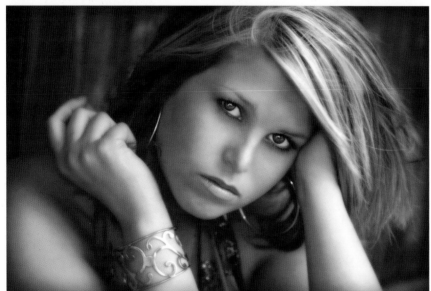

PLATE 73. PHOTOGRAPH BY TIM SCHOOLER.

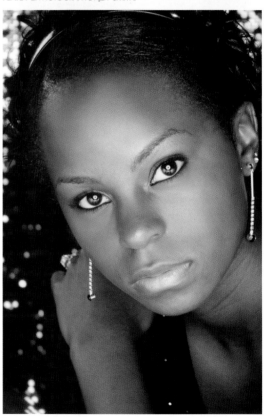

PLATE 74. PHOTOGRAPH BY JEFF SMITH.

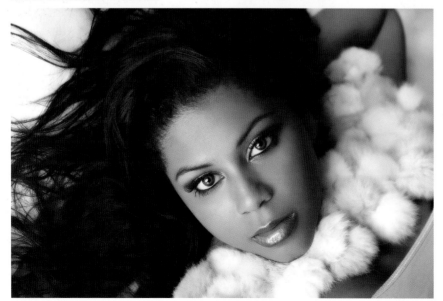

PLATE 75. PHOTOGRAPH BY TIM SCHOOLER.

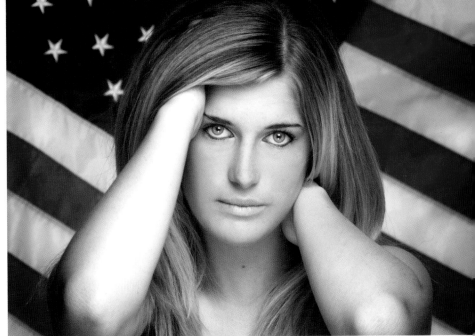

PLATE 76. PHOTOGRAPH BY JEFF SMITH.

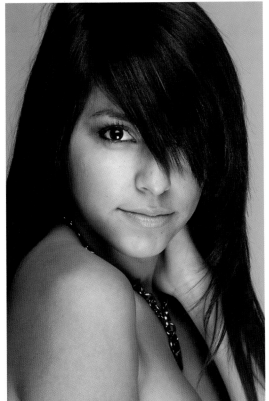

PLATE 77. PHOTOGRAPH BY JEFF SMITH.

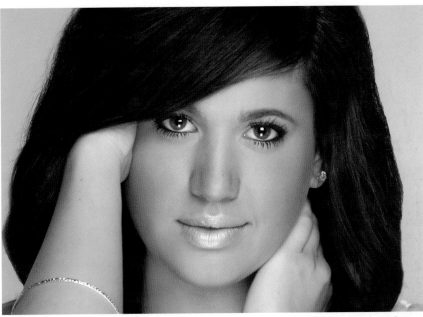

PLATE 78. PHOTOGRAPH BY JEFF SMITH.

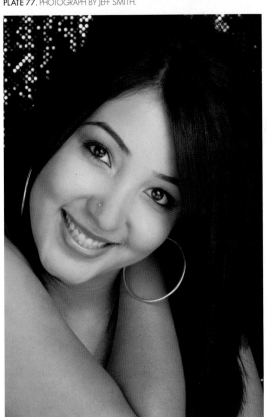

PLATE 79. PHOTOGRAPH BY JEFF SMITH.

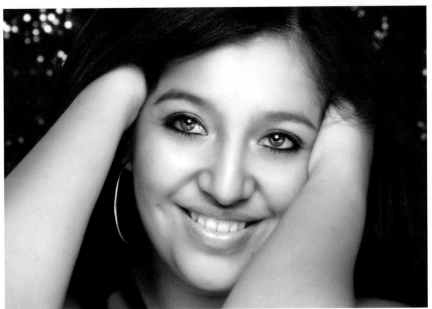

PLATE 80. PHOTOGRAPH BY JEFF SMITH.

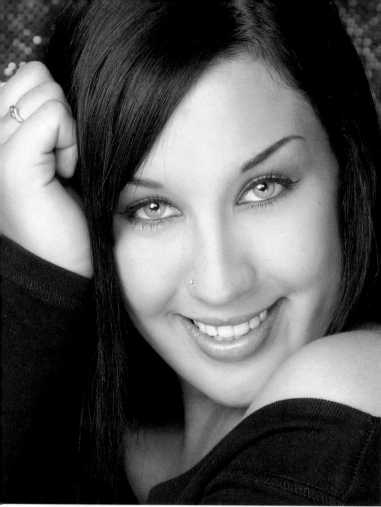

PLATE 81. PHOTOGRAPH BY JEFF SMITH.

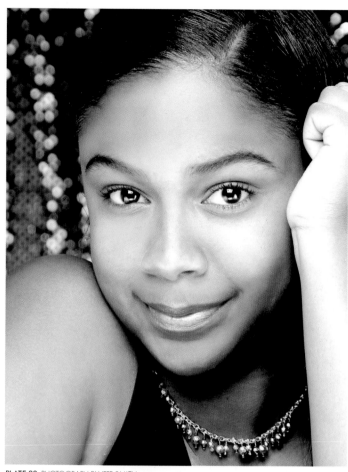

PLATE 82. PHOTOGRAPH BY JEFF SMITH.

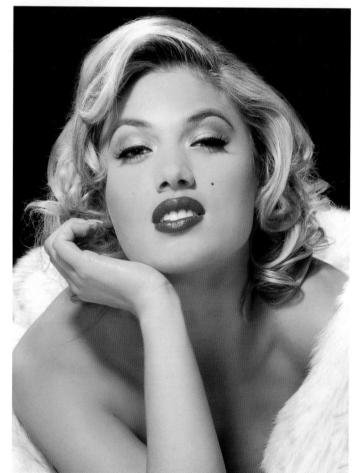

PLATE 83. PHOTOGRAPH BY BILLY PEGRAM.

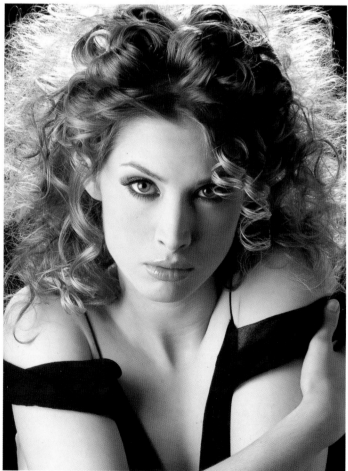

PLATE 84. PHOTOGRAPH BY BILLY PEGRAM.

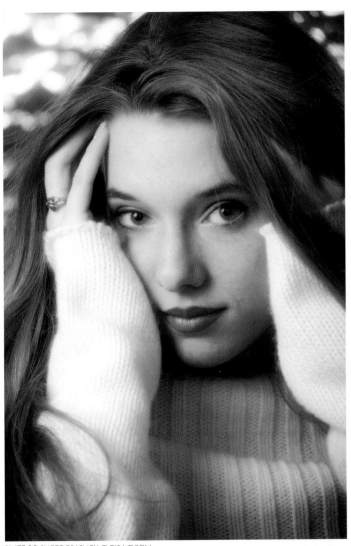

PLATE 85. PHOTOGRAPH BY CHRIS NELSON.

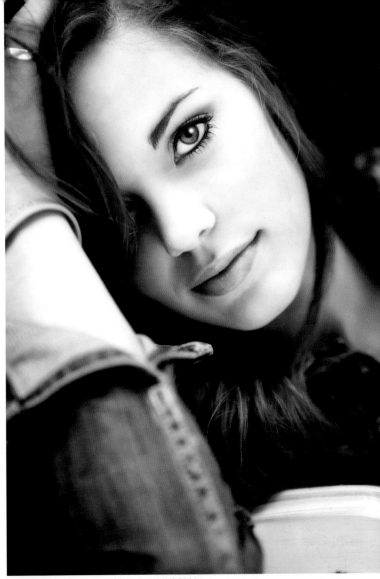

PLATE 86. PHOTOGRAPH BY JEFFREY AND JULIA WOODS.

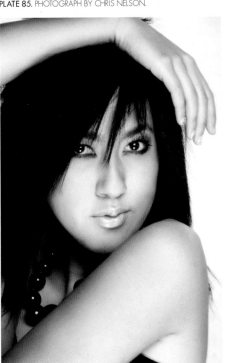

PLATE 87. PHOTOGRAPH BY JEFF SMITH.

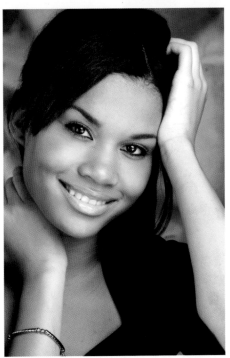

PLATE 88. PHOTOGRAPH BY JEFF SMITH.

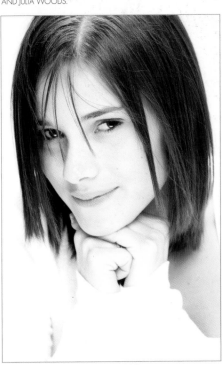

PLATE 89. PHOTOGRAPH BY CHRIS NELSON.

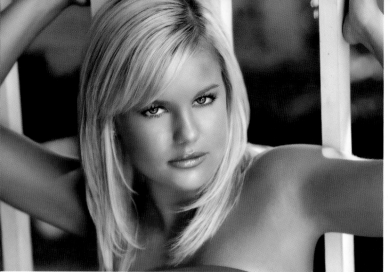

PLATE 90. PHOTOGRAPH BY TIM SCHOOLER.

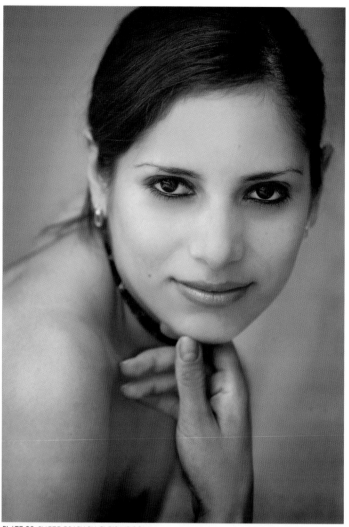

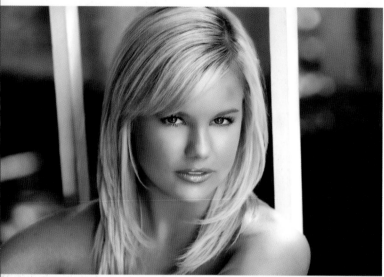

PLATE 91. PHOTOGRAPH BY TIM SCHOOLER.

PLATE 92. PHOTOGRAPH BY CHRIS NELSON.

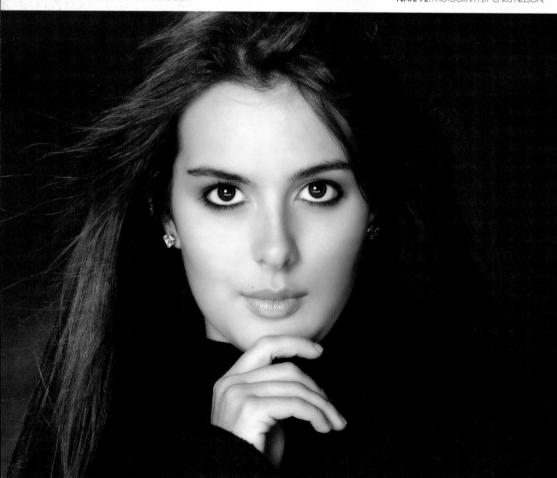

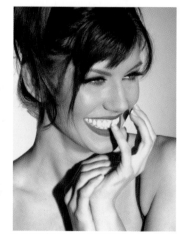

PLATE 93 (LEFT). PHOTOGRAPH BY
DEBORAH LYNN FERRO.

PLATE 94 (ABOVE). PHOTOGRAPH BY
BILLY PEGRAM.

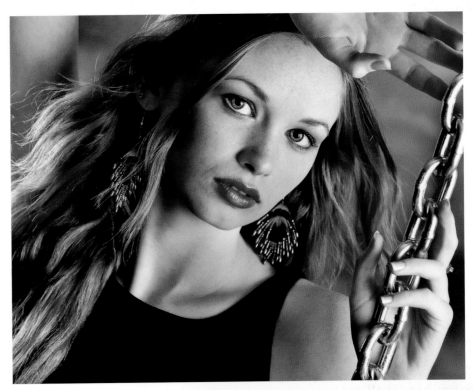

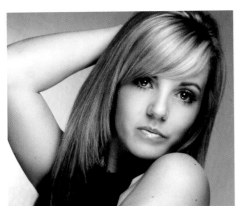

PLATE 95 (BELOW). PHOTOGRAPH BY JEFF SMITH.

PLATE 96 (RIGHT). PHOTOGRAPH BY TIM SCHOOLER.

PLATE 97 (BOTTOM). PHOTOGRAPH BY JEFFREY AND JULIA WOODS.

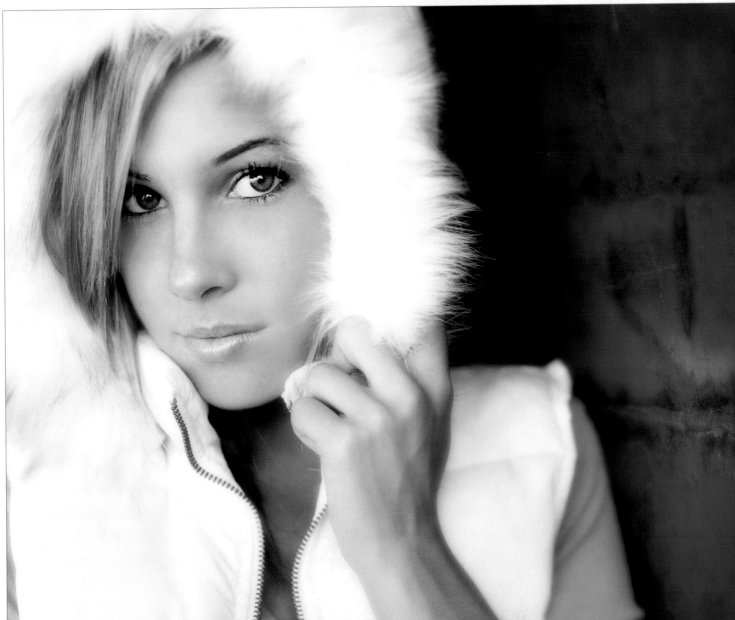

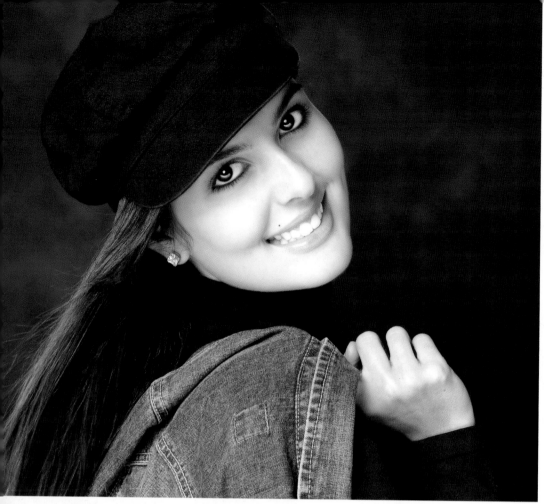

PLATE 98 (LEFT). PHOTOGRAPH
BY DEBORAH LYNN FERRO.

PLATE 99 (ABOVE). PHOTOGRAPH
BY STEVEN BEGLEITER.

PLATE 100 (BELOW). PHOTOGRAPH
BY CHRIS NELSON.

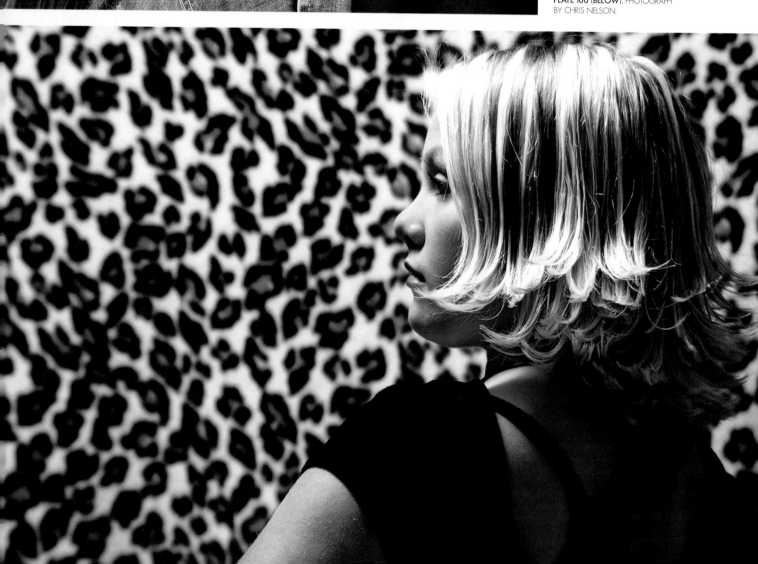

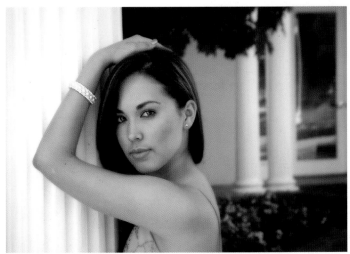

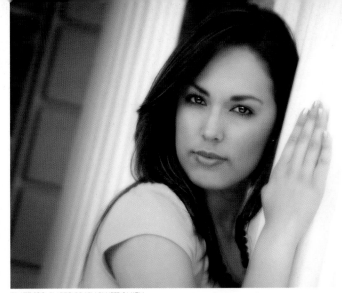

PLATE 101. PHOTOGRAPH BY JEFF SMITH.

PLATE 102. PHOTOGRAPH BY JEFF SMITH.

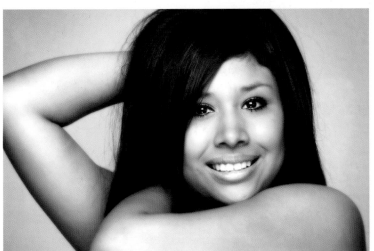

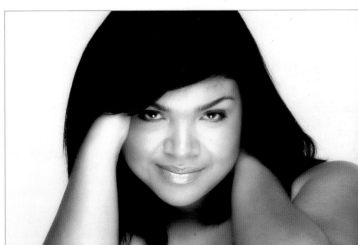

PLATE 103. PHOTOGRAPH BY JEFF SMITH.

PLATE 104. PHOTOGRAPH BY JEFF SMITH.

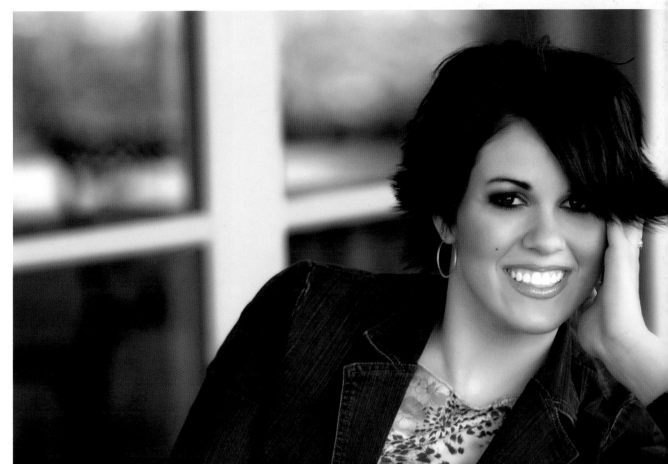

PLATE 105.
PHOTOGRAPH
BY DEBORAH
LYNN FERRO.

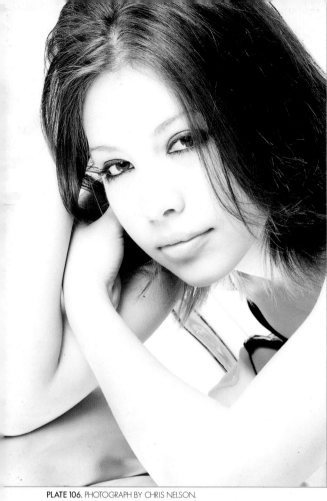

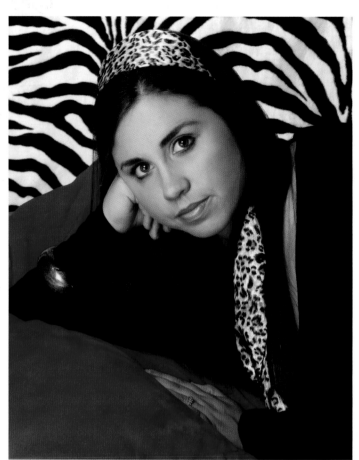

PLATE 106. PHOTOGRAPH BY CHRIS NELSON.

PLATE 107. PHOTOGRAPH BY JEFF SMITH.

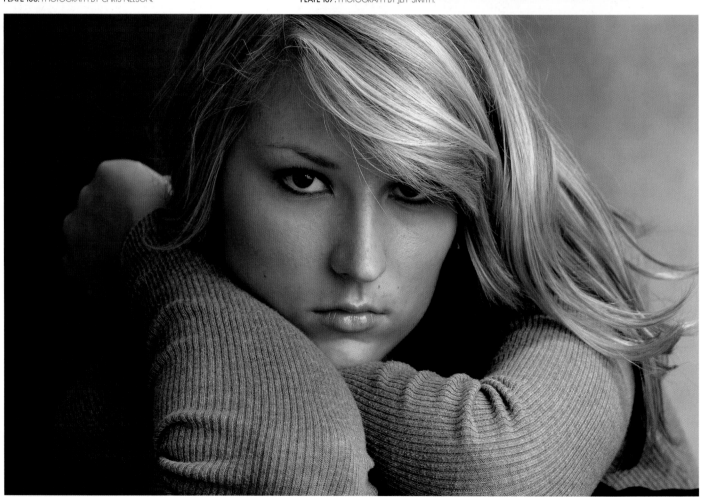

PLATE 108. PHOTOGRAPH BY CHRIS NELSON.

PLATE 109. PHOTOGRAPH BY JEFF SMITH.

PLATE 110. PHOTOGRAPH BY JEFF SMITH.

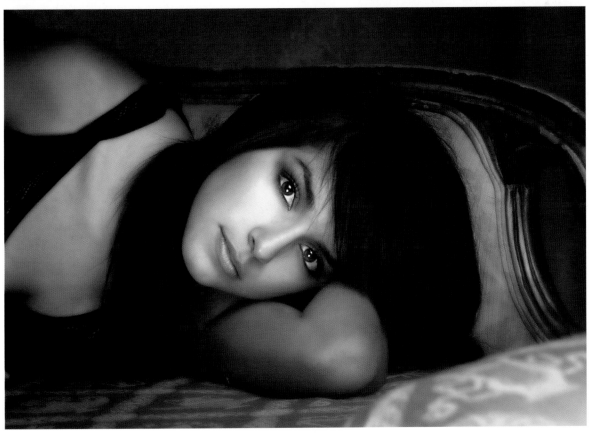

PLATE 111. PHOTOGRAPH BY
JEFF SMITH.

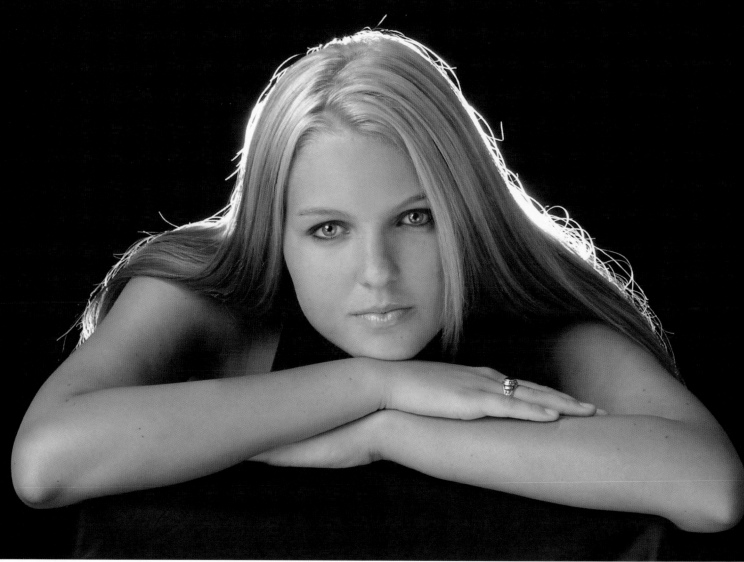

PLATE 112. PHOTOGRAPH BY JEFF SMITH.

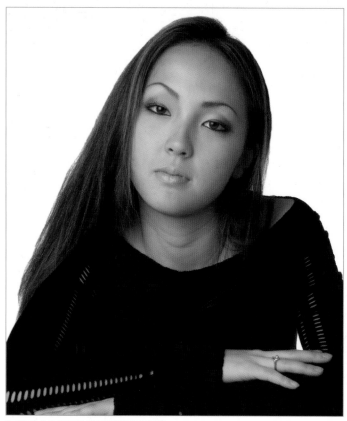

PLATE 113. PHOTOGRAPH BY STEPHEN DANTZIG.

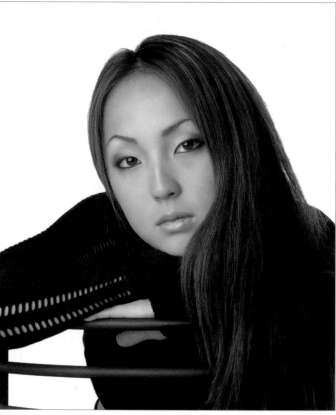

PLATE 114. PHOTOGRAPH BY STEPHEN DANTZIG.

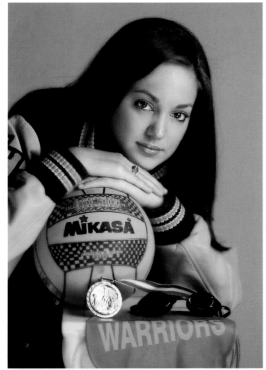

PLATE 115. PHOTOGRAPH BY JEFF SMITH.

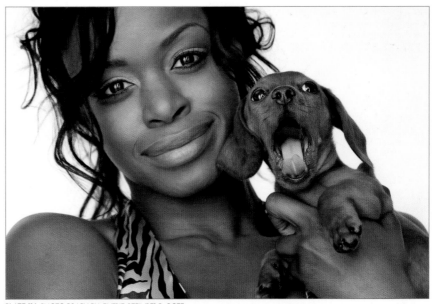

PLATE 116. PHOTOGRAPH BY CHERIE STEINBERG COTE.

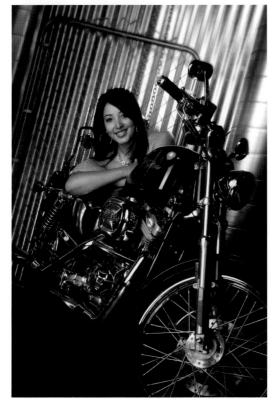

PLATE 117. PHOTOGRAPH BY JEFF SMITH.

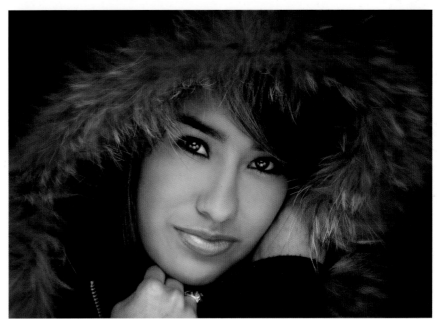

PLATE 118. PHOTOGRAPH BY JEFF SMITH.

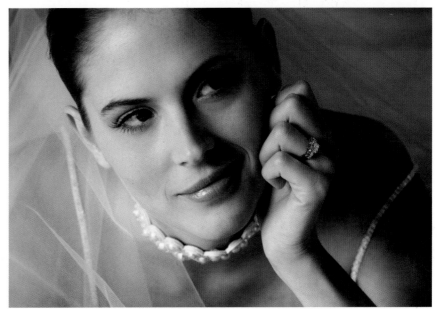

PLATE 119. PHOTOGRAPH BY CHERIE STEINBERG COTE.

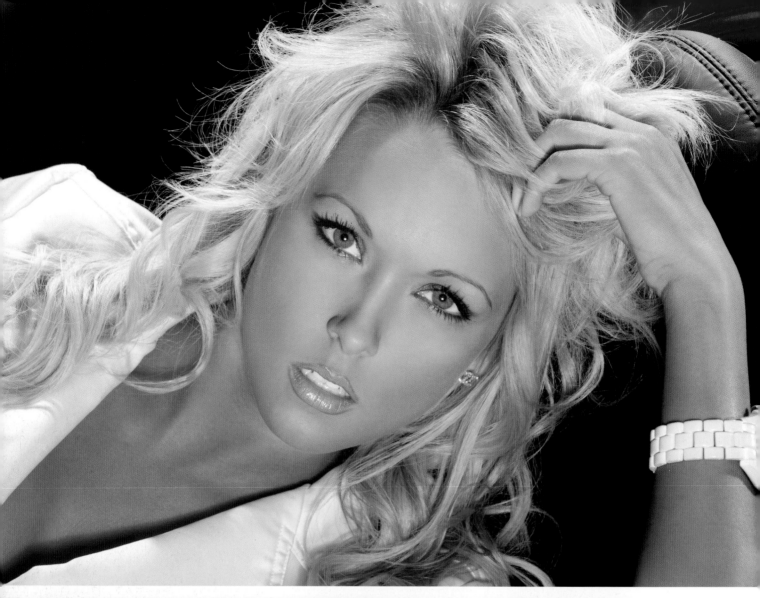

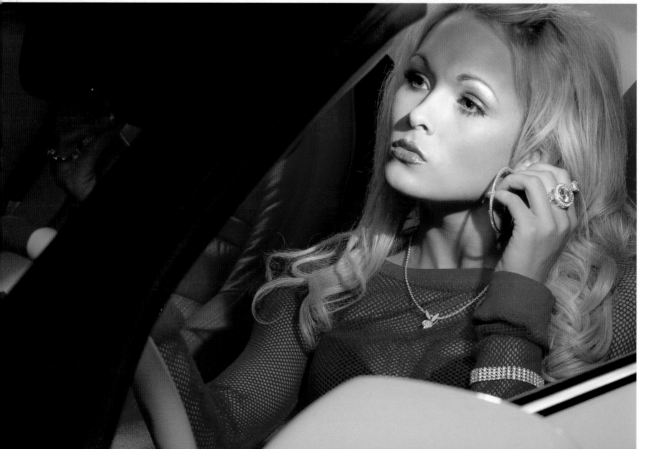

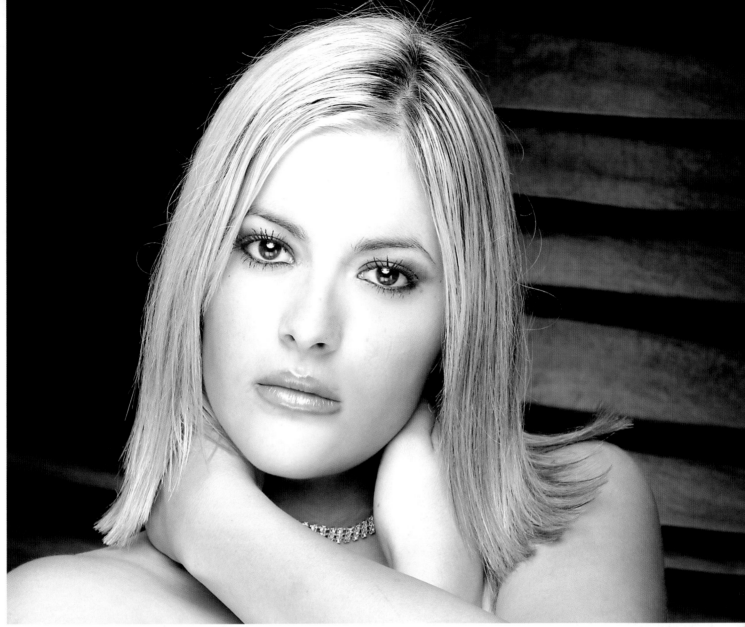

PLATE 122. PHOTOGRAPH BY JEFF SMITH.

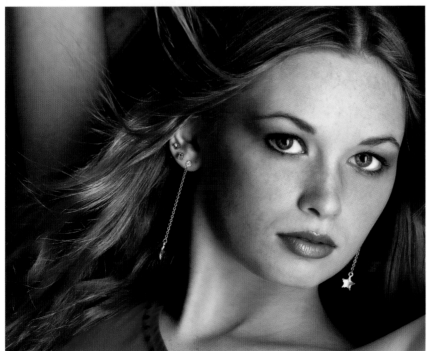

PLATE 123. PHOTOGRAPH BY TIM SCHOOLER.

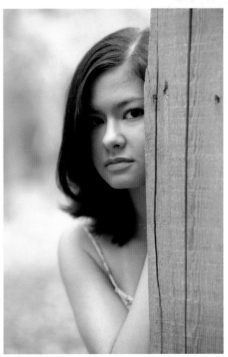

PLATE 124. PHOTOGRAPH BY CHRIS NELSON.

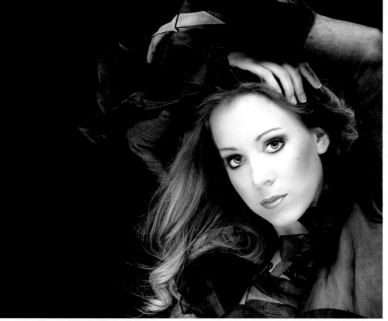

PLATE 125. PHOTOGRAPH BY DEBORAH LYNN FERRO.

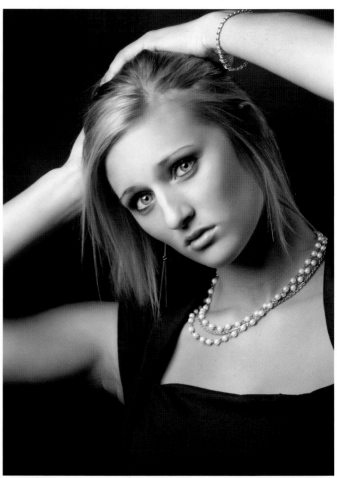

PLATE 126. PHOTOGRAPH BY DAN BROUILLETTE.

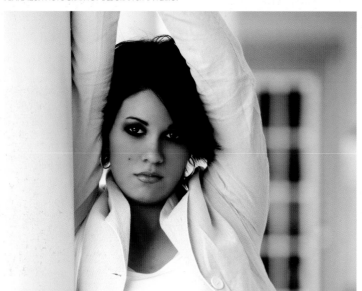

PLATE 127. PHOTOGRAPH BY DEBORAH LYNN FERRO.

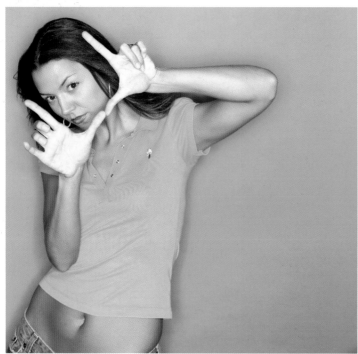

PLATE 128. PHOTOGRAPH BY WES KRONINGER.

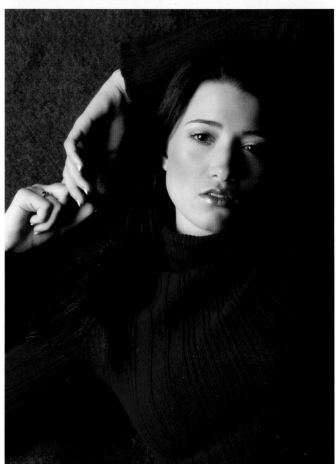

PLATE 129. PHOTOGRAPH BY WES KRONINGER.

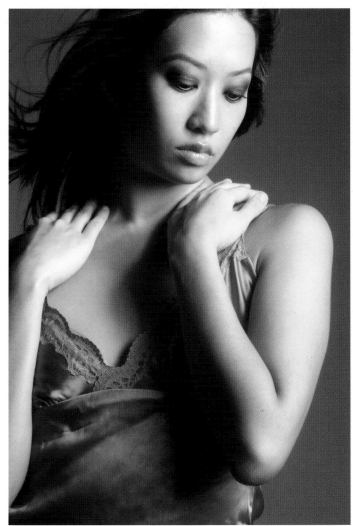

PLATE 130. PHOTOGRAPH BY STEPHEN DANTZIG.

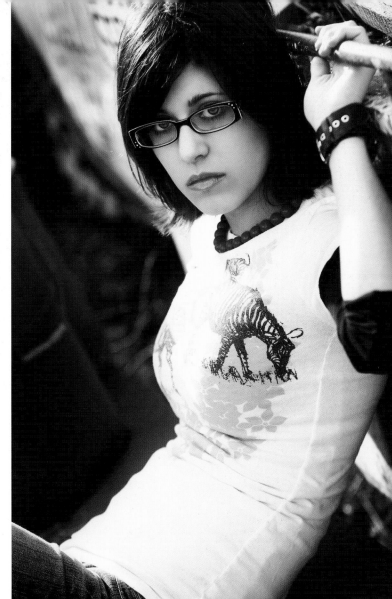

PLATE 131. PHOTOGRAPH BY DAN BROUILLETTE.

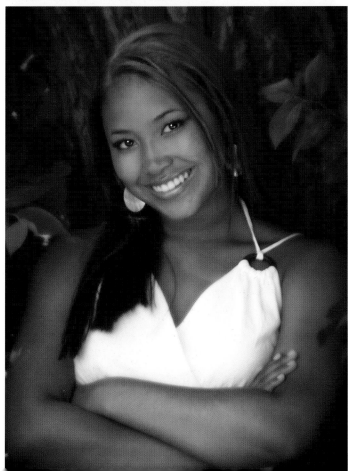

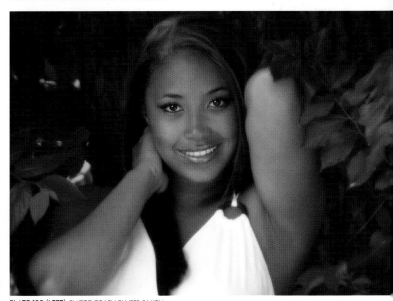

PLATE 132 (LEFT). PHOTOGRAPH BY JEFF SMITH.

PLATE 133 (ABOVE). PHOTOGRAPH BY JEFF SMITH.

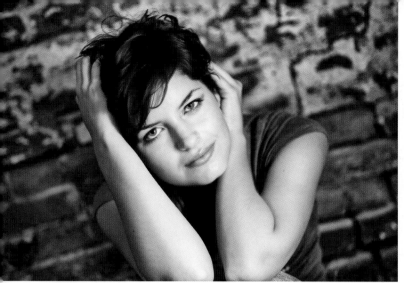

PLATE 134. PHOTOGRAPH BY JEFFREY AND JULIA WOODS.

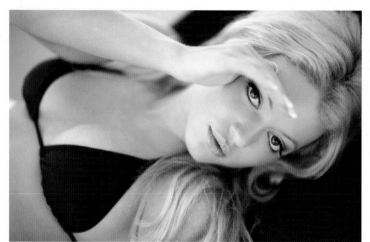

PLATE 136. PHOTOGRAPH BY ROLANDO GOMEZ.

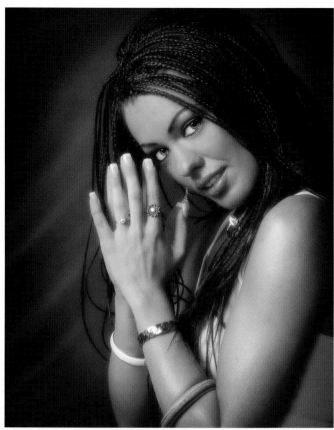

PLATE 135. PHOTOGRAPH BY HERNAN RODRIGUEZ.

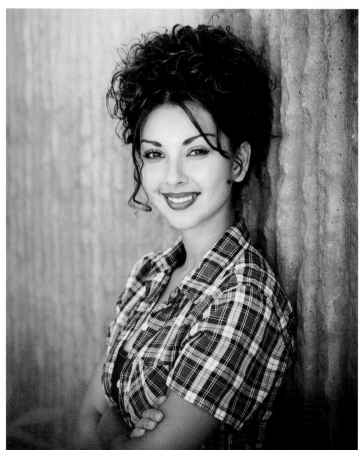

PLATE 137. PHOTOGRAPH BY JEFF SMITH.

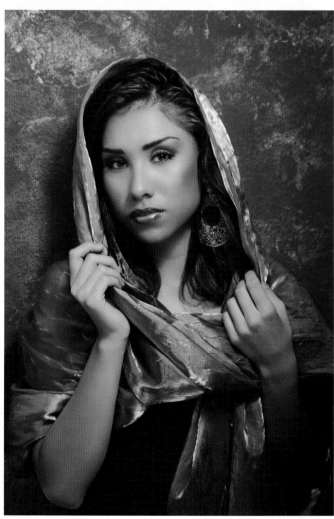

PLATE 138. PHOTOGRAPH BY HERNAN RODRIGUEZ.

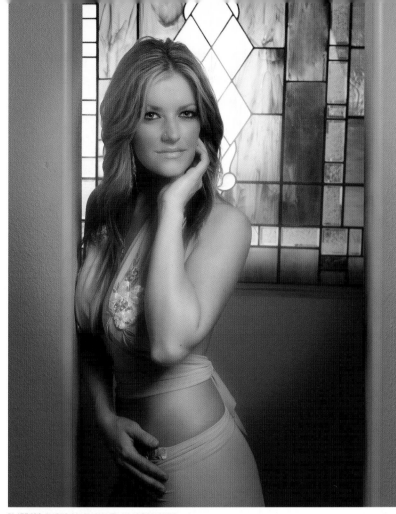

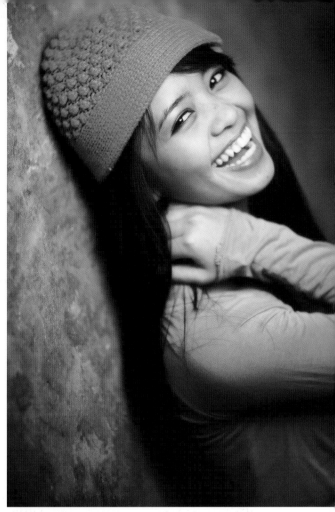

PLATE 139. PHOTOGRAPH BY HERNAN RODRIGUEZ.

PLATE 140. PHOTOGRAPH BY JEFFREY AND JULIA WOODS.

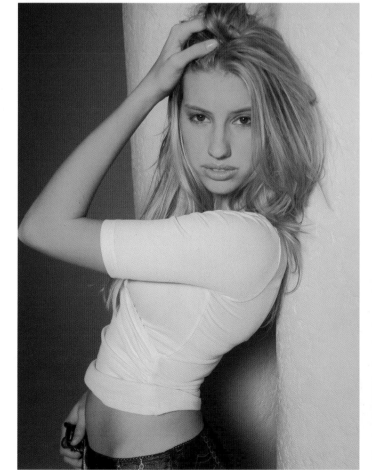

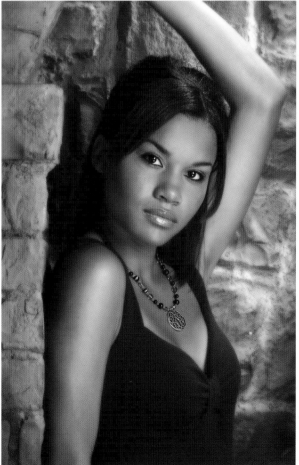

PLATE 141. PHOTOGRAPH BY BILLY PEGRAM.

PLATE 142. PHOTOGRAPH BY JEFF SMITH.

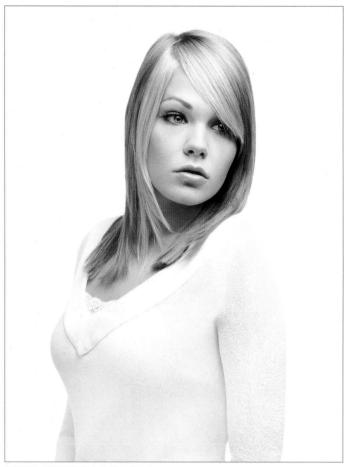

PLATE 143. PHOTOGRAPH BY WES KRONINGER.

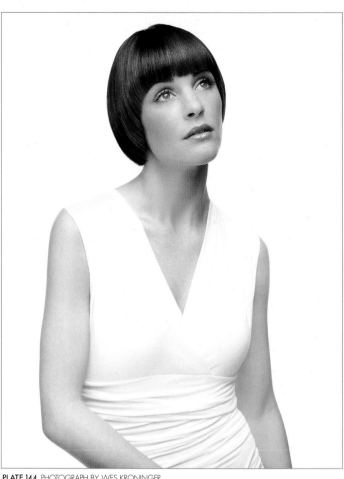

PLATE 144. PHOTOGRAPH BY WES KRONINGER.

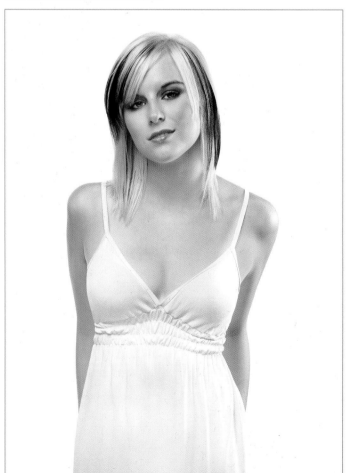

PLATE 145. PHOTOGRAPH BY WES KRONINGER.

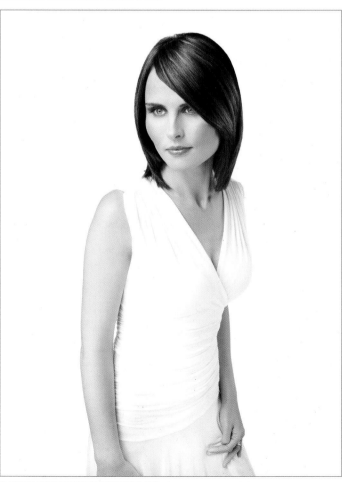

PLATE 146. PHOTOGRAPH BY WES KRONINGER.

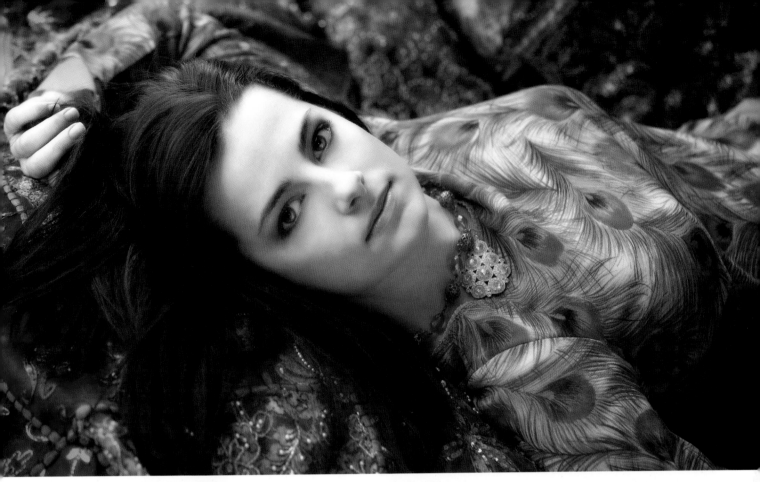

PLATE 147 (ABOVE). PHOTOGRAPH BY VICKI TAUFER.

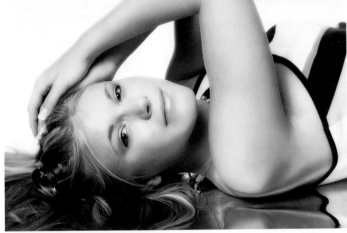

PLATE 148. PHOTOGRAPH BY CHRIS NELSON.

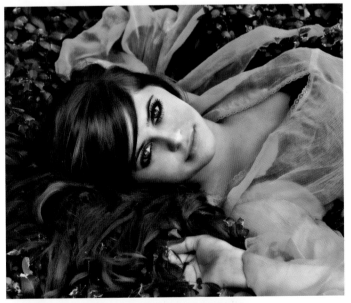

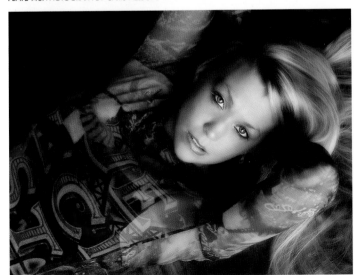

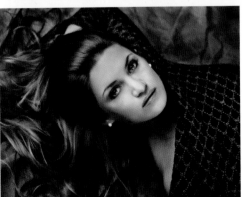

PLATE 149 (ABOVE).
PHOTOGRAPH BY TIM
SCHOOLER.

PLATE 150 (FAR LEFT).
PHOTOGRAPH BY TIM
SCHOOLER.

PLATE 151 (LEFT).
PHOTOGRAPH BY TIM
SCHOOLER.

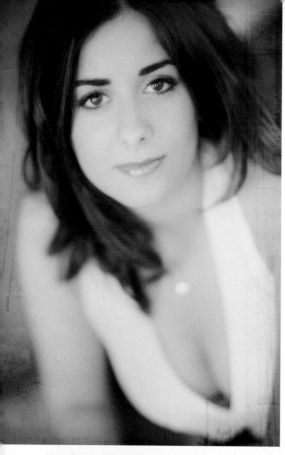

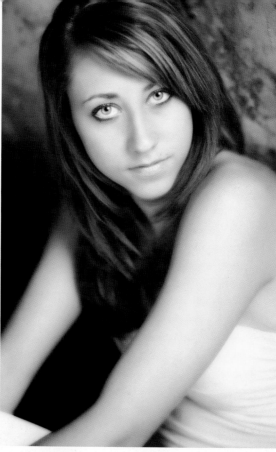

PLATE 152 (FAR LEFT). PHOTOGRAPH BY JEFFREY AND JULIA WOODS.

PLATE 153 (LEFT). PHOTOGRAPH BY JEFFREY AND JULIA WOODS.

PLATE 154 (BELOW). PHOTOGRAPH BY JEFFREY AND JULIA WOODS.

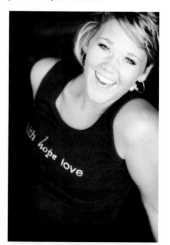

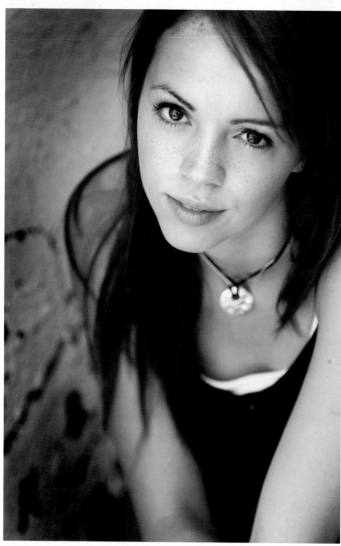

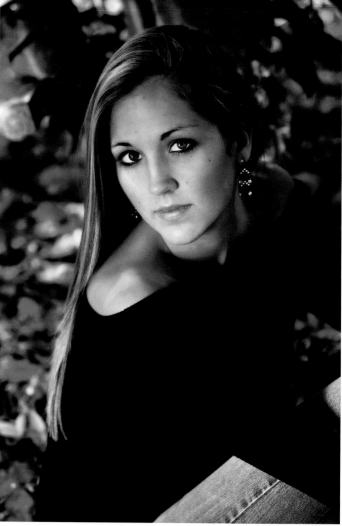

PLATE 155. PHOTOGRAPH BY DAN BROUILLETTE.

PLATE 156. PHOTOGRAPH BY TIM SCHOOLER.

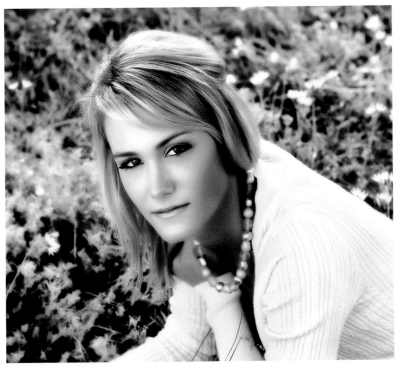

PLATE 157. PHOTOGRAPH BY TIM SCHOOLER.

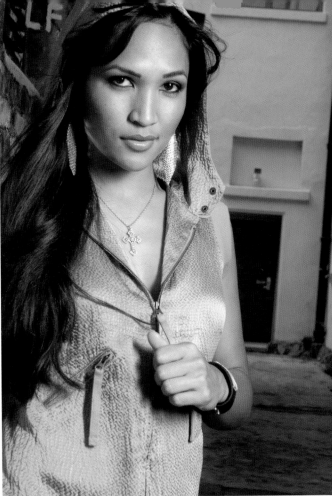

PLATE 158. PHOTOGRAPH BY STEPHEN DANTZIG.

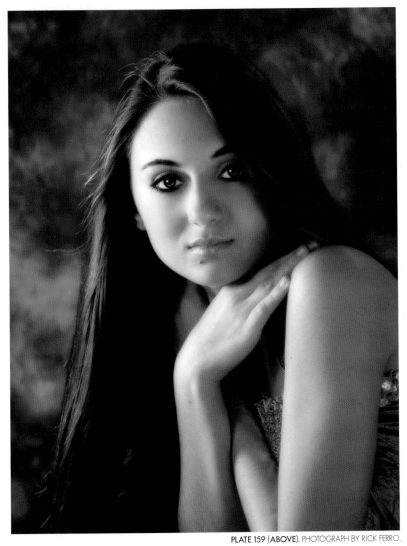

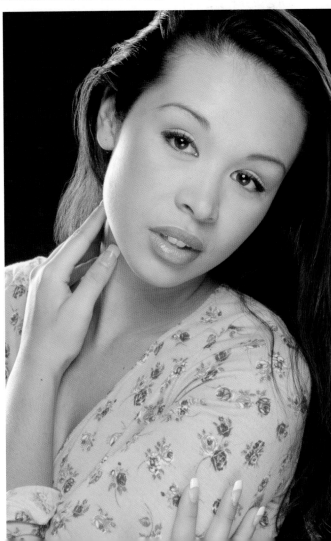

PLATE 159 (ABOVE). PHOTOGRAPH BY RICK FERRO.

PLATE 160 (RIGHT). PHOTOGRAPH BY STEPHEN DANTZIG.

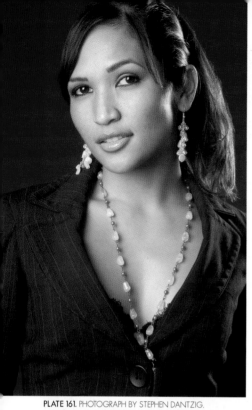

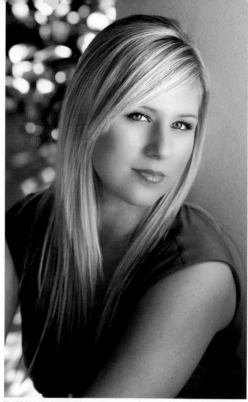

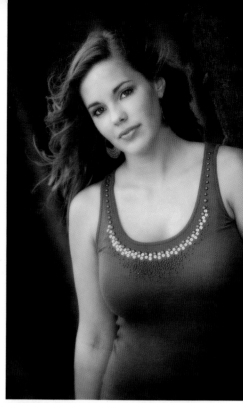

PLATE 161. PHOTOGRAPH BY STEPHEN DANTZIG.

PLATE 162. PHOTOGRAPH BY TIM SCHOOLER.

PLATE 163. PHOTOGRAPH BY JEFFREY AND JULIA WOODS.

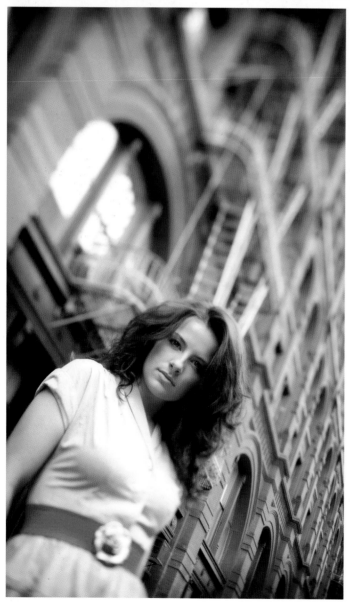

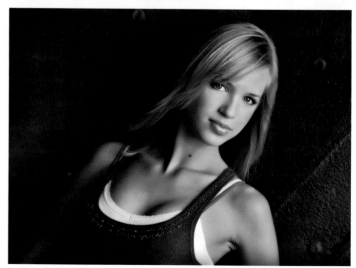

PLATE 164. PHOTOGRAPH BY JEFFREY AND JULIA WOODS.

PLATE 165 (LEFT). PHOTOGRAPH BY VICKI TAUFER.

PLATE 166 (ABOVE). PHOTOGRAPH BY TIM SCHOOLER.

PLATE 167 (BELOW). PHOTOGRAPH BY CHERIE STEINBERG COTE.

PLATE 168 (RIGHT). PHOTOGRAPH BY HERNAN RODRIGUEZ.

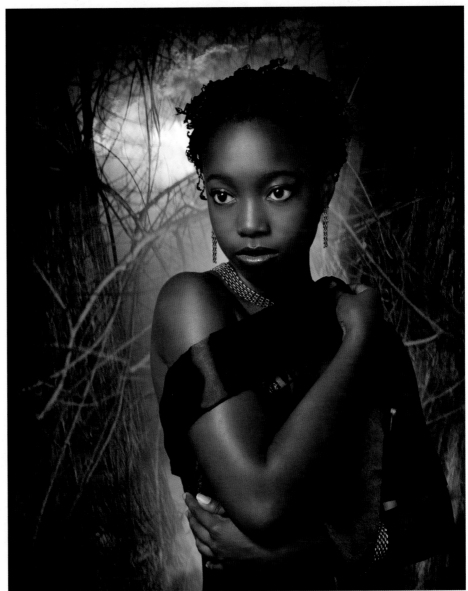

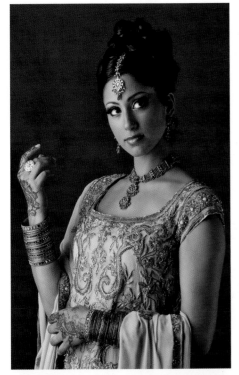

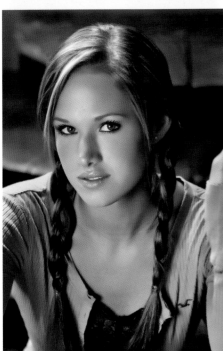

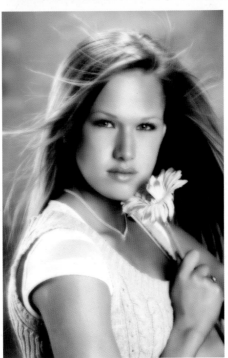

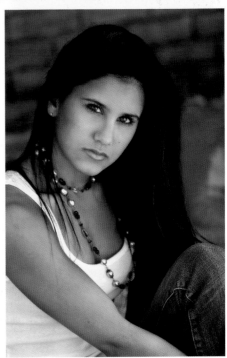

PLATE 169. PHOTOGRAPH BY TIM SCHOOLER.

PLATE 170. PHOTOGRAPH BY TIM SCHOOLER.

PLATE 171. PHOTOGRAPH BY TIM SCHOOLER.

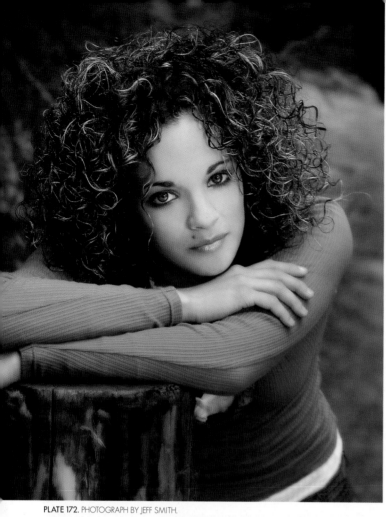

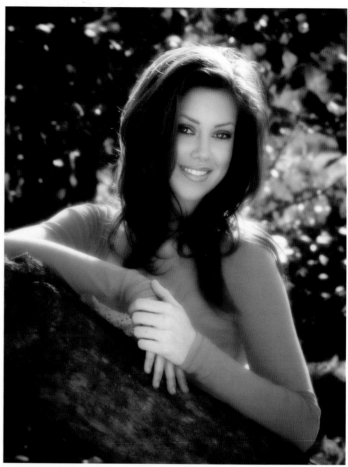

PLATE 172. PHOTOGRAPH BY JEFF SMITH.

PLATE 173. PHOTOGRAPH BY JEFF SMITH.

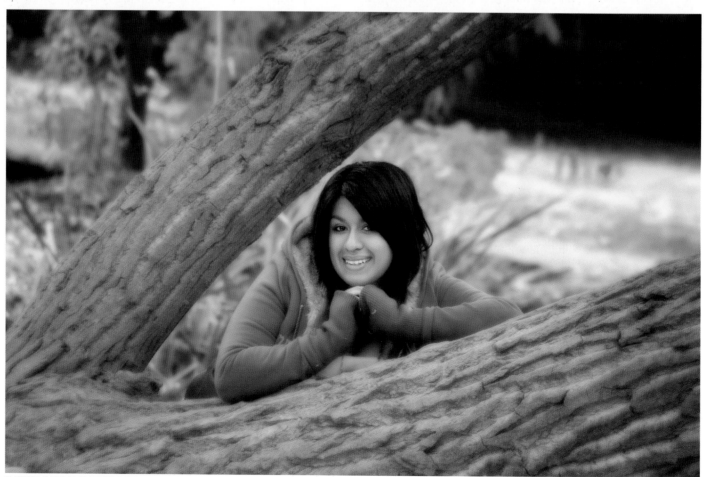

PLATE 174. PHOTOGRAPH BY JEFF SMITH.

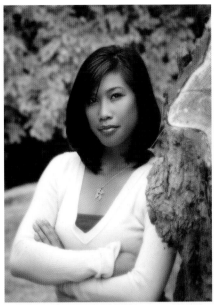

PLATE 175. PHOTOGRAPH BY JEFF SMITH.

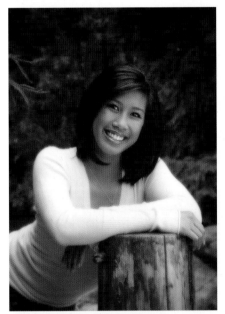

PLATE 176. PHOTOGRAPH BY JEFF SMITH.

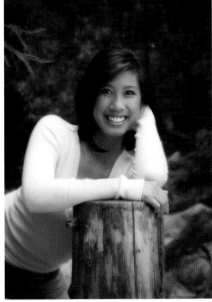

PLATE 177. PHOTOGRAPH BY JEFF SMITH.

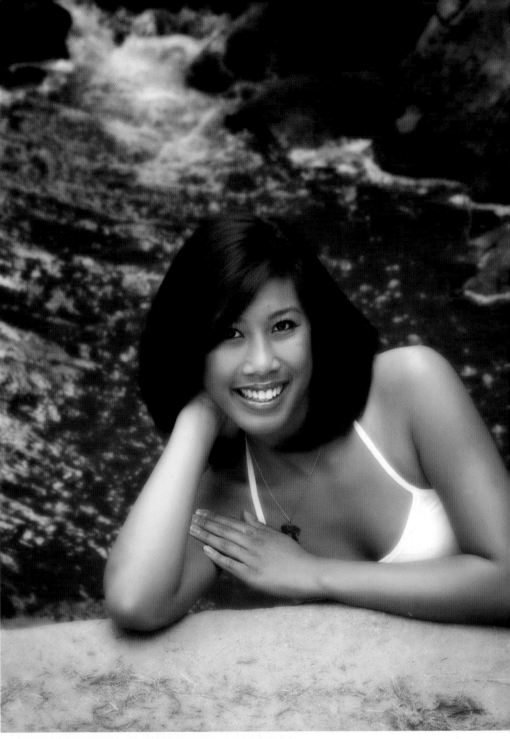

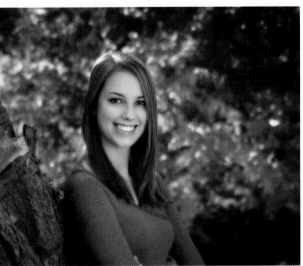

PLATE 178 (ABOVE). PHOTOGRAPH BY JEFF SMITH.

PLATE 179 (LEFT). PHOTOGRAPH BY JEFF SMITH.

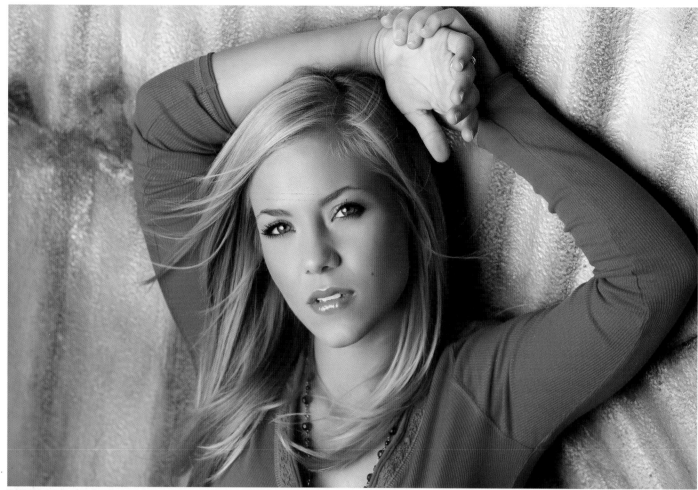

PLATE 180. PHOTOGRAPH BY TIM SCHOOLER.

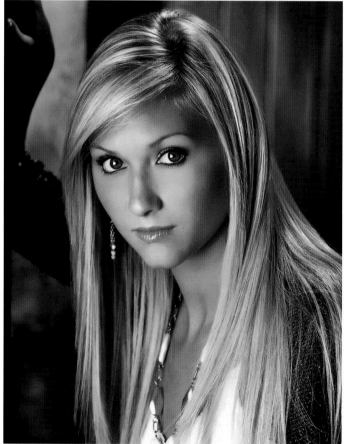

PLATE 181. PHOTOGRAPH BY TIM SCHOOLER.

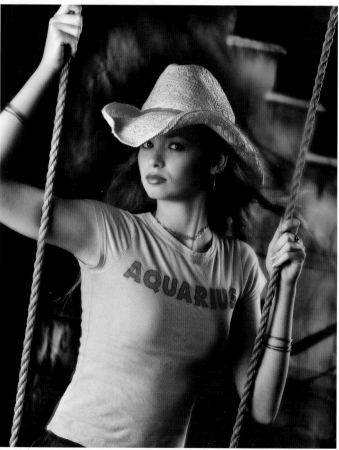

PLATE 182. PHOTOGRAPH BY TIM SCHOOLER.

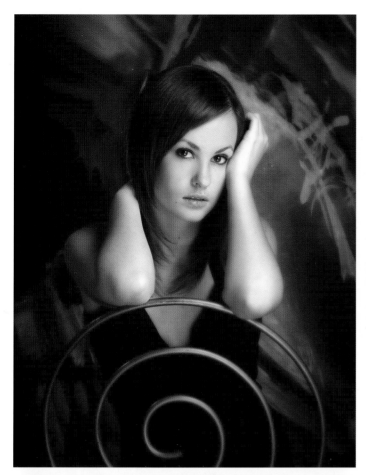

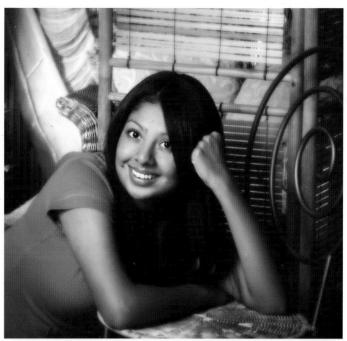

PLATE 183 (LEFT). PHOTOGRAPH BY JEFF SMITH.

PLATE 184 (BELOW). PHOTOGRAPH BY JEFF SMITH.

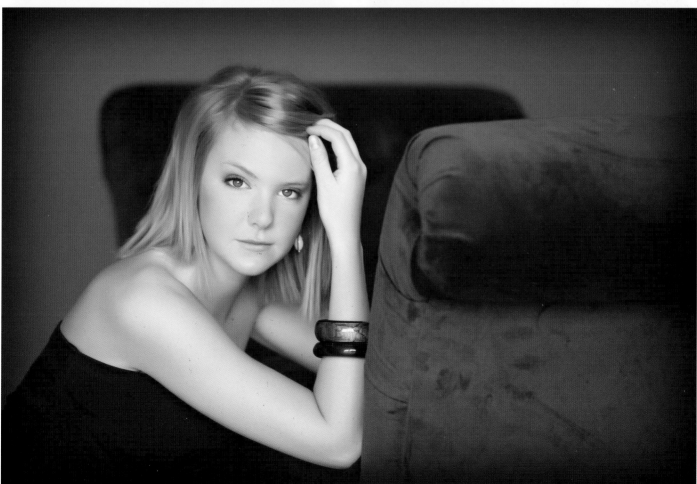

PLATE 185. PHOTOGRAPH BY VICKI TAUFER.

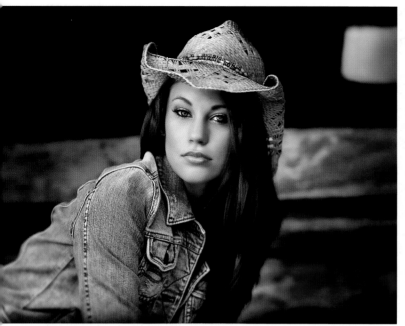

PLATE 186. PHOTOGRAPH BY TIM SCHOOLER.

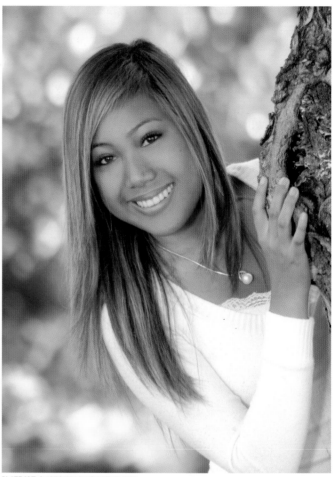

PLATE 187. PHOTOGRAPH BY JEFF SMITH.

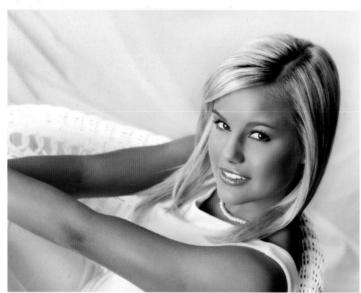

PLATE 188. PHOTOGRAPH BY TIM SCHOOLER.

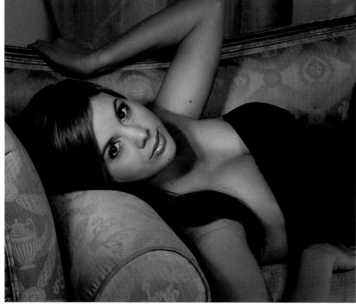

PLATE 189. PHOTOGRAPH BY JEFF SMITH.

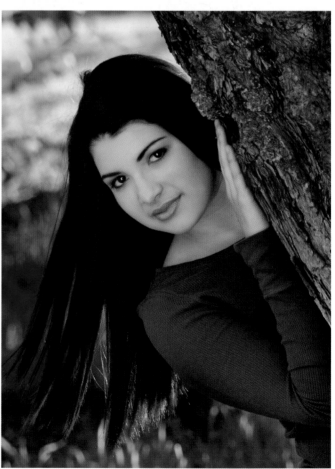

PLATE 190. PHOTOGRAPH BY JEFF SMITH.

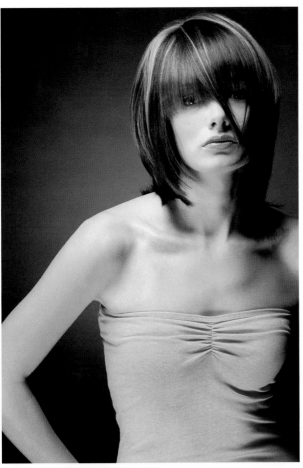

PLATE 191. PHOTOGRAPH BY WES KRONINGER.

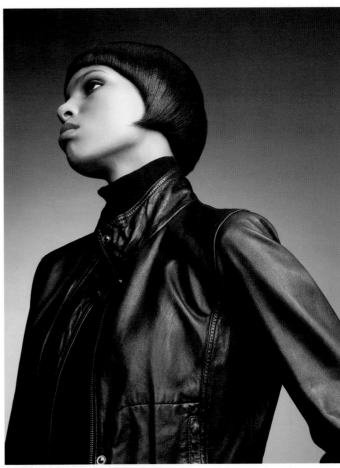

PLATE 192. PHOTOGRAPH BY WES KRONINGER.

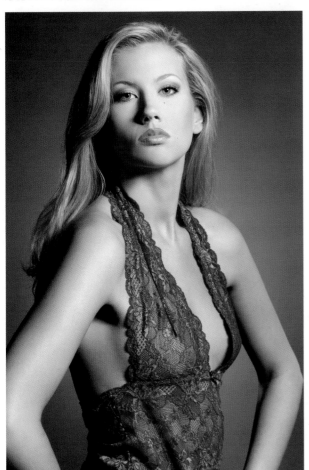

PLATE 193. PHOTOGRAPH BY WES KRONINGER.

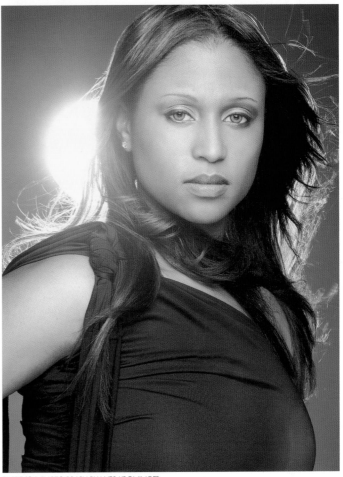

PLATE 194. PHOTOGRAPH BY WES KRONINGER.

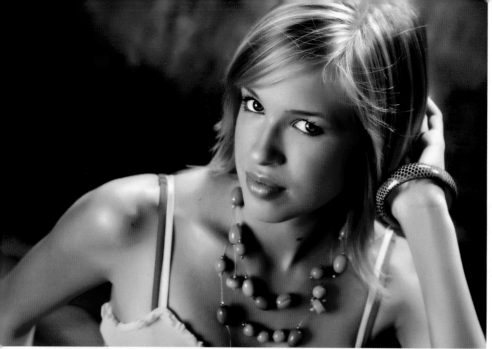

PLATE 195. PHOTOGRAPH BY TIM SCHOOLER.

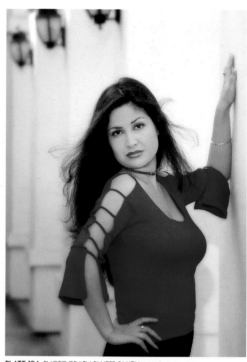

PLATE 196. PHOTOGRAPH BY JEFF SMITH.

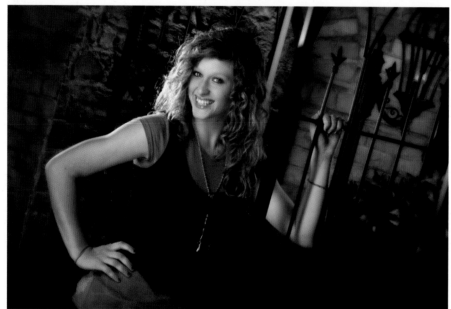

PLATE 197. PHOTOGRAPH BY JEFF SMITH.

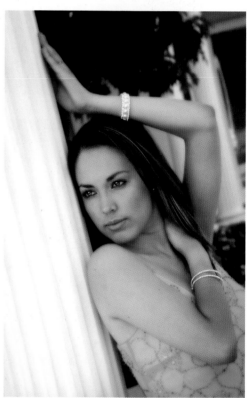

PLATE 198. PHOTOGRAPH BY JEFF SMITH.

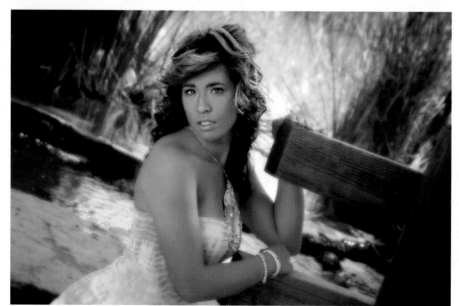

PLATE 199. PHOTOGRAPH BY JEFF SMITH.

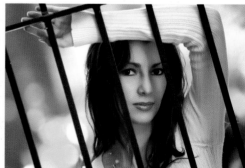

PLATE 200. PHOTOGRAPH BY TIM SCHOOLER.

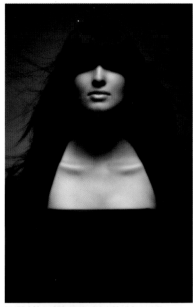

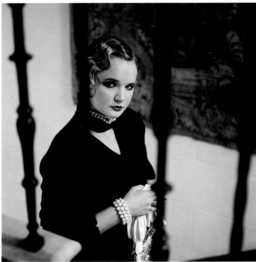

PLATE 202 (LEFT). PHOTOGRAPH BY RICK FERRO.

PLATE 203 (BELOW). PHOTOGRAPH BY CHERIE STEINBERG COTE.

PLATE 201. PHOTOGRAPH BY WES KRONINGER.

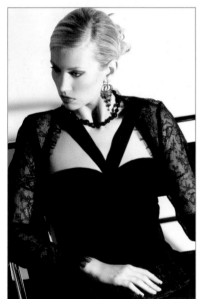

PLATE 204. PHOTOGRAPH BY WES KRONINGER.

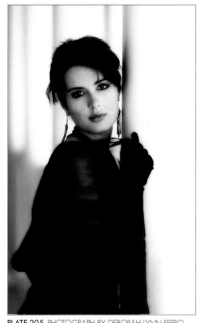

PLATE 205. PHOTOGRAPH BY DEBORAH LYNN FERRO.

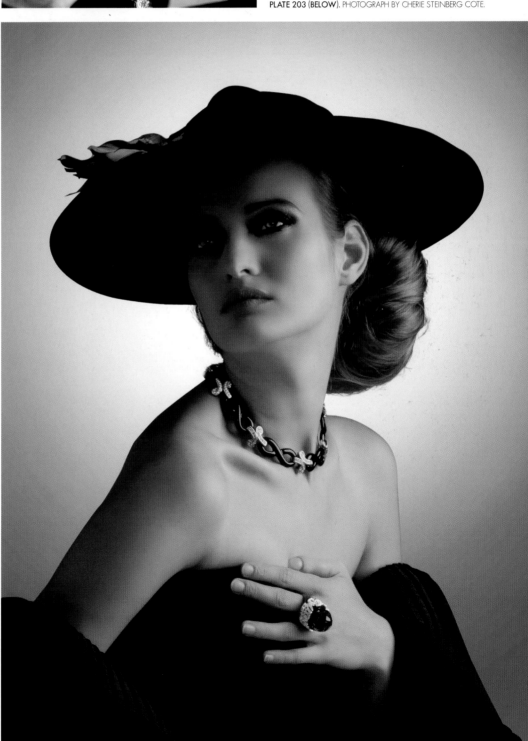

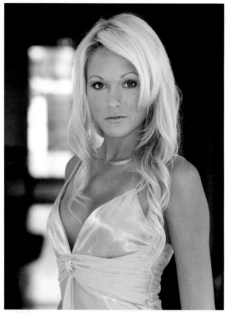

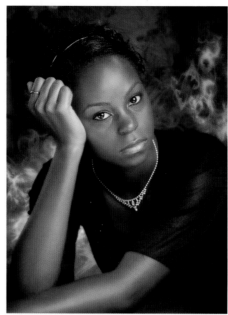

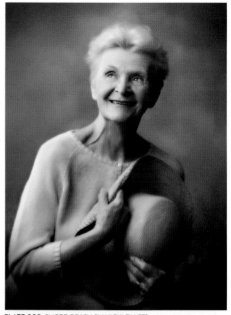

PLATE 206. PHOTOGRAPH BY ROLANDO GOMEZ.

PLATE 207. PHOTOGRAPH BY JEFF SMITH.

PLATE 208. PHOTOGRAPH BY VICKI TAUFER.

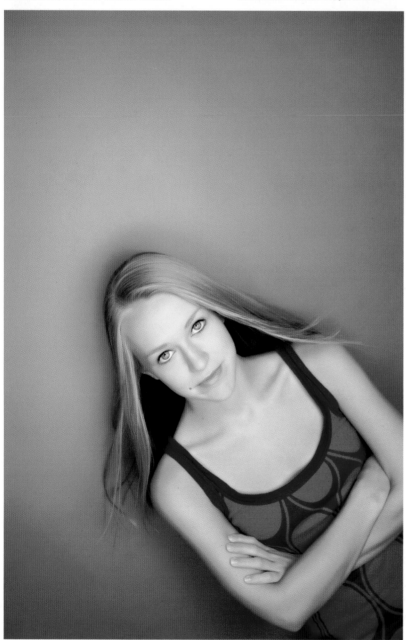

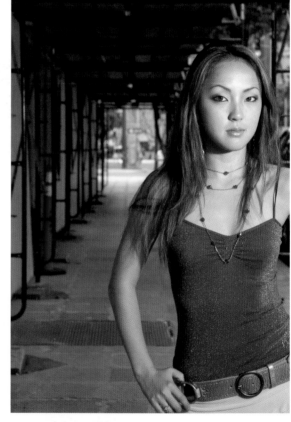

PLATE 209 (FAR LEFT). PHOTOGRAPH BY VICKI TAUFER.

PLATE 210 (ABOVE). PHOTOGRAPH BY STEPHEN DANTZIG.

PLATE 211 (LEFT). PHOTOGRAPH BY DEBORAH LYNN FERRO.

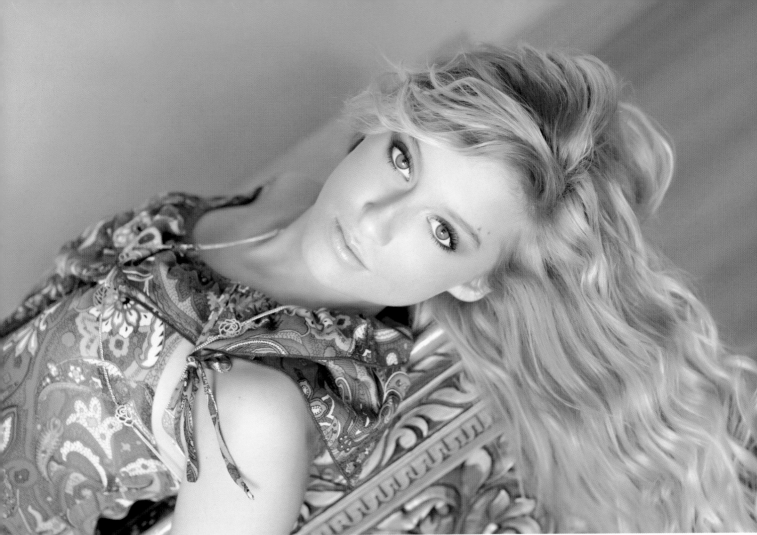

PLATE 212 (TOP). PHOTOGRAPH BY VICKI TAUFER.

PLATE 213 (ABOVE). PHOTOGRAPH BY DEBORAH LYNN FERRO.

PLATE 214 (RIGHT). PHOTOGRAPH BY JEFFREY AND JULIA WOODS.

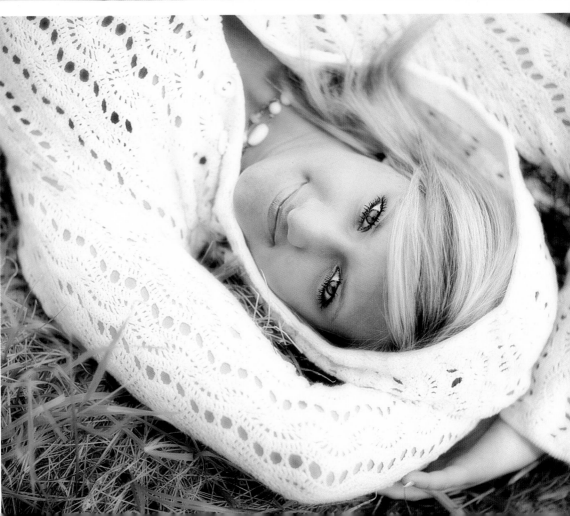

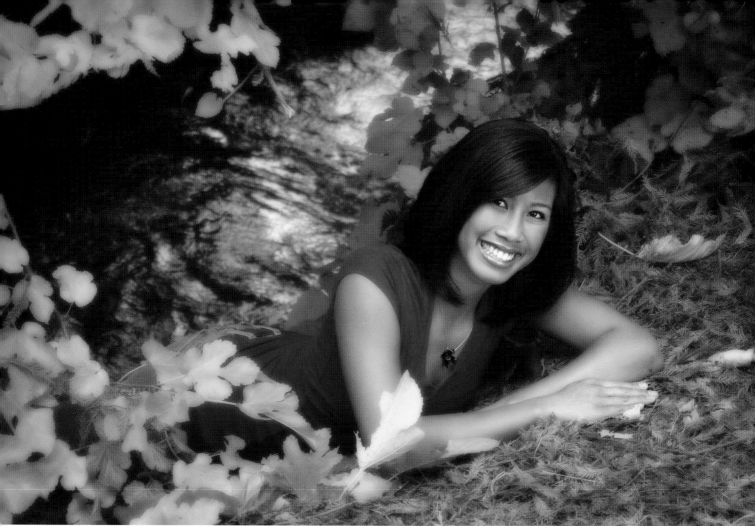

PLATE 215. PHOTOGRAPH BY JEFF SMITH.

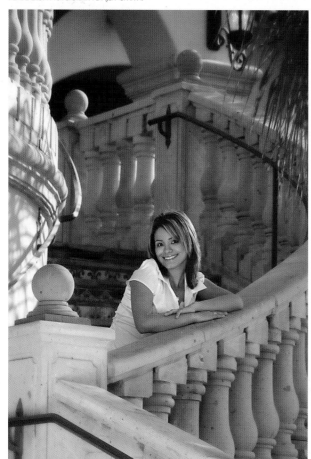

PLATE 216. PHOTOGRAPH BY JEFF SMITH.

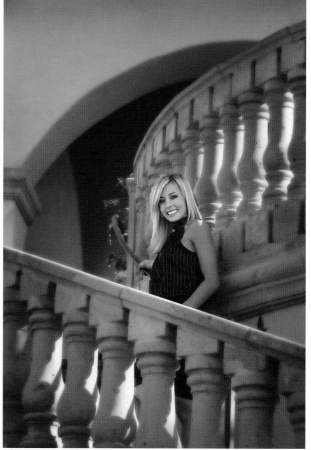

PLATE 217. PHOTOGRAPH BY JEFF SMITH.

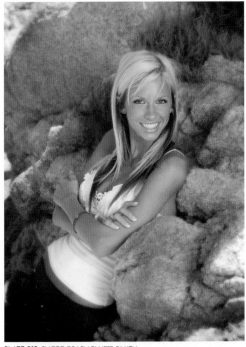

PLATE 218. PHOTOGRAPH BY JEFF SMITH.

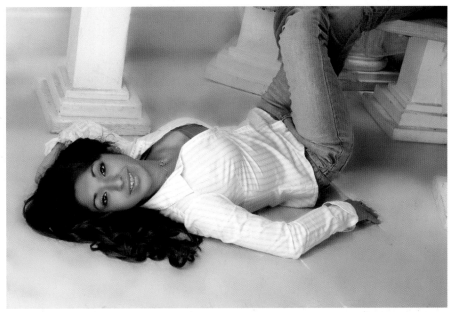

PLATE 219. PHOTOGRAPH BY JEFF SMITH.

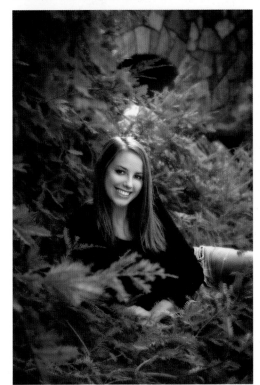

PLATE 220. PHOTOGRAPH BY JEFF SMITH.

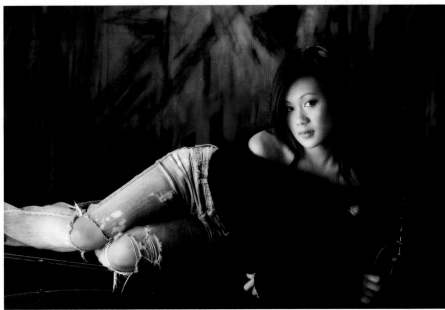

PLATE 221. PHOTOGRAPH BY TIM SCHOOLER.

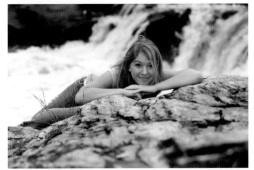

PLATE 222. PHOTOGRAPH BY CHRIS NELSON.

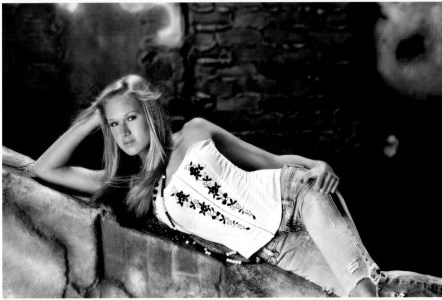

PLATE 223. PHOTOGRAPH BY TIM SCHOOLER.

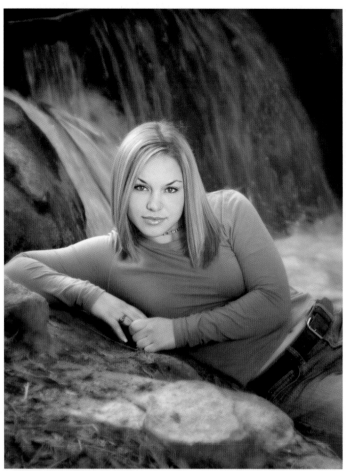

PLATE 224. PHOTOGRAPH BY JEFF SMITH.

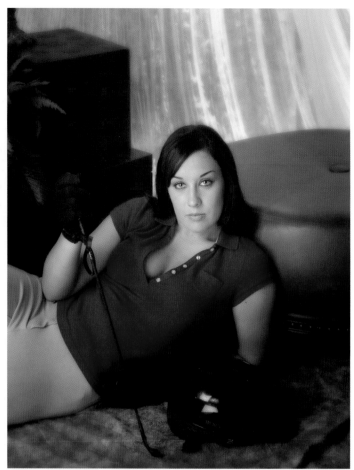

PLATE 225. PHOTOGRAPH BY JEFF SMITH.

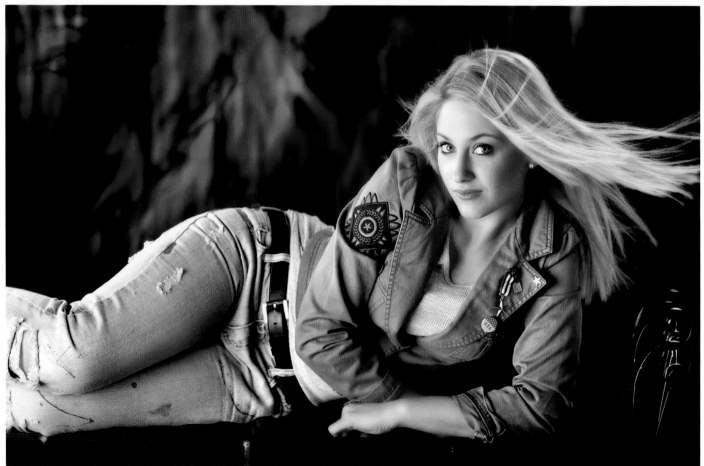

PLATE 226. PHOTOGRAPH BY TIM SCHOOLER.

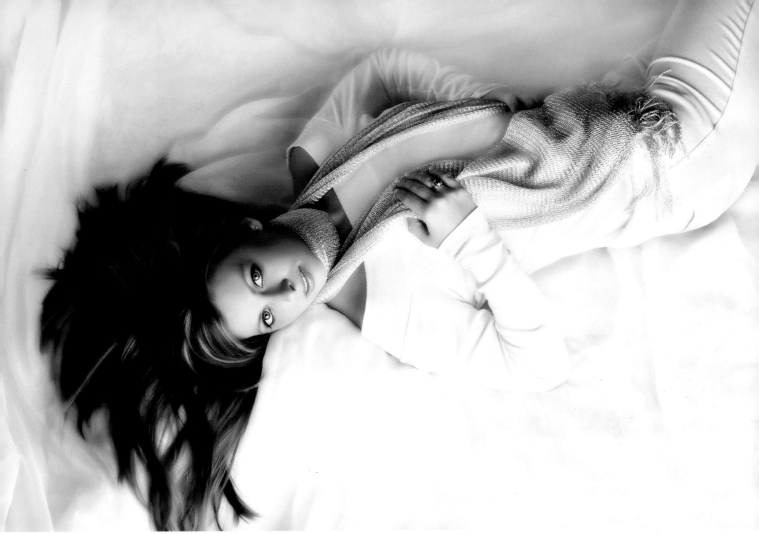

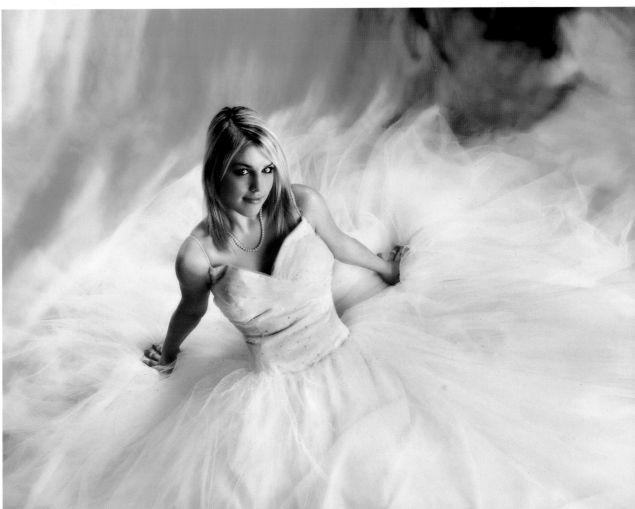

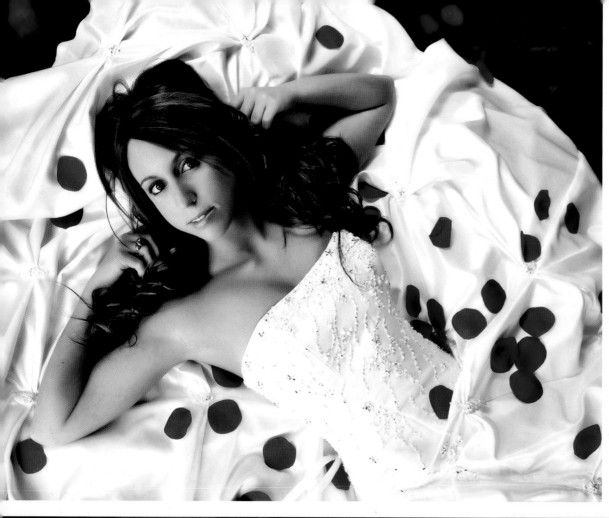

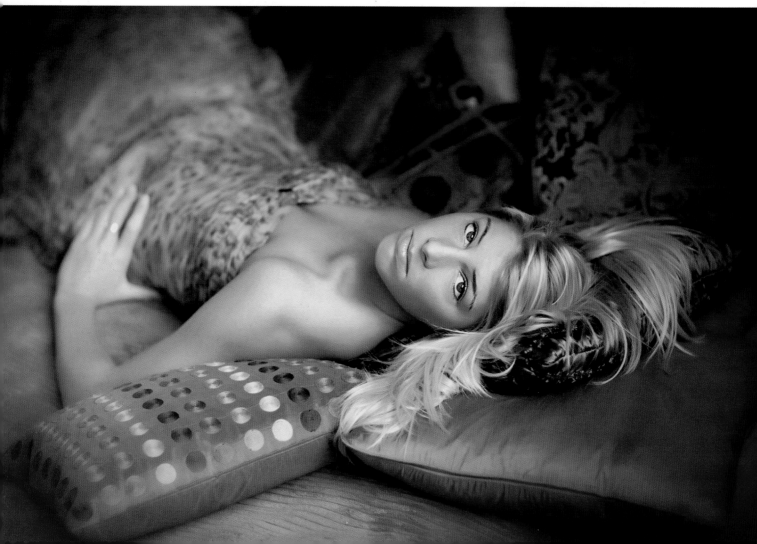

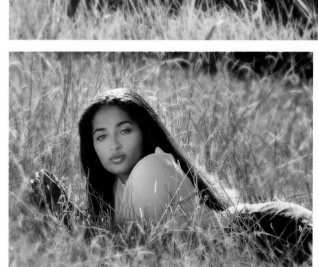

PLATE 231 (TOP RIGHT). PHOTOGRAPH BY JEFF SMITH.

PLATE 232 (BELOW). PHOTOGRAPH BY DAN BROUILLETTE.

PLATE 233 (BOTTOM RIGHT). PHOTOGRAPH BY JEFF SMITH.

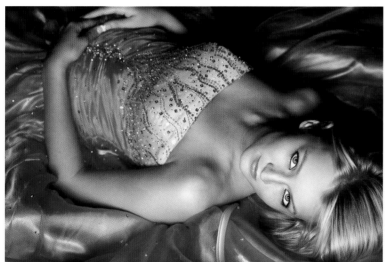

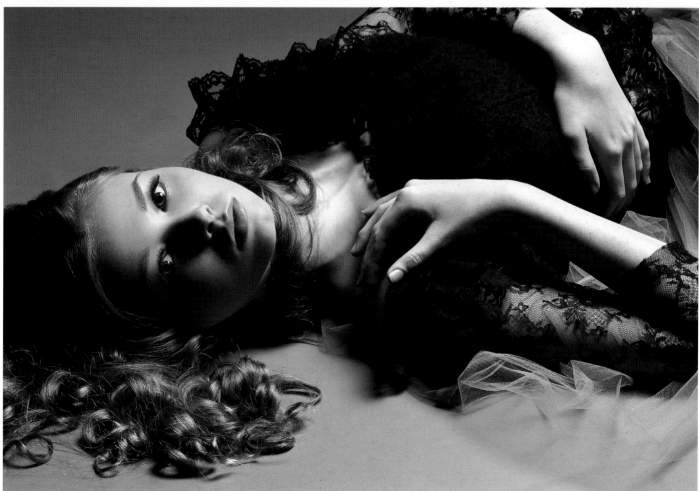

PLATE 234. PHOTOGRAPH BY WES KRONINGER.

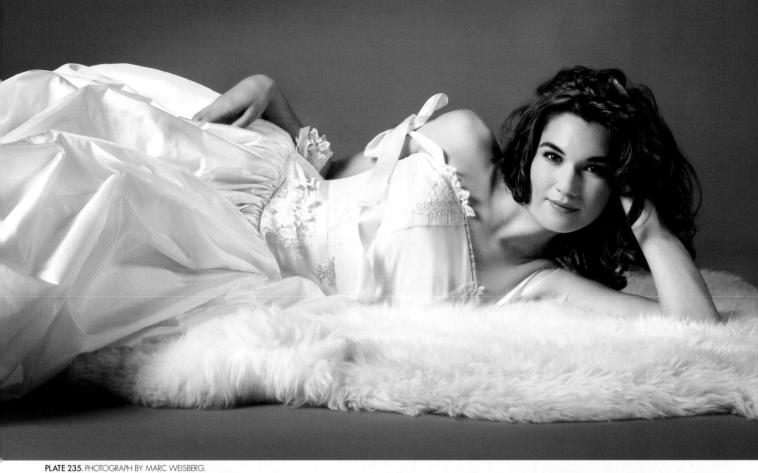

PLATE 235. PHOTOGRAPH BY MARC WEISBERG.

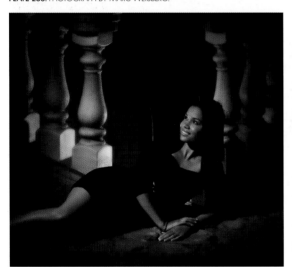

PLATE 236. PHOTOGRAPH BY JEFF SMITH.

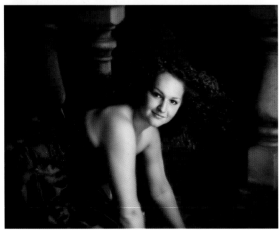

PLATE 237. PHOTOGRAPH BY JEFF SMITH.

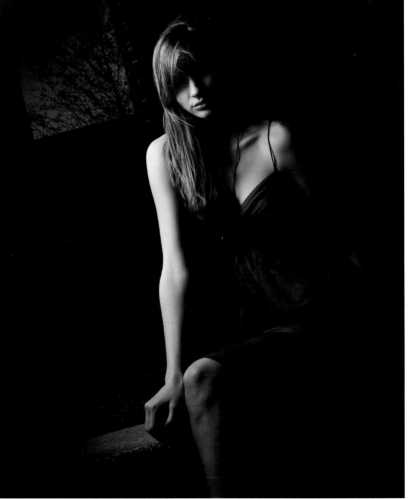

PLATE 238. PHOTOGRAPH BY DAN BROUILLETTE.

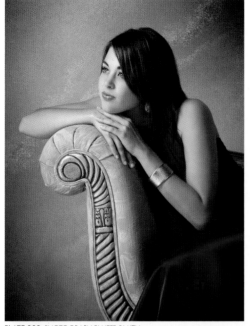

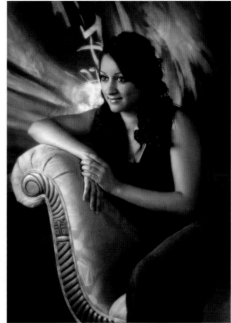

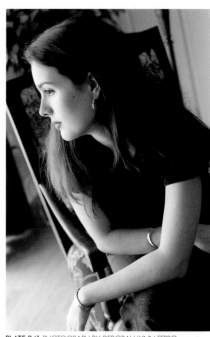

PLATE 239. PHOTOGRAPH BY JEFF SMITH.

PLATE 240. PHOTOGRAPH BY JEFF SMITH.

PLATE 241. PHOTOGRAPH BY DEBORAH LYNN FERRO.

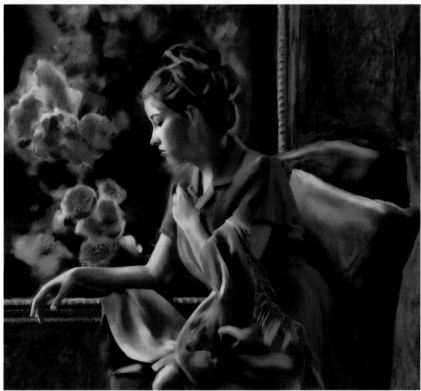

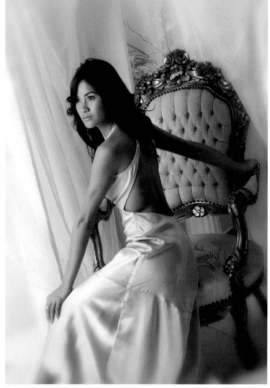

PLATE 242. PHOTOGRAPH BY DEBORAH LYNN FERRO.

PLATE 243. PHOTOGRAPH BY JEFF SMITH.

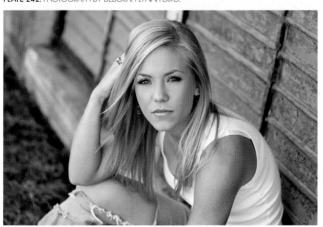

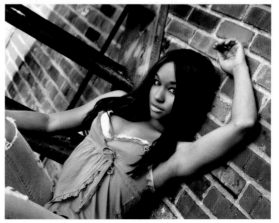

PLATE 244 (FAR LEFT).
PHOTOGRAPH BY TIM
SCHOOLER.

PLATE 245 (LEFT).
PHOTOGRAPH BY TIM
SCHOOLER.

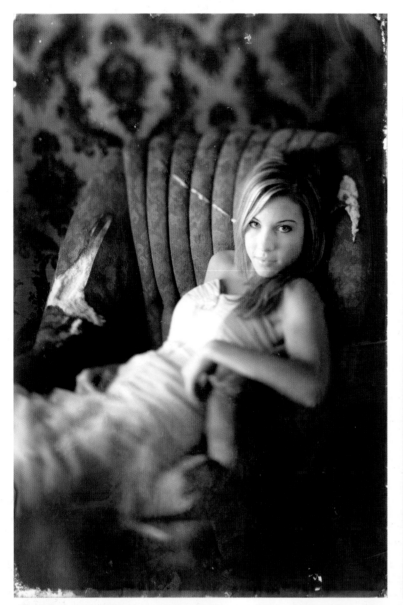

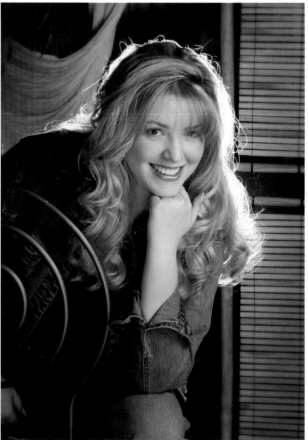

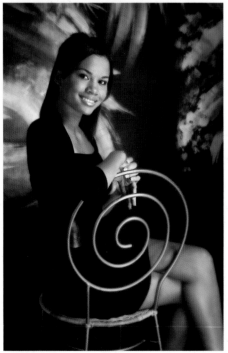

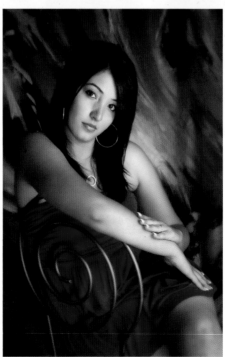

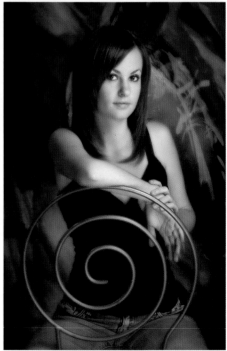

PLATE 248. PHOTOGRAPH BY JEFF SMITH.

PLATE 249. PHOTOGRAPH BY JEFF SMITH.

PLATE 250. PHOTOGRAPH BY JEFF SMITH.

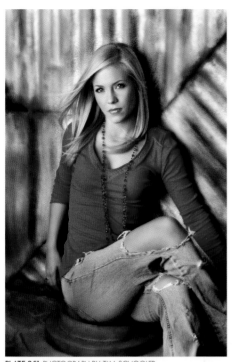

PLATE 251. PHOTOGRAPH BY TIM SCHOOLER.

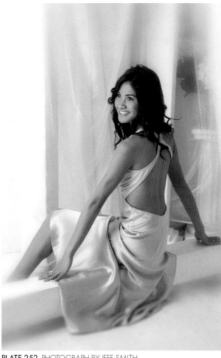

PLATE 252. PHOTOGRAPH BY JEFF SMITH.

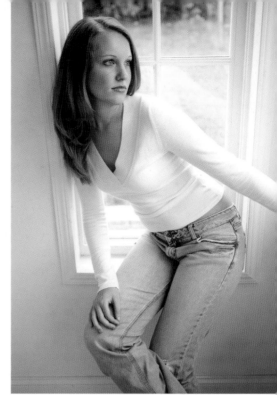

PLATE 253. PHOTOGRAPH BY CHRIS NELSON.

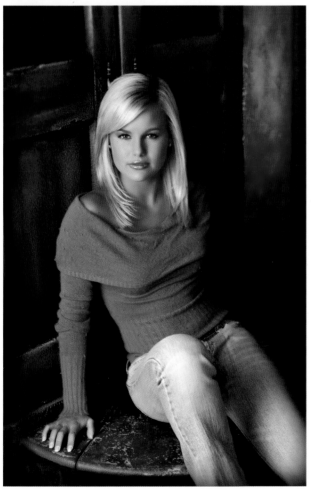

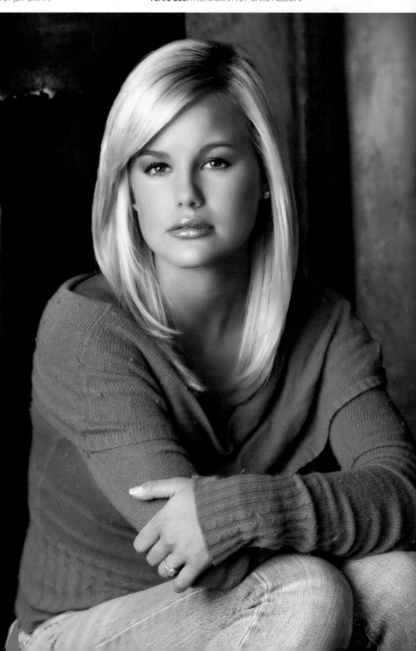

PLATE 254 (ABOVE). PHOTOGRAPH
BY TIM SCHOOLER.

PLATE 255 (RIGHT). PHOTOGRAPH
BY TIM SCHOOLER.

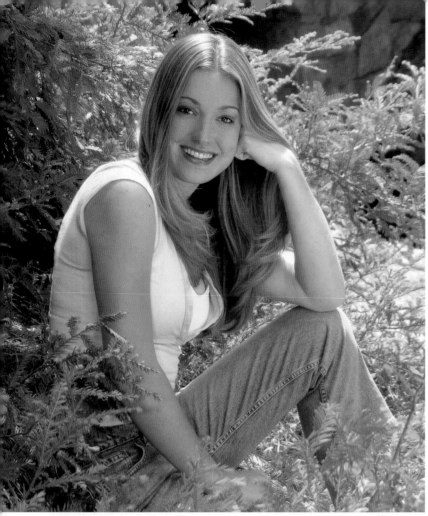

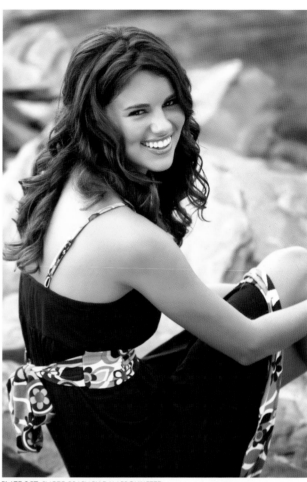

PLATE 256. PHOTOGRAPH BY JEFF SMITH.

PLATE 257. PHOTOGRAPH BY DAN BROUILLETTE.

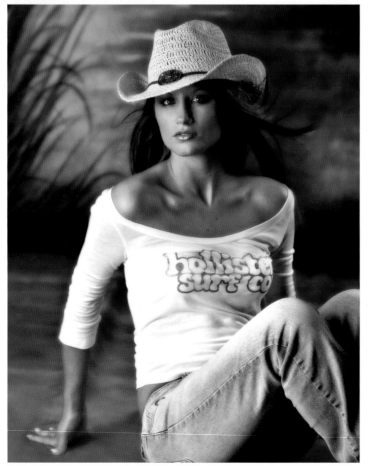

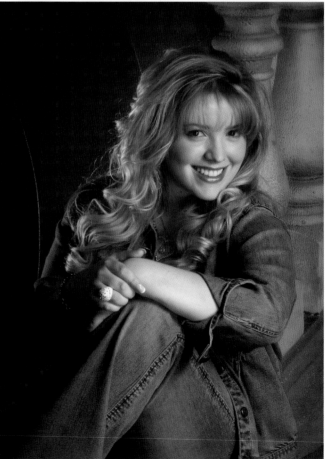

PLATE 258. PHOTOGRAPH BY TIM SCHOOLER.

PLATE 259. PHOTOGRAPH BY JEFF SMITH.

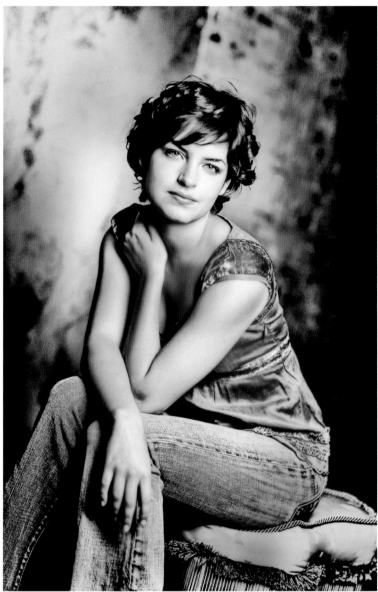

PLATE 260. PHOTOGRAPH BY JEFFREY AND JULIA WOODS.

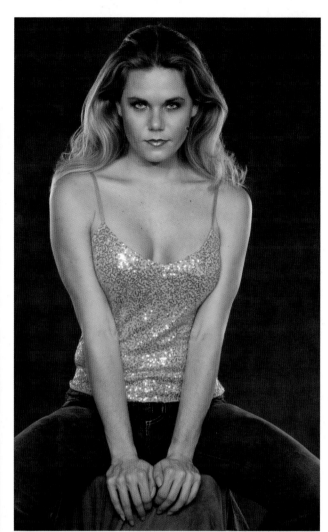

PLATE 261. PHOTOGRAPH BY STEPHEN DANTZIG.

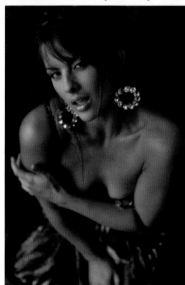

PLATE 262. PHOTOGRAPH BY
CHERIE STEINBERG COTE.

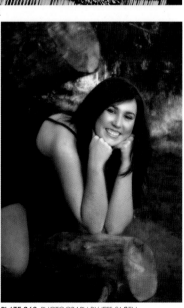

PLATE 263. PHOTOGRAPH BY JEFF SMITH.

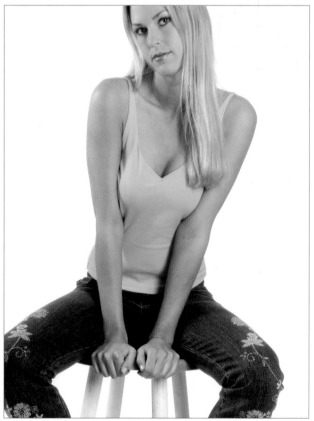

PLATE 264. PHOTOGRAPH BY STEPHEN DANTZIG.

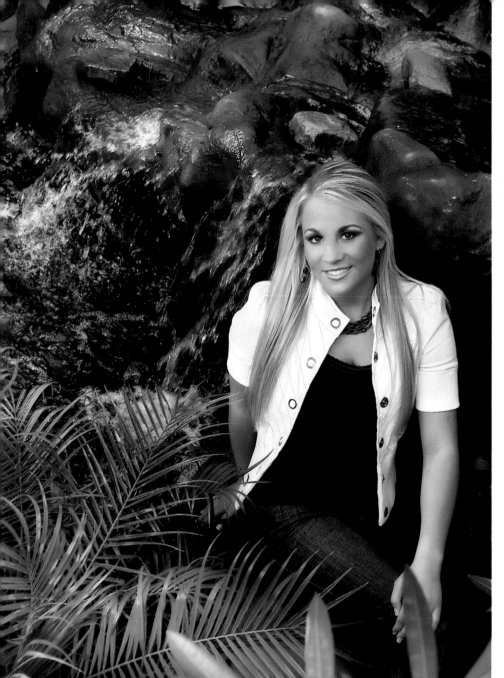

PLATE 265 (LEFT). PHOTOGRAPH BY TIM SCHOOLER.

PLATE 266 (BELOW). PHOTOGRAPH BY STEVEN BEGLEITER.

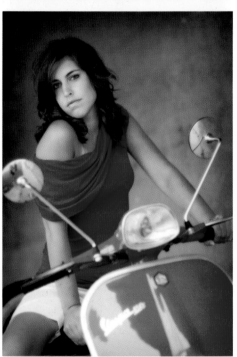

PLATE 267. PHOTOGRAPH BY JEFFREY AND JULIA WOODS.

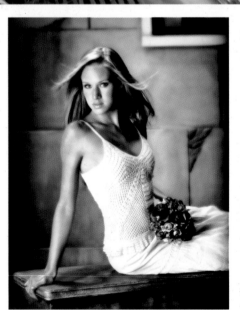

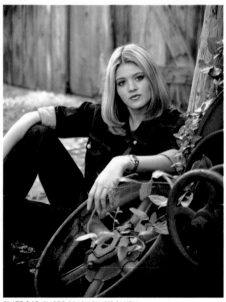

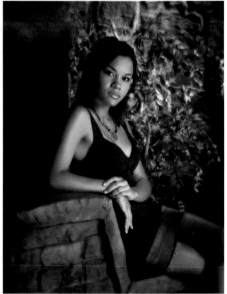

PLATE 268. PHOTOGRAPH BY TIM SCHOOLER.

PLATE 269. PHOTOGRAPH BY JEFF SMITH.

PLATE 270. PHOTOGRAPH BY TIM SCHOOLER.

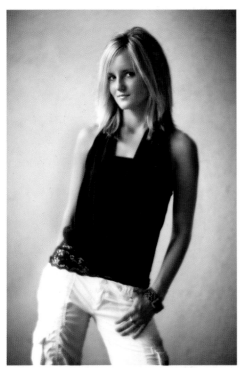

PLATE 271. PHOTOGRAPH BY JEFFREY AND JULIA WOODS.

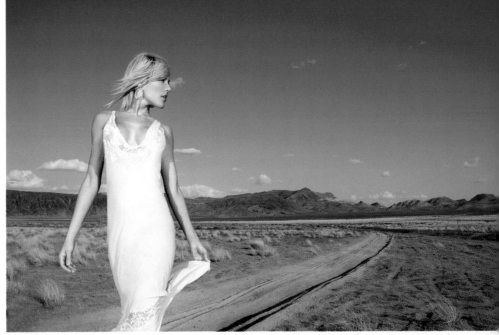

PLATE 272. PHOTOGRAPH BY BILLY PEGRAM.

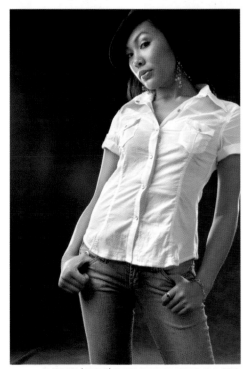

PLATE 273 (ABOVE). PHOTOGRAPH BY STEPHEN DANTZIG.

PLATE 274 (RIGHT). PHOTOGRAPH BY STEPHEN DANTZIG.

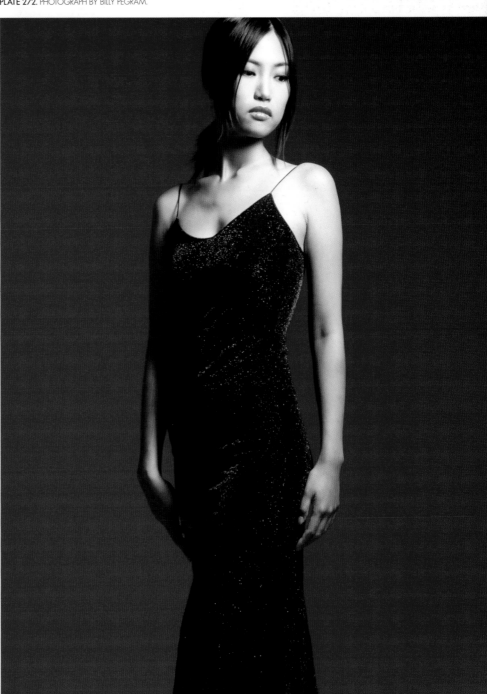

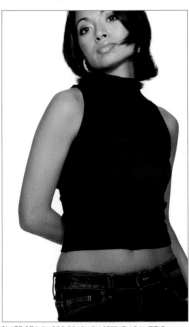

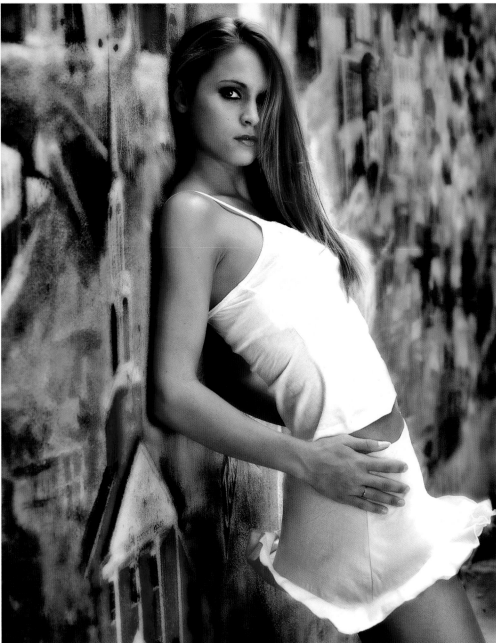

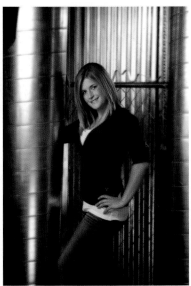

PLATE 276. PHOTOGRAPH BY STEPHEN DANTZIG.

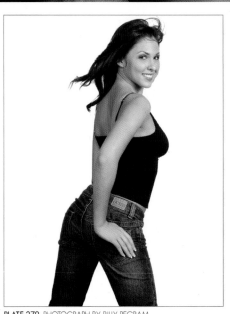

PLATE 277. PHOTOGRAPH BY JEFF SMITH.

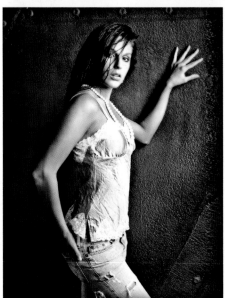

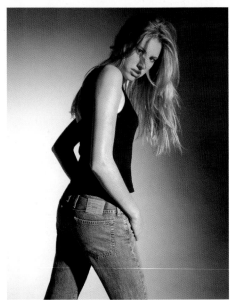

PLATE 278. PHOTOGRAPH BY TIM SCHOOLER.

PLATE 279. PHOTOGRAPH BY BILLY PEGRAM.

PLATE 280. PHOTOGRAPH BY BILLY PEGRAM..

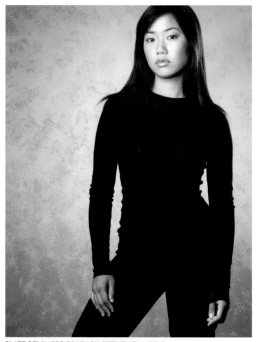

PLATE 281 PHOTOGRAPH BY STEPHEN DANTZIG.

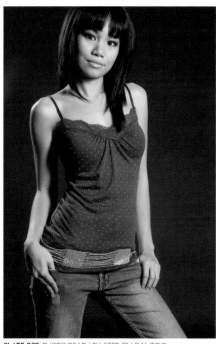

PLATE 282 PHOTOGRAPH BY STEPHEN DANTZIG.

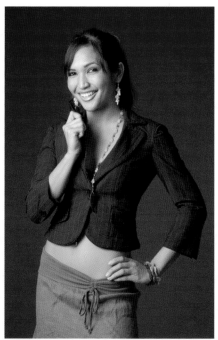

PLATE 283. PHOTOGRAPH BY STEPHEN DANTZIG.

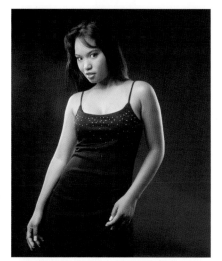

PLATE 284. PHOTOGRAPH BY STEPHEN DANTZIG.

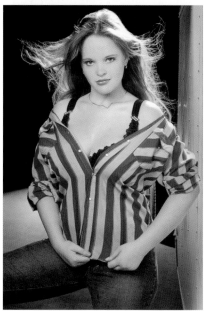

PLATE 285 (ABOVE). PHOTOGRAPH BY BILLY PEGRAM.

PLATE 286 (RIGHT). PHOTOGRAPH BY JEFF SMITH.

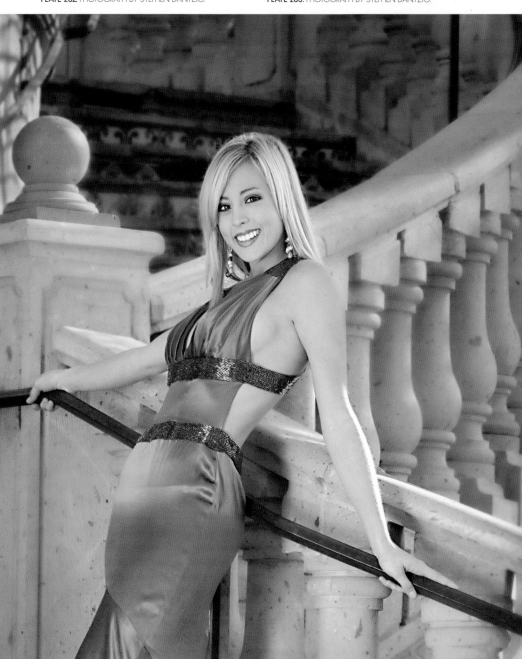

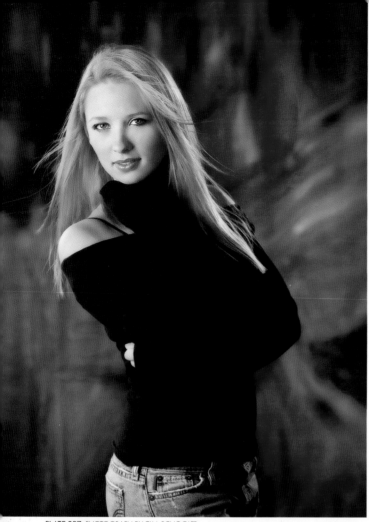

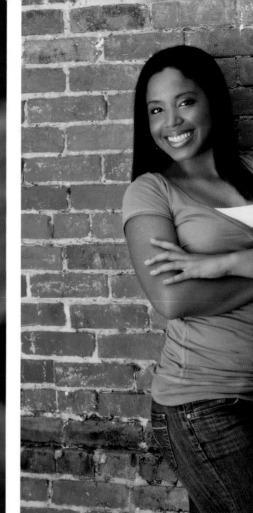

PLATE 287. PHOTOGRAPH BY TIM SCHOOLER.

PLATE 288. PHOTOGRAPH BY TIM SCHOOLER.

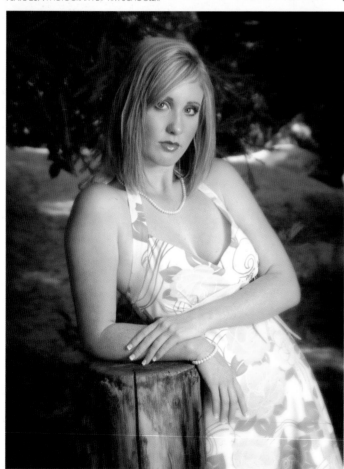

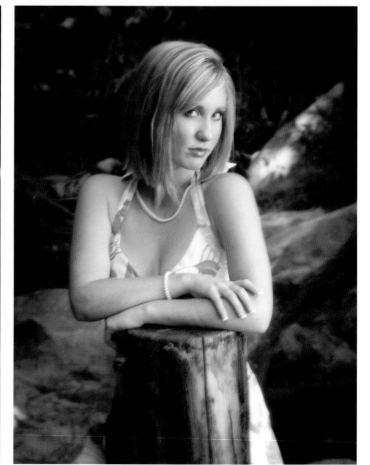

PLATE 289. PHOTOGRAPH BY JEFF SMITH.

PLATE 290. PHOTOGRAPH BY JEFF SMITH.

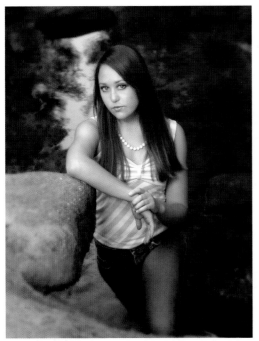

PLATE 291. PHOTOGRAPH BY JEFF SMITH.

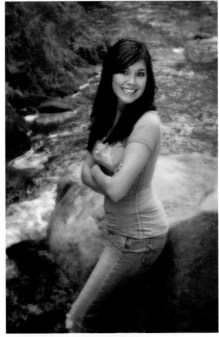

PLATE 292. PHOTOGRAPH BY JEFF SMITH.

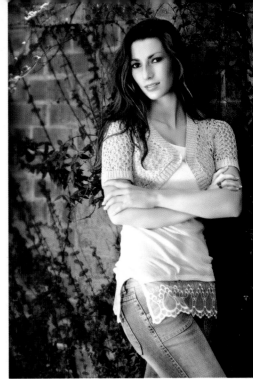

PLATE 293. PHOTOGRAPH BY TIM SCHOOLER.

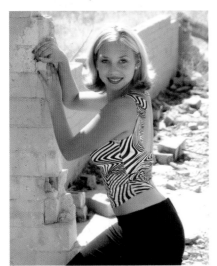

PLATE 294. PHOTOGRAPH BY JEFF SMITH.

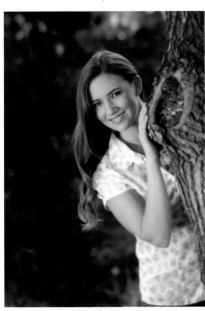

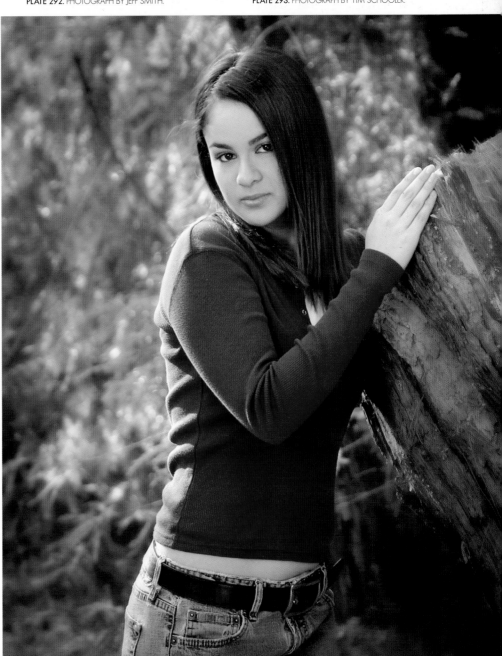

PLATE 295 (ABOVE). PHOTOGRAPH BY JEFF SMITH.

PLATE 296 (RIGHT). PHOTOGRAPH BY JEFF SMITH.

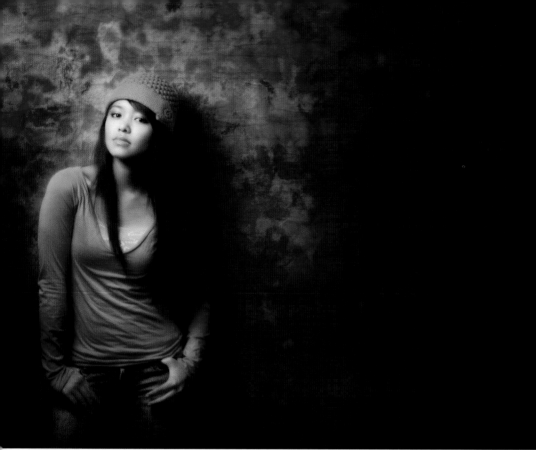

PLATE 297 (LEFT). PHOTOGRAPH BY JEFFREY AND JULIA WOODS.

PLATE 298 (BELOW). PHOTOGRAPH BY TIM SCHOOLER.

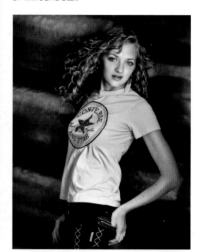

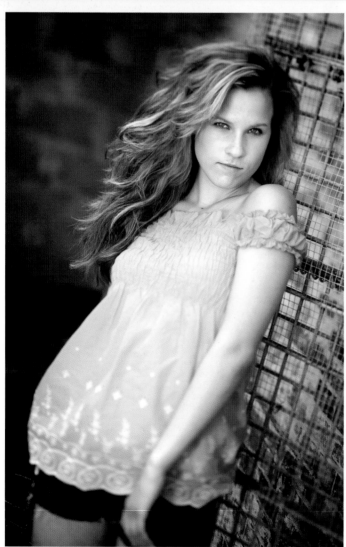

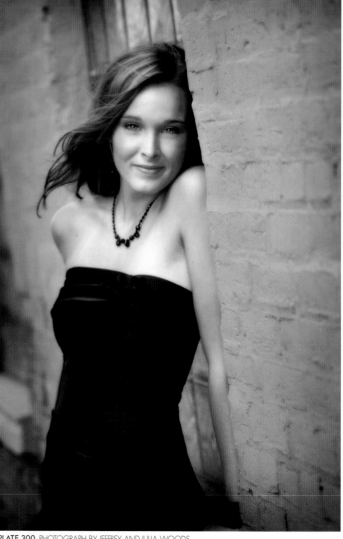

PLATE 299. PHOTOGRAPH BY JEFFREY AND JULIA WOODS.

PLATE 300. PHOTOGRAPH BY JEFFREY AND JULIA WOODS.

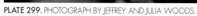

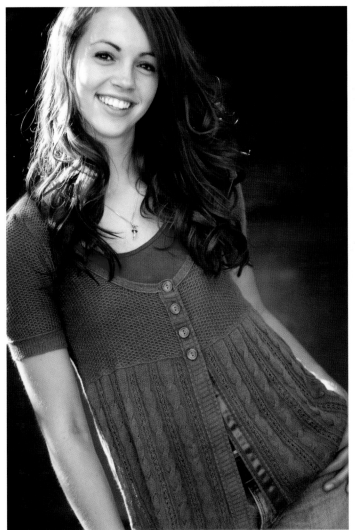

PLATE 301. PHOTOGRAPH BY DAN BROUILLETTE.

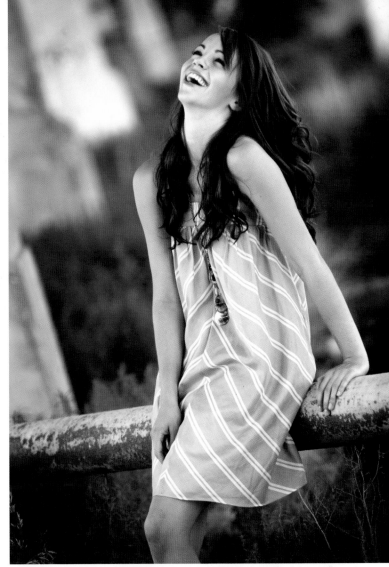

PLATE 302. PHOTOGRAPH BY DAN BROUILLETTE.

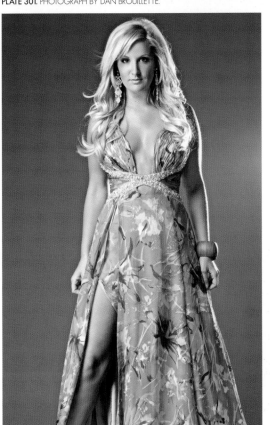

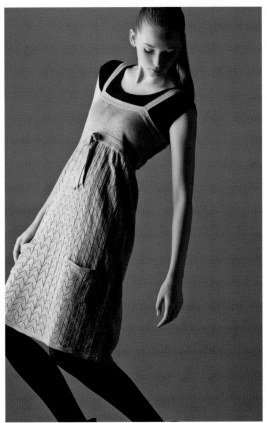

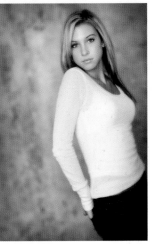

PLATE 303 (FAR LEFT). PHOTOGRAPH BY WES KRONINGER.

PLATE 304 (LEFT). PHOTOGRAPH BY WES KRONINGER.

PLATE 305 (ABOVE). PHOTOGRAPH BY JEFFREY AND JULIA WOODS.

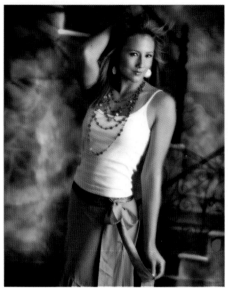

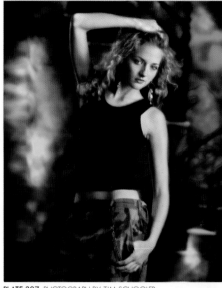

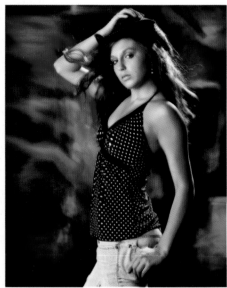

PLATE 306. *PHOTOGRAPH BY TIM SCHOOLER.*

PLATE 307. *PHOTOGRAPH BY TIM SCHOOLER.*

PLATE 308. *PHOTOGRAPH BY TIM SCHOOLER.*

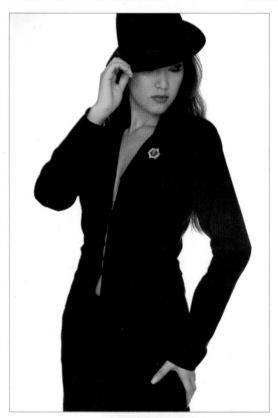

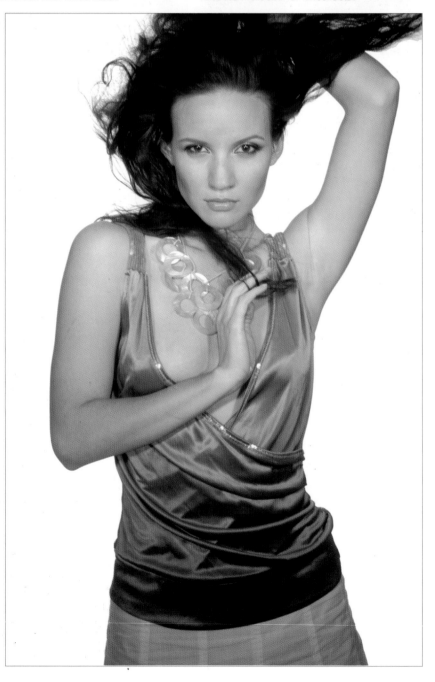

PLATE 309 (ABOVE). *PHOTOGRAPH BY STEPHEN DANTZIG.*

PLATE 310 (RIGHT). *PHOTOGRAPH BY TIM SCHOOLER.*

PLATE 311 (FAR RIGHT). *PHOTOGRAPH BY STEPHEN DANTZIG.*

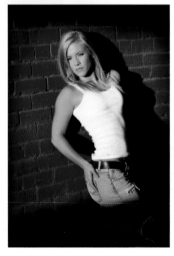

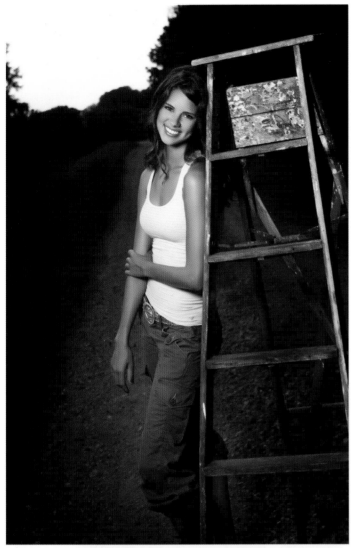

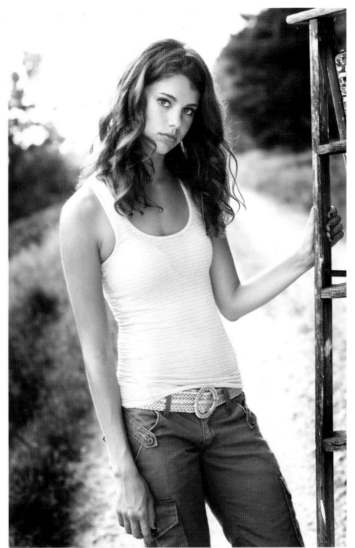

PLATE 312. PHOTOGRAPH BY DAN BROUILLETTE.

PLATE 313. PHOTOGRAPH BY DAN BROUILLETTE.

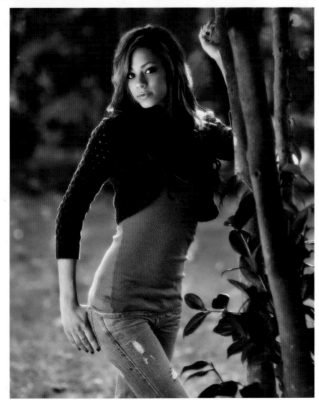

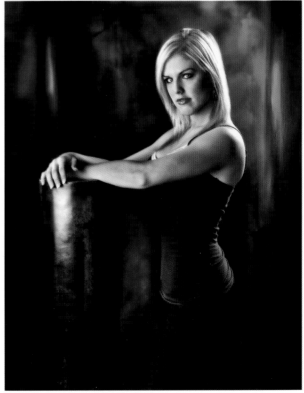

PLATE 314. PHOTOGRAPH BY TIM SCHOOLER.

PLATE 315. PHOTOGRAPH BY TIM SCHOOLER.

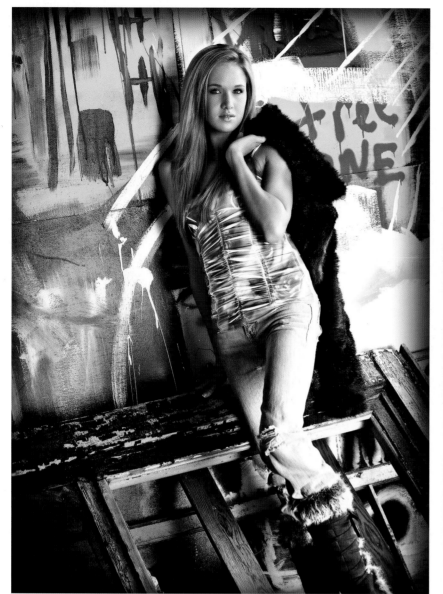

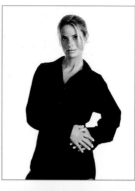

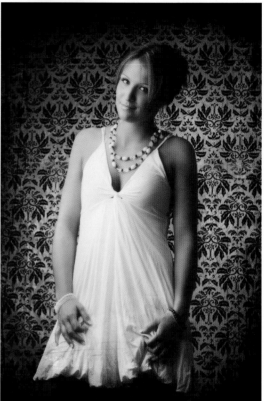

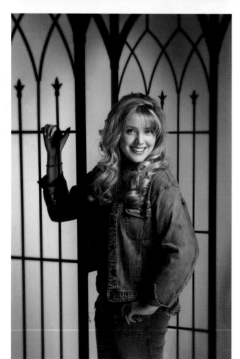

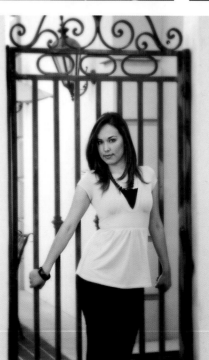

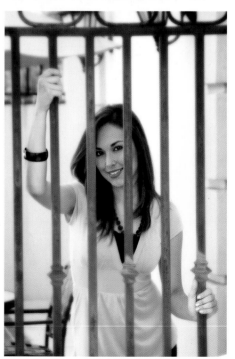

PLATE 319. PHOTOGRAPH BY JEFF SMITH.

PLATE 320. PHOTOGRAPH BY JEFF SMITH.

PLATE 321. PHOTOGRAPH BY JEFF SMITH.

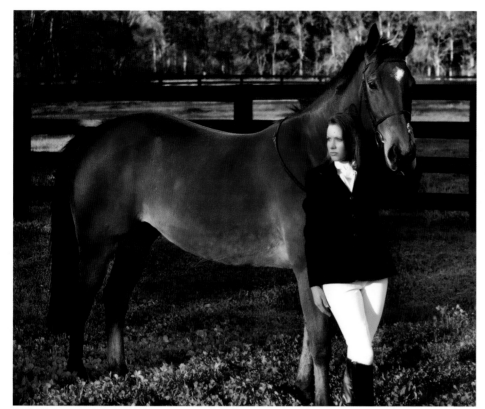

PLATE 322. PHOTOGRAPH BY TIM SCHOOLER.

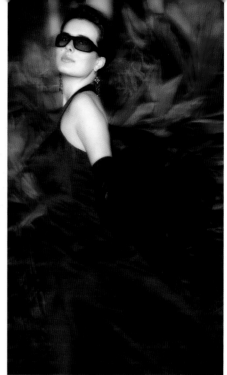

PLATE 323. PHOTOGRAPH BY DEBORAH LYNN FERRO.

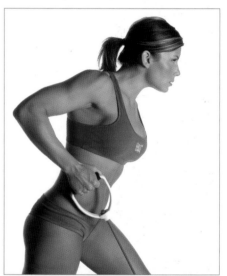

PLATE 324. PHOTOGRAPH BY BILLY PEGRAM.

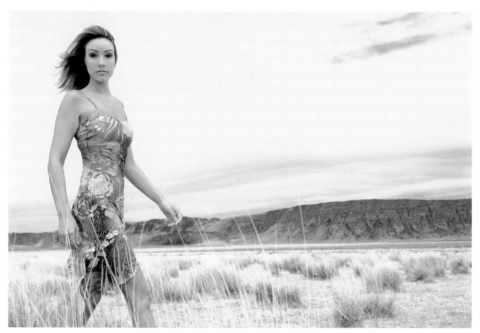

PLATE 325 (ABOVE).
PHOTOGRAPH BY BILLY PEGRAM.

PLATE 326 (RIGHT).
PHOTOGRAPH BY JEFF SMITH.

PLATE 327 (CENTER RIGHT).
PHOTOGRAPH BY JEFF SMITH.

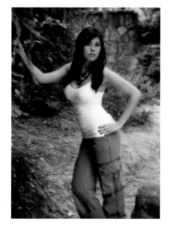

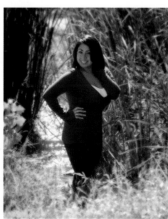

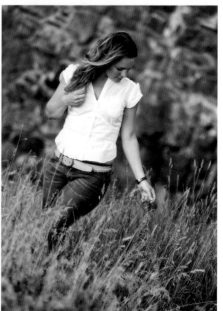

PLATE 328. PHOTOGRAPH BY MARC WEISBERG.

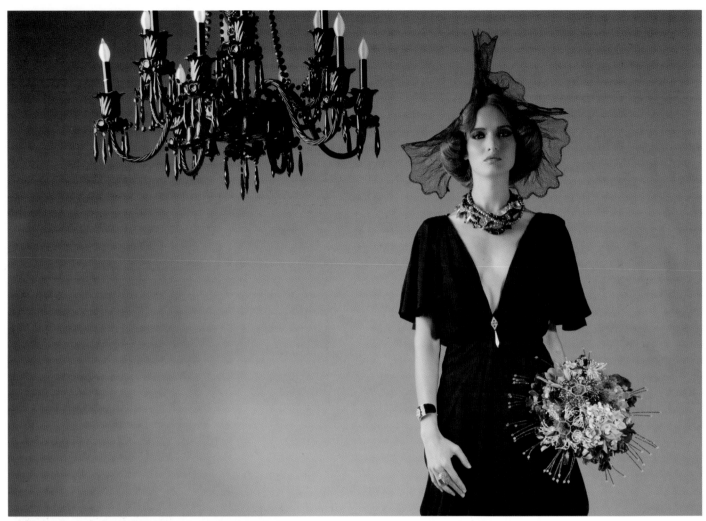

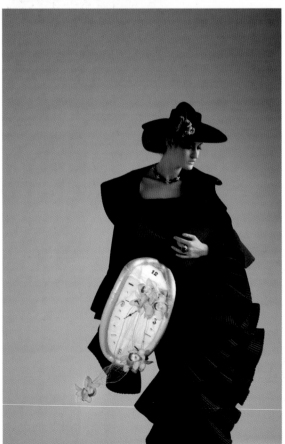

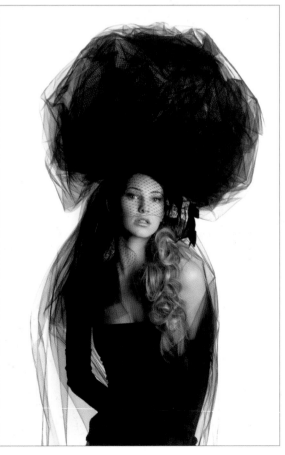

PLATE 329 (ABOVE).
PHOTOGRAPH BY CHERIE
STEINBERG COTE.

PLATE 330 (FAR LEFT).
PHOTOGRAPH BY CHERIE
STEINBERG COTE.

PLATE 331 (LEFT).
PHOTOGRAPH BY CHERIE
STEINBERG COTE.

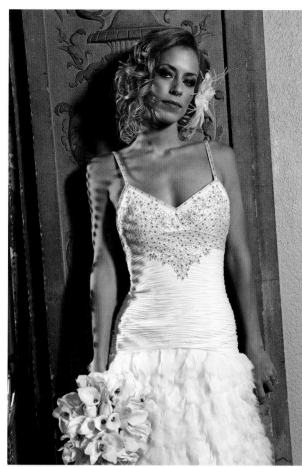

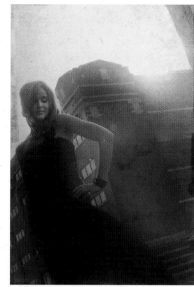

PLATE 333. PHOTOGRAPH BY JEFFREY AND JULIA WOODS.

PLATE 334. PHOTOGRAPH BY JEFFREY AND JULIA WOODS.

PLATE 332. PHOTOGRAPH BY CHERIE STEINBERG COTE.

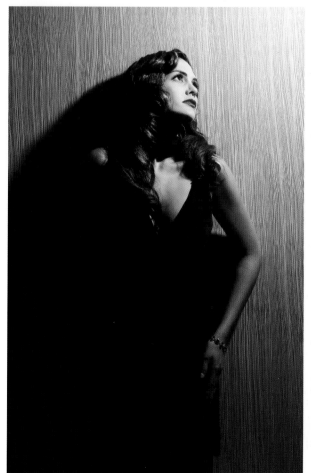

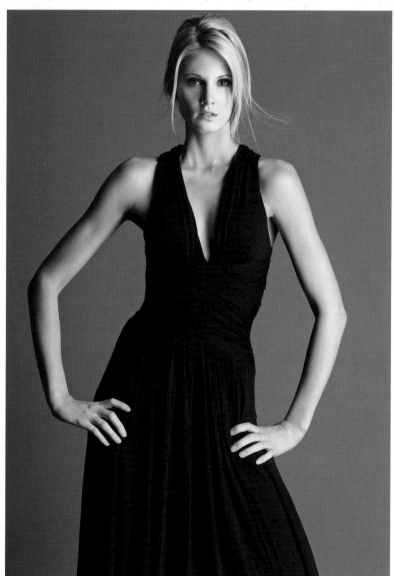

PLATE 335. PHOTOGRAPH BY WES KRONINGER.

PLATE 336. PHOTOGRAPH BY WES KRONINGER.

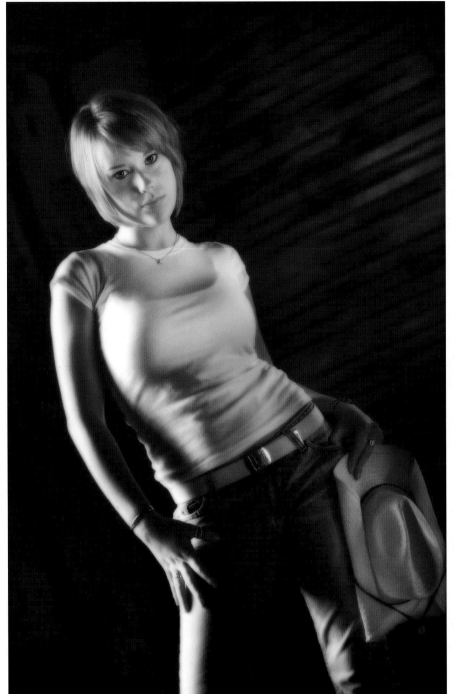

PLATE 337. PHOTOGRAPH BY JEFFREY AND JULIA WOODS.

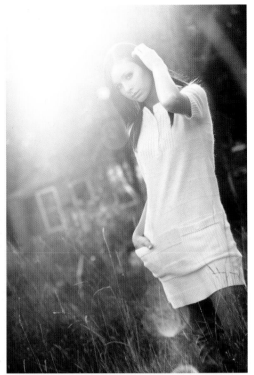

PLATE 338. PHOTOGRAPH BY DAN BROUILLETTE.

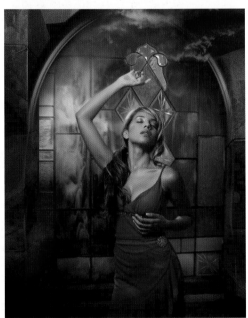

PLATE 339. PHOTOGRAPH BY HERNAN RODRIGUEZ.

PLATE 340. PHOTOGRAPH BY JEFF SMITH.

PLATE 341. PHOTOGRAPH BY TIM SCHOOLER.

PLATE 342. PHOTOGRAPH BY JEFF SMITH.

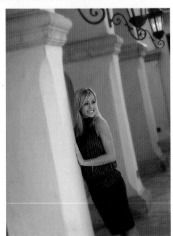

PLATE 343. PHOTOGRAPH BY JEFF SMITH.

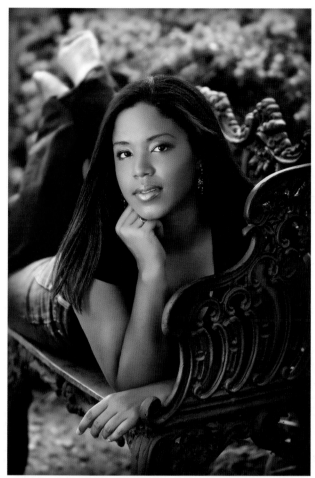

PLATE 344. PHOTOGRAPH BY TIM SCHOOLER.

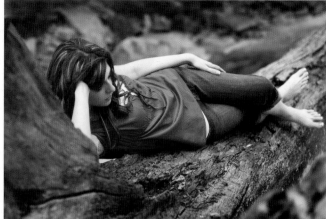

PLATE 345. PHOTOGRAPH BY DAN BROUILLETTE.

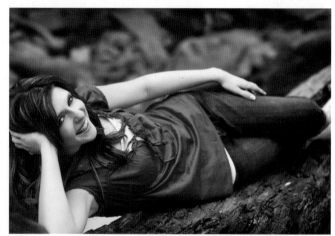

PLATE 346. PHOTOGRAPH BY DAN BROUILLETTE.

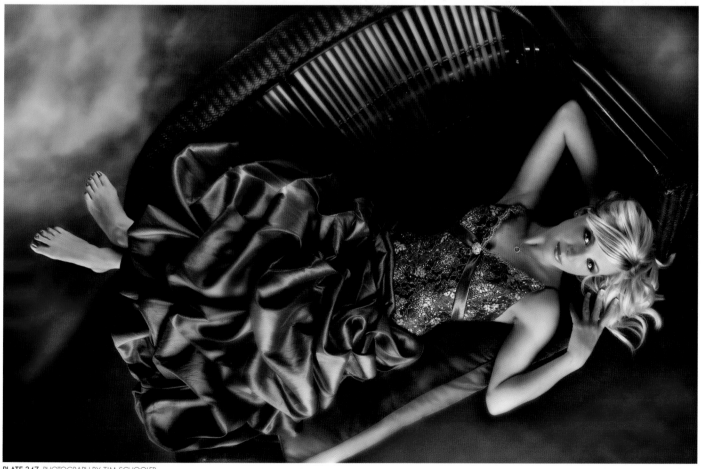

PLATE 347. PHOTOGRAPH BY TIM SCHOOLER.

PLATE 348. PHOTOGRAPH BY JEFF SMITH.

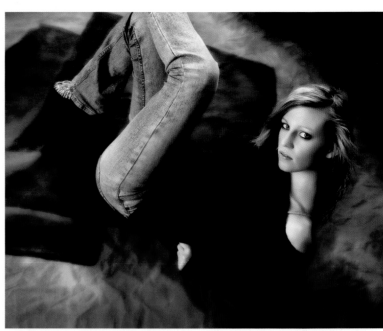

PLATE 349. PHOTOGRAPH BY TIM SCHOOLER.

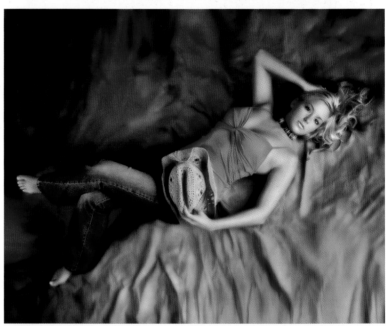

PLATE 351. PHOTOGRAPH BY TIM SCHOOLER.

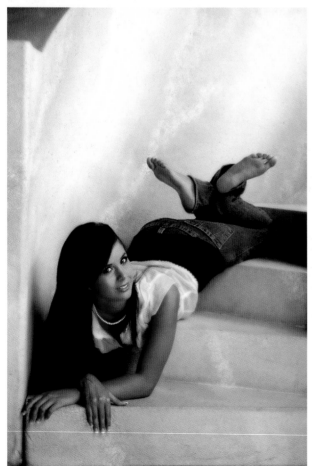

PLATE 350. PHOTOGRAPH BY JEFF SMITH.

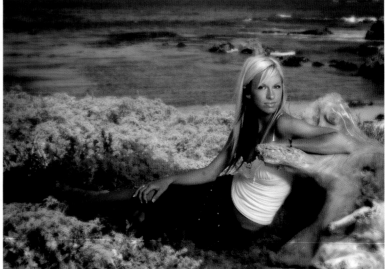

PLATE 352. PHOTOGRAPH BY JEFF SMITH.

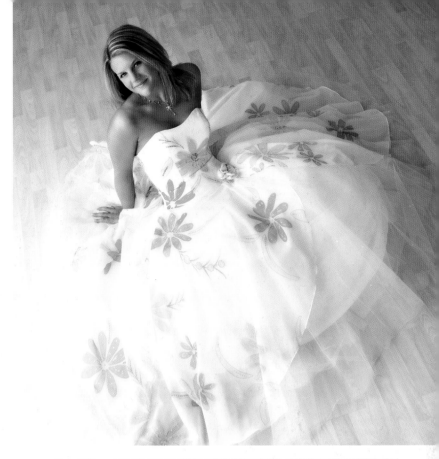

PLATE 353 (BELOW). PHOTOGRAPH BY STEPHEN DANTZIG.

PLATE 354 (RIGHT). PHOTOGRAPH BY VICKI TAUFER.

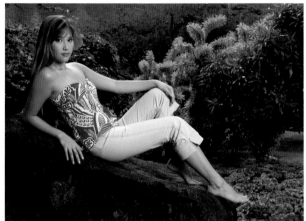

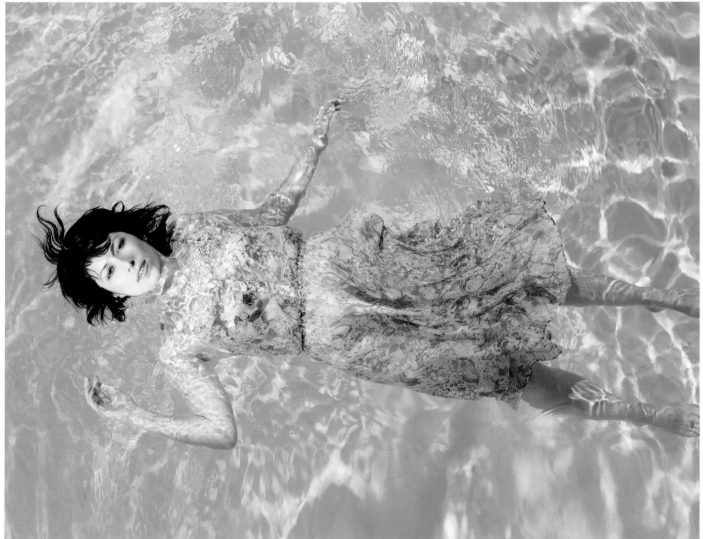

PLATE 355. PHOTOGRAPH BY WES KRONINGER.

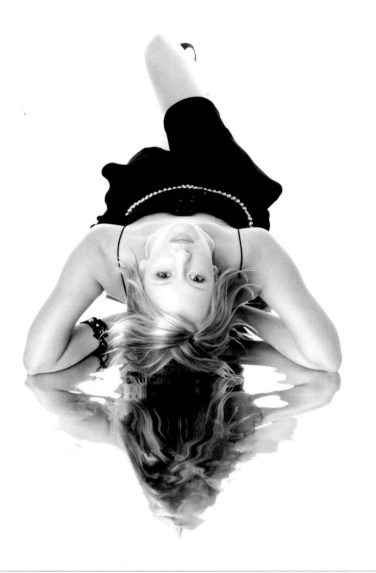

PLATE 356. PHOTOGRAPH BY CHRIS NELSON.

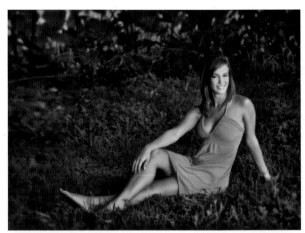

PLATE 357. PHOTOGRAPH BY TIM SCHOOLER.

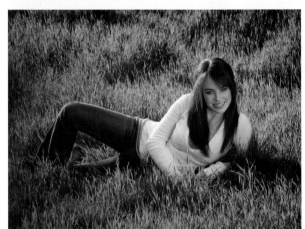

PLATE 358. PHOTOGRAPH BY JEFF SMITH.

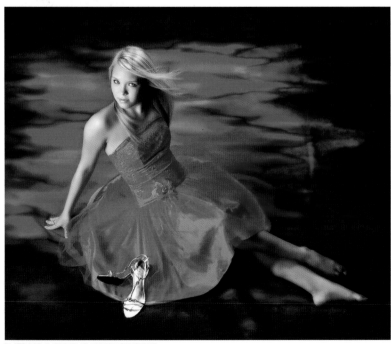

PLATE 359. PHOTOGRAPH BY TIM SCHOOLER.

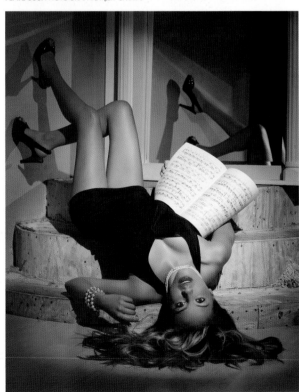

PLATE 360. PHOTOGRAPH BY HERNAN RODRIGUEZ.

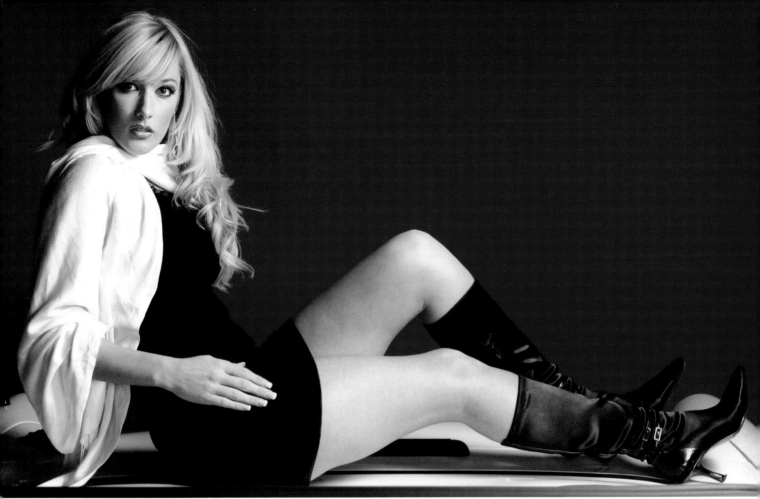

PLATE 361. PHOTOGRAPH BY ROLANDO GOMEZ.

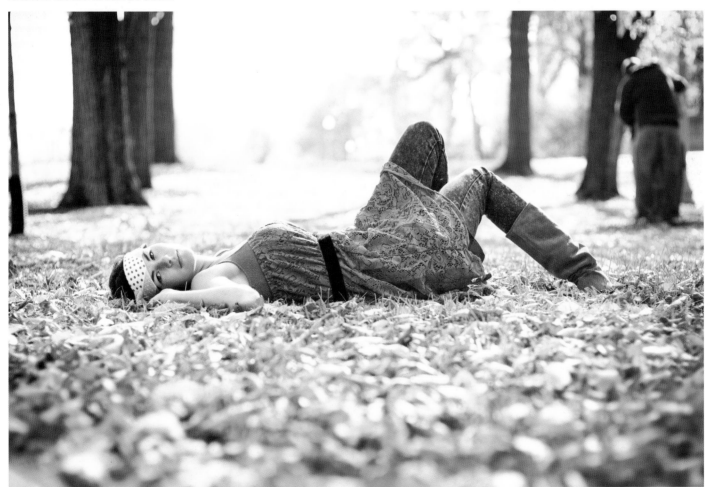

PLATE 362. PHOTOGRAPH BY DAN BROUILLETTE.

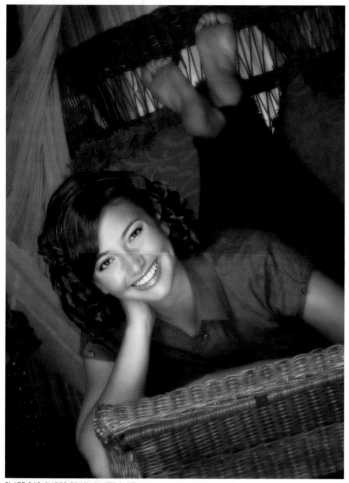

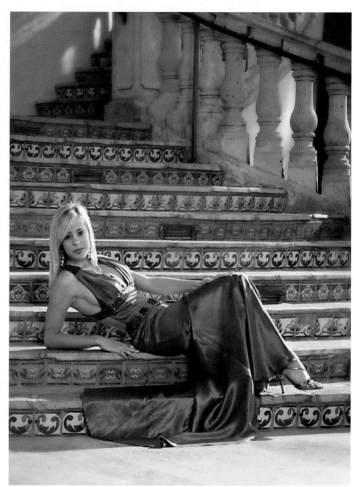

PLATE 363. PHOTOGRAPH BY JEFF SMITH.

PLATE 364. PHOTOGRAPH BY JEFF SMITH.

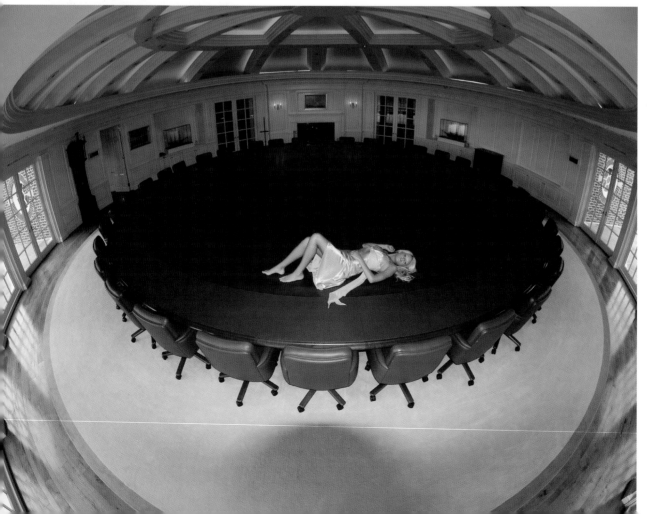

PLATE 365.
PHOTOGRAPH BY
ROLANDO GOMEZ.

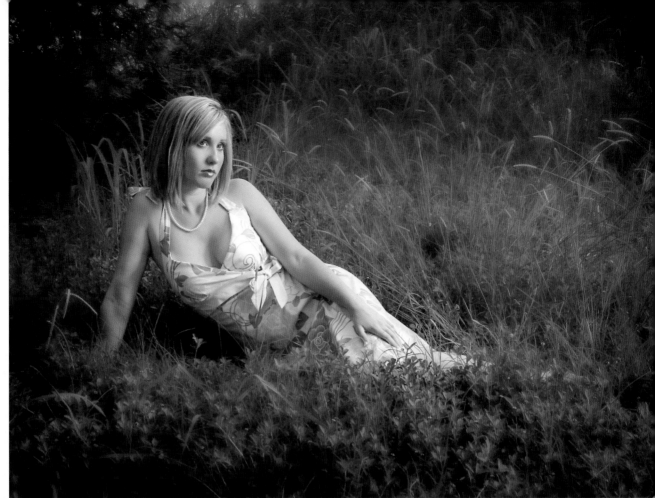

PLATE 366.
PHOTOGRAPH
BY JEFF SMITH.

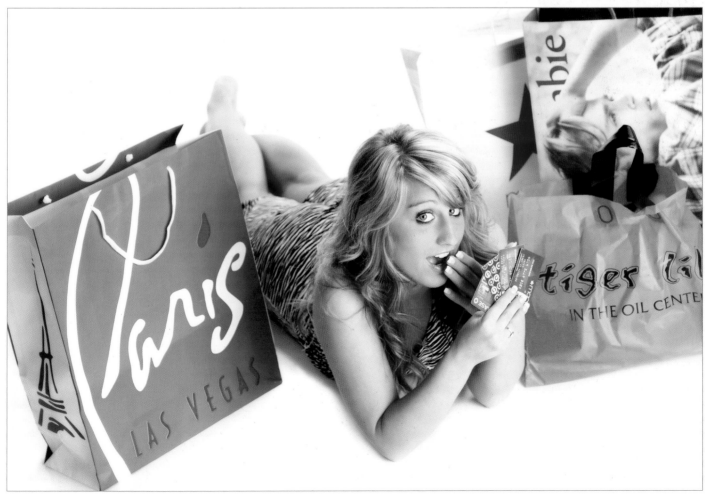

PLATE 367. PHOTOGRAPH BY TIM SCHOOLER.

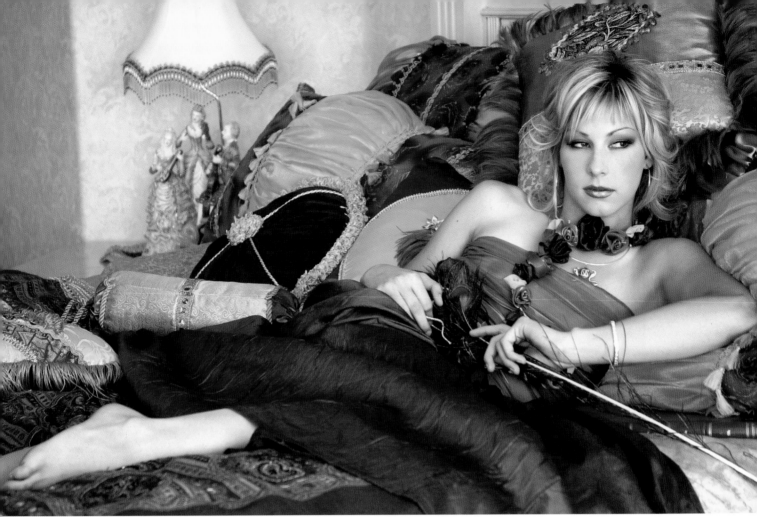

PLATE 368. PHOTOGRAPH BY BILLY PEGRAM.

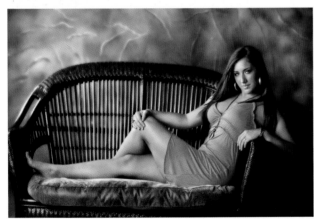

PLATE 369. PHOTOGRAPH BY TIM SCHOOLER.

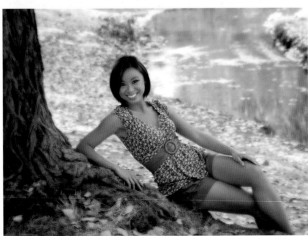

PLATE 370. PHOTOGRAPH BY JEFF SMITH.

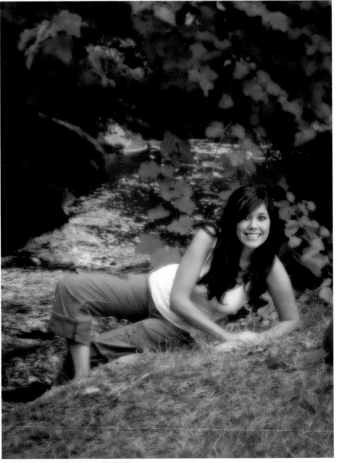

PLATE 371. PHOTOGRAPH BY JEFF SMITH.

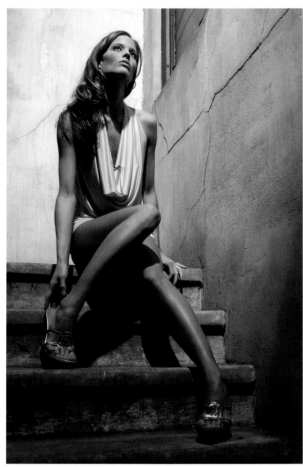

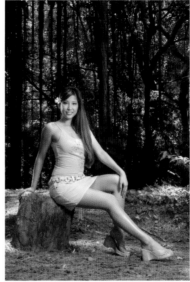

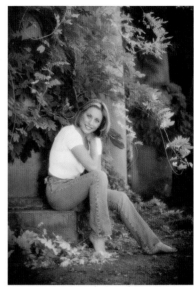

PLATE 373. PHOTOGRAPH BY STEPHEN DANTZIG.

PLATE 374. PHOTOGRAPH BY JEFF SMITH.

PLATE 372. PHOTOGRAPH BY ROLANDO GOMEZ.

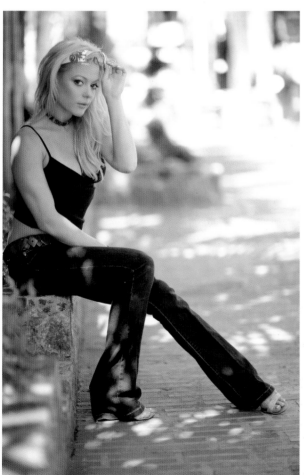

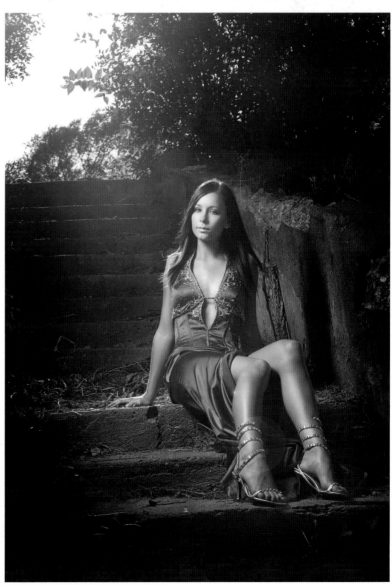

PLATE 375. PHOTOGRAPH BY ROLANDO GOMEZ.

PLATE 376. PHOTOGRAPH BY DAN BROUILLETTE.

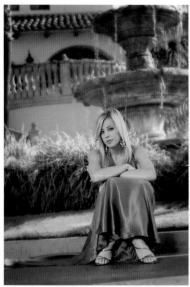

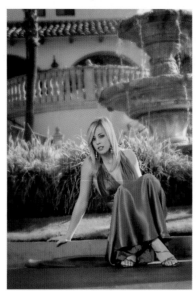

PLATE 377. PHOTOGRAPH BY JEFF SMITH.

PLATE 378. PHOTOGRAPH BY JEFF SMITH.

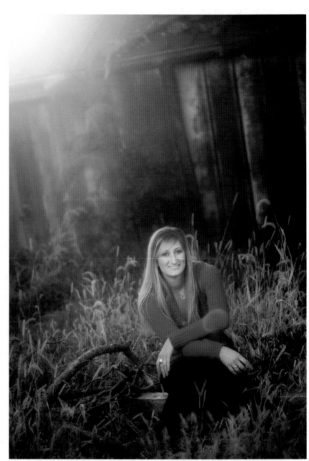

PLATE 379. PHOTOGRAPH BY JEFFREY AND JULIA WOODS.

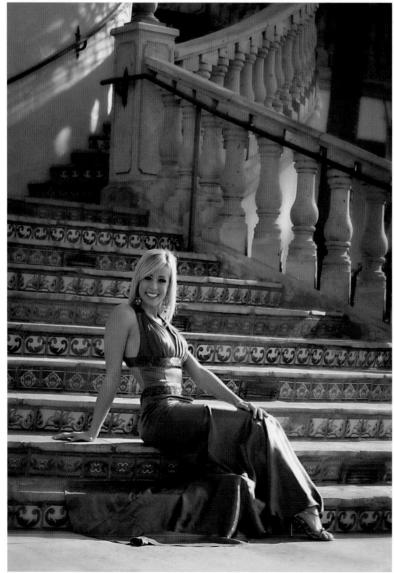

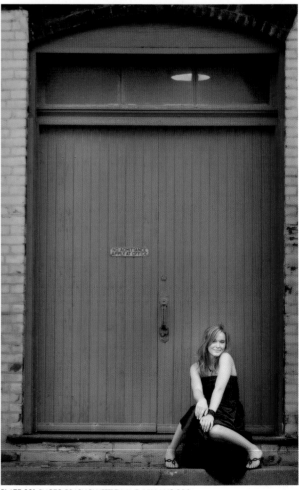

PLATE 380. PHOTOGRAPH BY JEFF SMITH.

PLATE 381. PHOTOGRAPH BY JEFFREY AND JULIA WOODS.

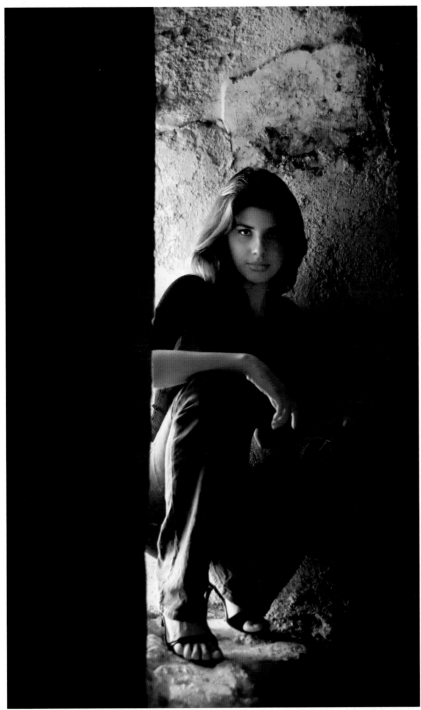

PLATE 382. PHOTOGRAPH BY CHRIS NELSON.

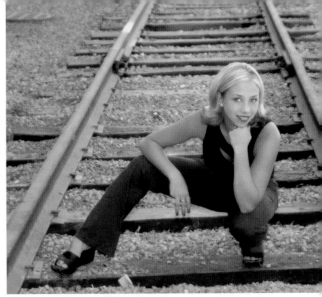

PLATE 383. PHOTOGRAPH BY JEFF SMITH.

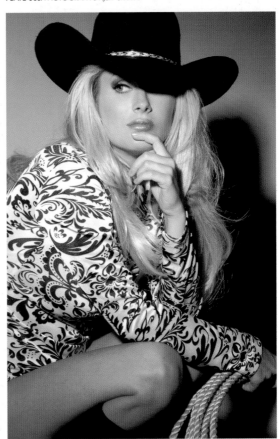

PLATE 384. PHOTOGRAPH BY BILLY PEGRAM.

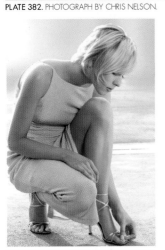

PLATE 385. PHOTOGRAPH BY BILLY PEGRAM.

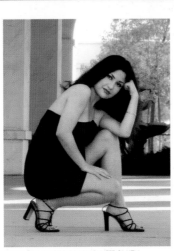

PLATE 386. PHOTOGRAPH BY JEFF SMITH.

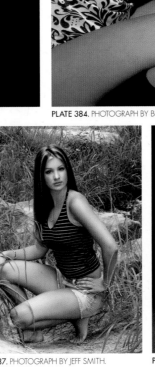

PLATE 387. PHOTOGRAPH BY JEFF SMITH.

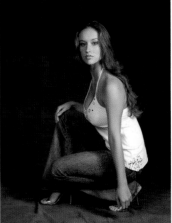

PLATE 388. PHOTOGRAPH BY STEPHEN DANTZIG.

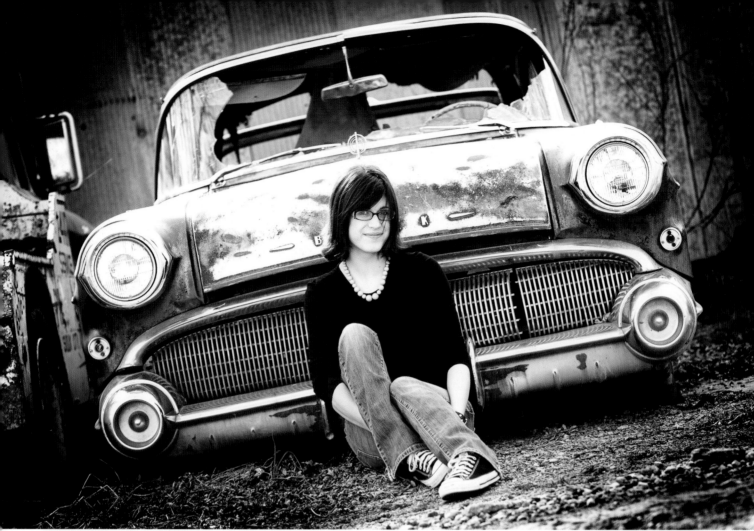

PLATE 389. PHOTOGRAPH BY DAN BROUILLETTE.

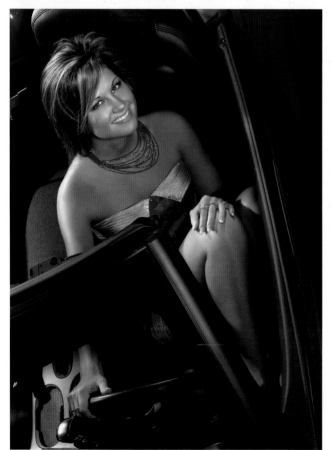

PLATE 390. PHOTOGRAPH BY ROLANDO GOMEZ.

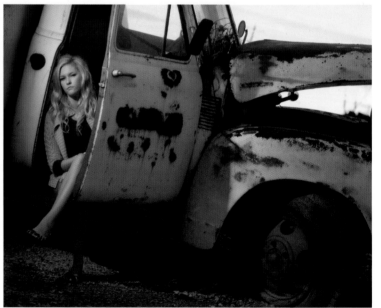

PLATE 391. PHOTOGRAPH BY JEFFREY AND JULIA WOODS.

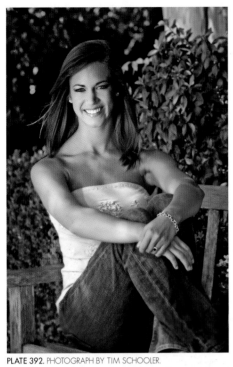

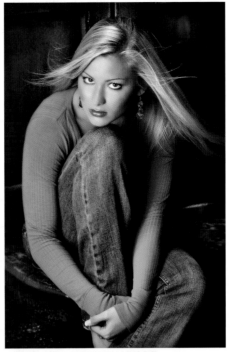

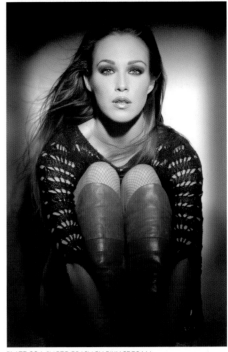

PLATE 392. PHOTOGRAPH BY TIM SCHOOLER.

PLATE 393. PHOTOGRAPH BY TIM SCHOOLER.

PLATE 394. PHOTOGRAPH BY BILLY PEGRAM.

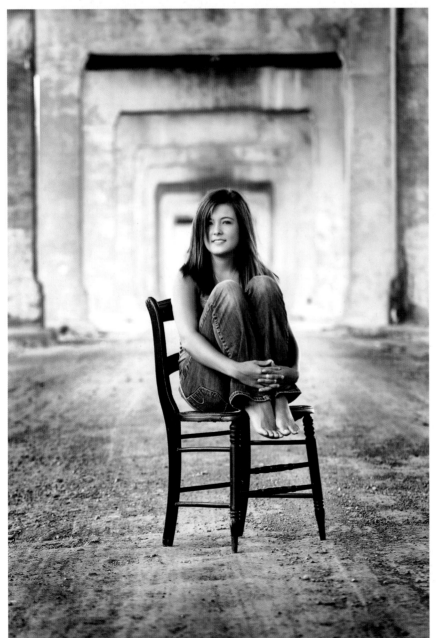

PLATE 395 (LEFT). PHOTOGRAPH BY DAN BROUILLETTE.

PLATE 396 (ABOVE). PHOTOGRAPH BY DAN BROUILLETTE.

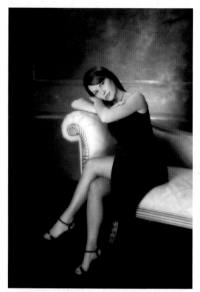

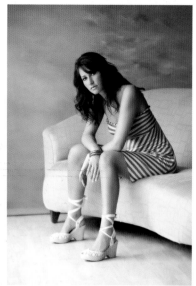

PLATE 397. PHOTOGRAPH BY JEFF SMITH.

PLATE 398. PHOTOGRAPH BY JEFFREY AND JULIA WOODS.

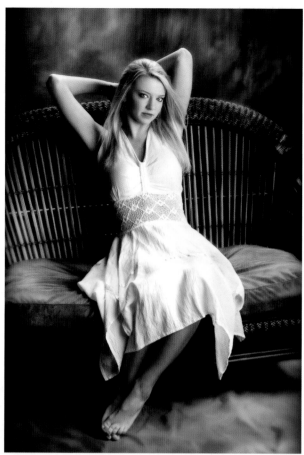

PLATE 399. PHOTOGRAPH BY TIM SCHOOLER.

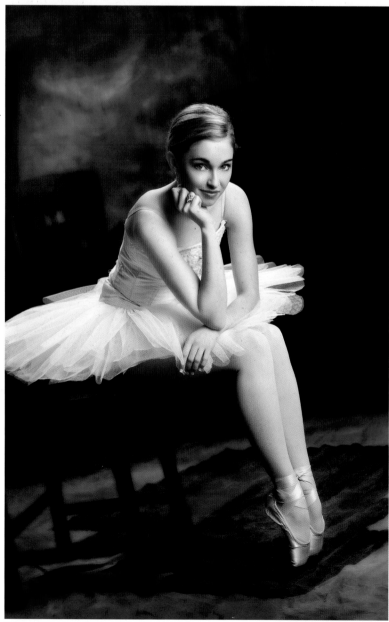

PLATE 400. PHOTOGRAPH BY TIM SCHOOLER.

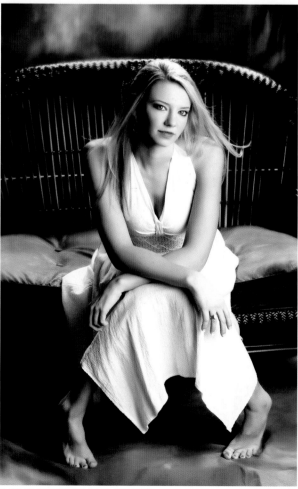

PLATE 401. PHOTOGRAPH BY TIM SCHOOLER.

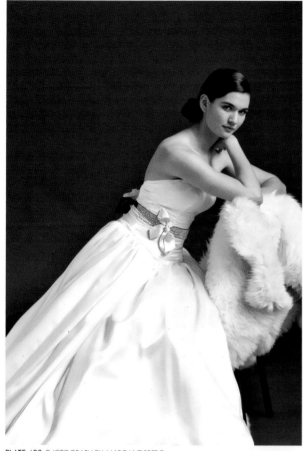

PLATE 402. PHOTOGRAPH BY MARC WEISBERG.

PLATE 403. PHOTOGRAPH BY CHERIE STEINBERG COTE.

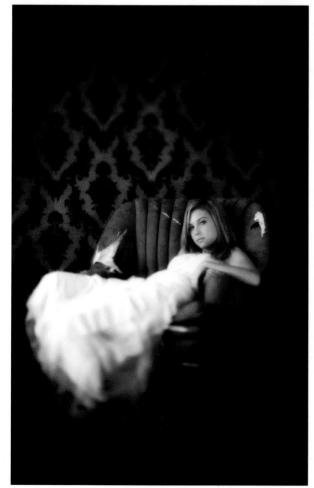

PLATE 404. PHOTOGRAPH BY JEFFREY AND JULIA WOODS.

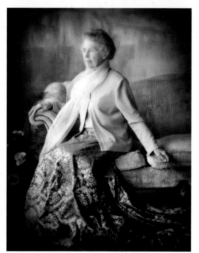

PLATE 405. PHOTOGRAPH BY VICKI TAUFER.

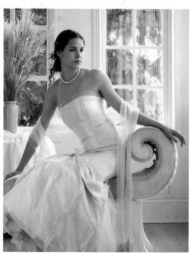

PLATE 406. PHOTOGRAPH BY CHRIS NELSON.

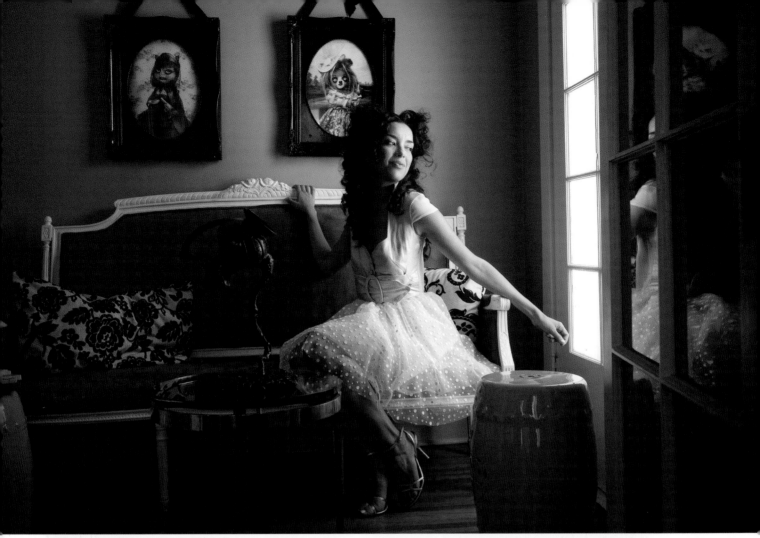

PLATE 407. PHOTOGRAPH BY CHERIE STEINBERG COTE.

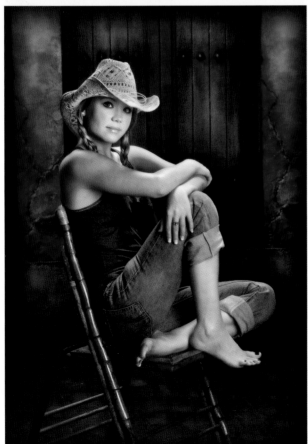

PLATE 408. PHOTOGRAPH BY TIM SCHOOLER.

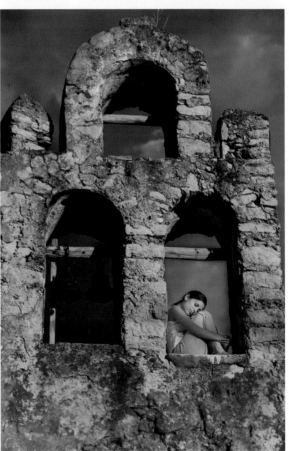

PLATE 409. PHOTOGRAPH BY CHRIS NELSON.

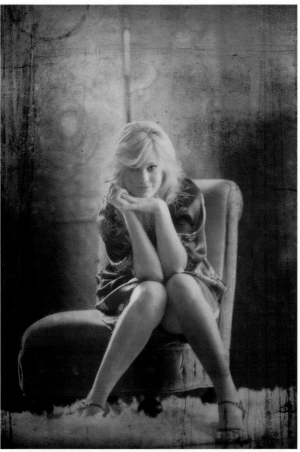

PLATE 410. PHOTOGRAPH BY JEFFREY AND JULIA WOODS.

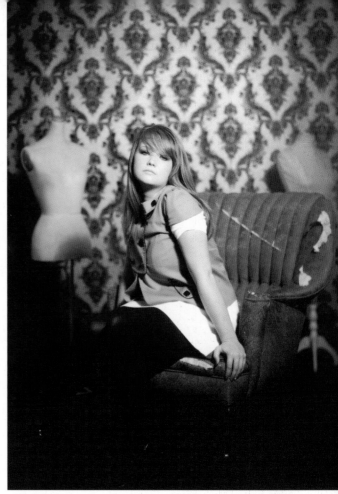

PLATE 411. PHOTOGRAPH BY JEFFREY AND JULIA WOODS.

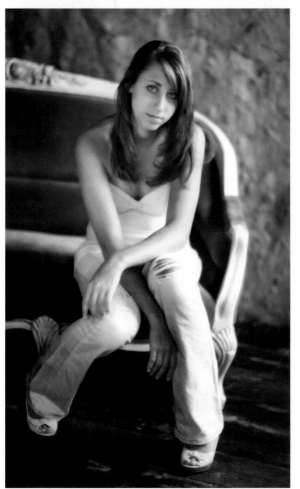

PLATE 412. PHOTOGRAPH BY JEFFREY AND JULIA WOODS.

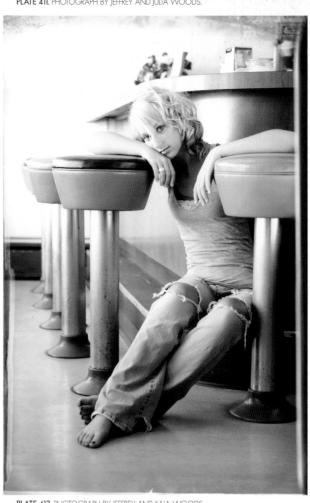

PLATE 413. PHOTOGRAPH BY JEFFREY AND JULIA WOODS.

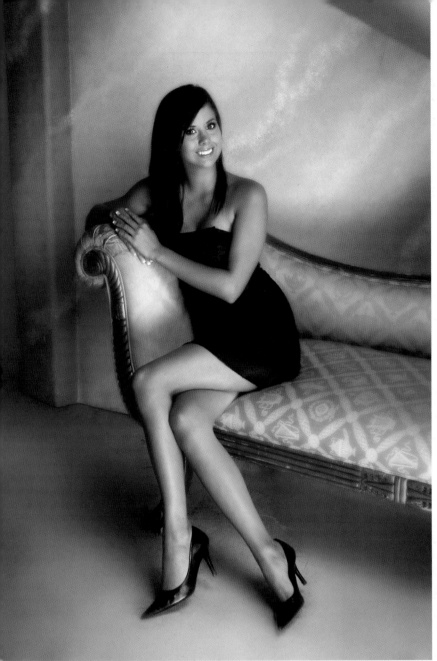

PLATE 414. PHOTOGRAPH BY JEFF SMITH.

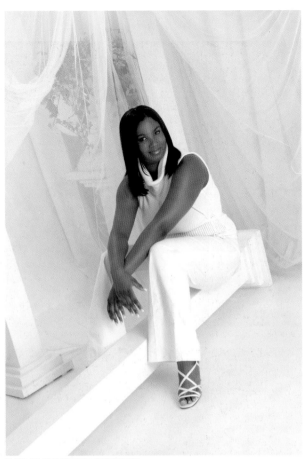

PLATE 415. PHOTOGRAPH BY JEFF SMITH.

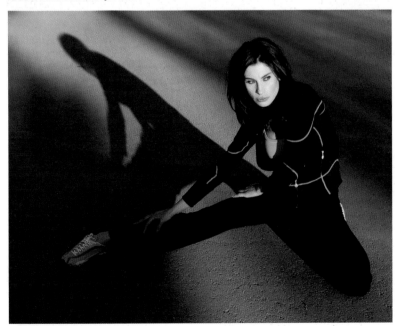

PLATE 416. PHOTOGRAPH BY BILLY PEGRAM.

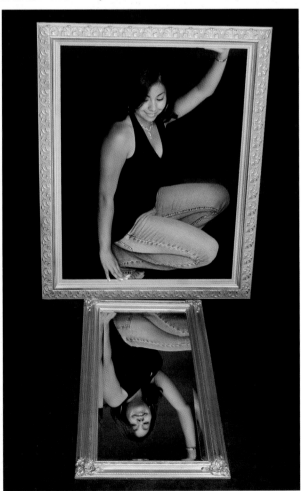

PLATE 417. PHOTOGRAPH BY JEFF SMITH.

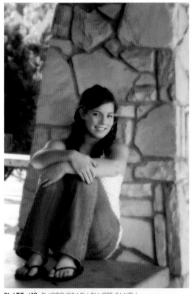

PLATE 418. PHOTOGRAPH BY JEFF SMITH.

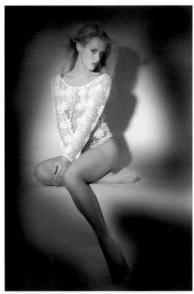

PLATE 419. PHOTOGRAPH BY BILLY PEGRAM.

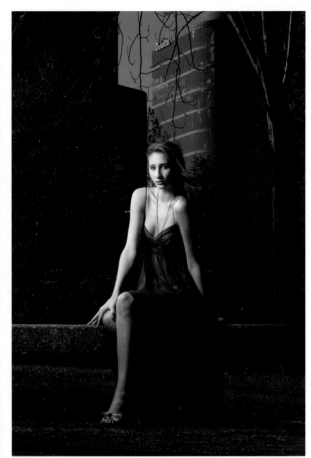

PLATE 420. PHOTOGRAPH BY DAN BROUILLETTE.

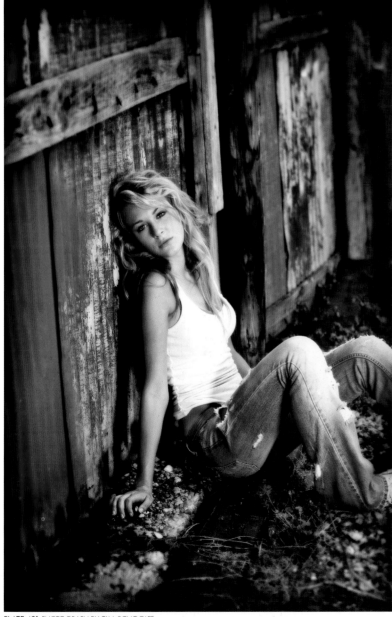

PLATE 421. PHOTOGRAPH BY TIM SCHOOLER.

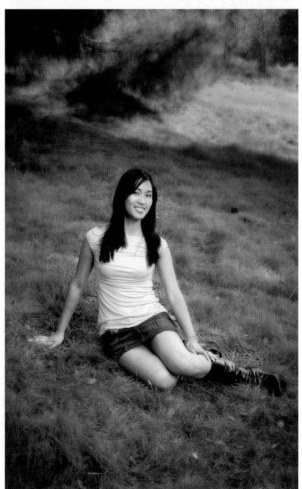

PLATE 422. PHOTOGRAPH BY JEFF SMITH.

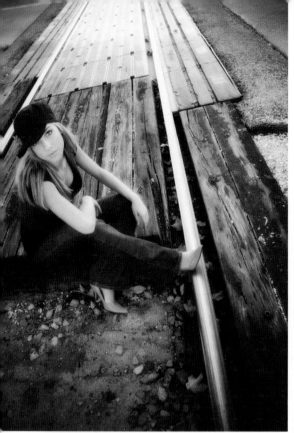

PLATE 423. PHOTOGRAPH BY JEFFREY AND JULIA WOODS.

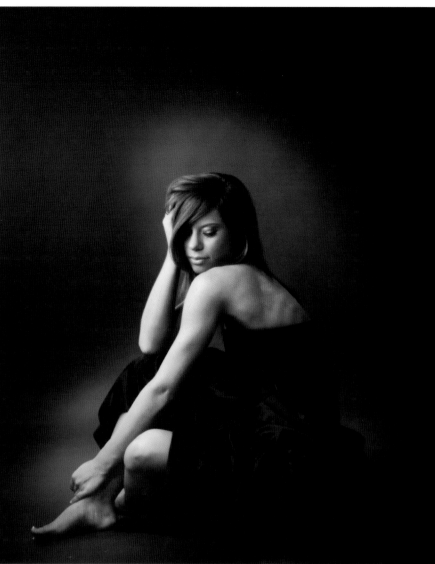

PLATE 424. PHOTOGRAPH BY JEFFREY AND JULIA WOODS.

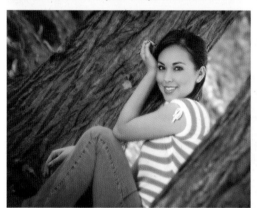

PLATE 425. PHOTOGRAPH BY JEFF SMITH.

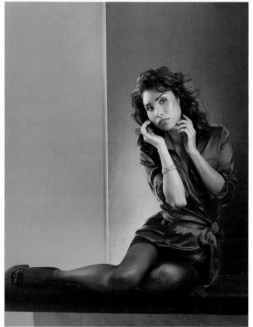

PLATE 426. PHOTOGRAPH BY HERNAN RODRIGUEZ.

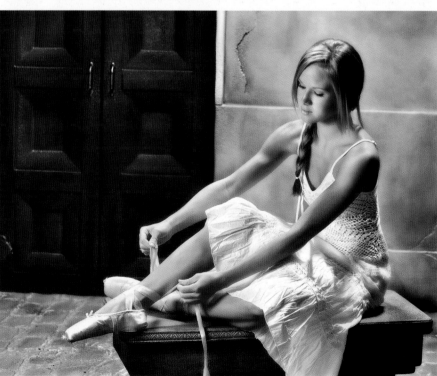

PLATE 427. PHOTOGRAPH BY TIM SCHOOLER.

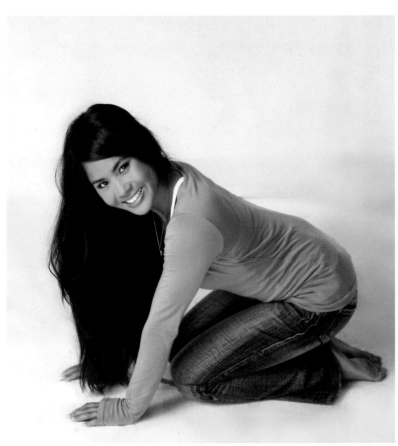

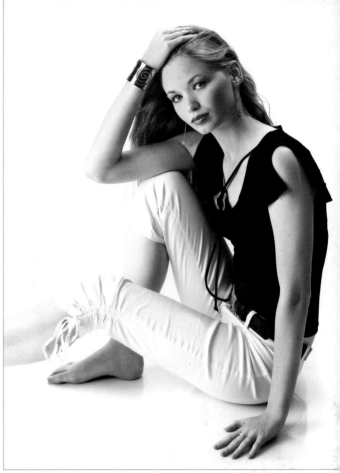

PLATE 428. PHOTOGRAPH BY JEFF SMITH.

PLATE 429. PHOTOGRAPH BY TIM SCHOOLER.

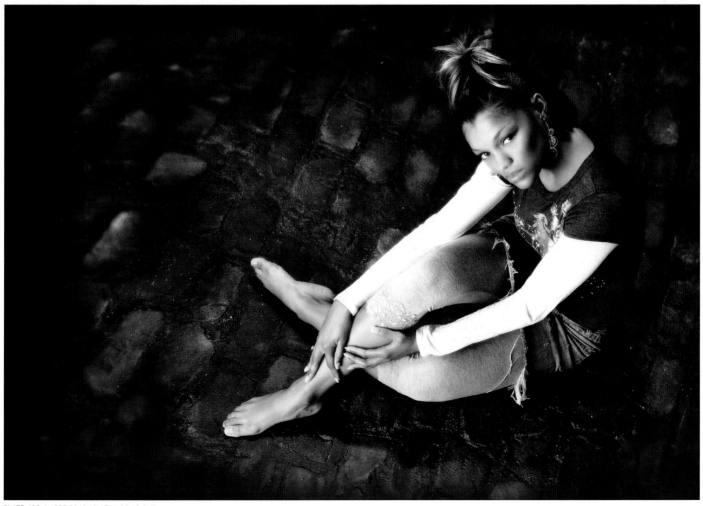

PLATE 430. PHOTOGRAPH BY TIM SCHOOLER.

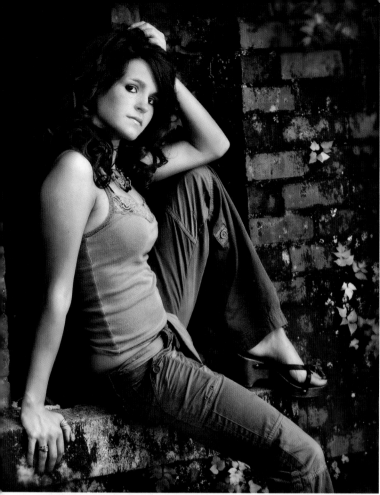

PLATE 431. PHOTOGRAPH BY TIM SCHOOLER.

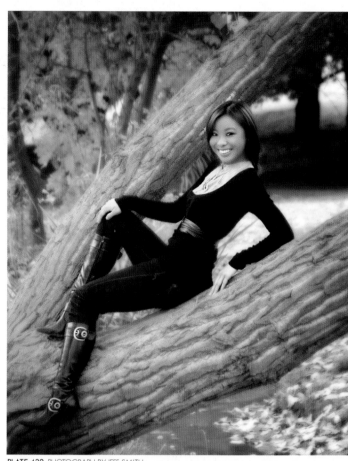

PLATE 432. PHOTOGRAPH BY JEFF SMITH.

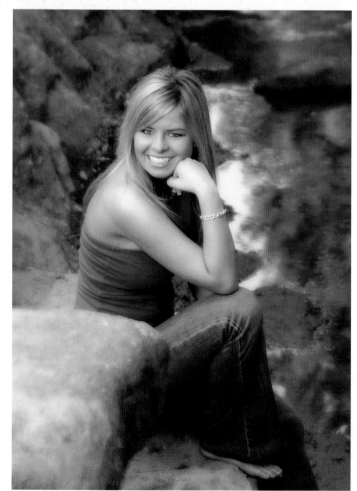

PLATE 433. PHOTOGRAPH BY JEFF SMITH.

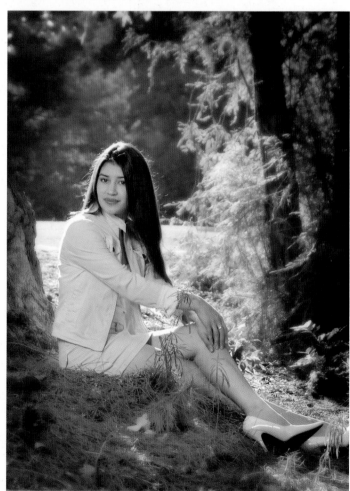

PLATE 434. PHOTOGRAPH BY JEFF SMITH.

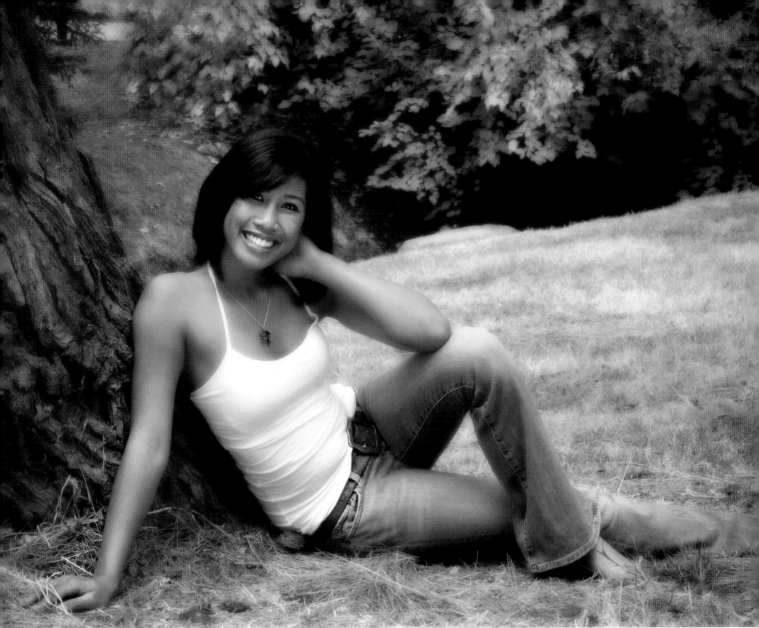

PLATE 435. PHOTOGRAPH BY JEFF SMITH.

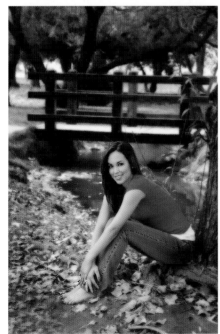

PLATE 436. PHOTOGRAPH BY JEFF SMITH.

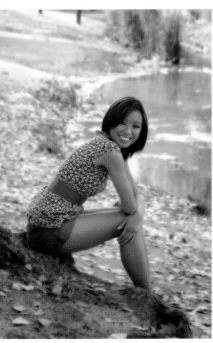

PLATE 437. PHOTOGRAPH BY JEFF SMITH.

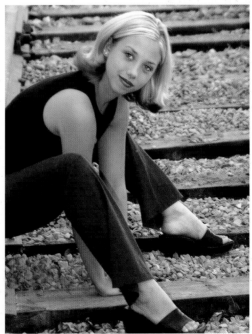

PLATE 438. PHOTOGRAPH BY JEFF SMITH.

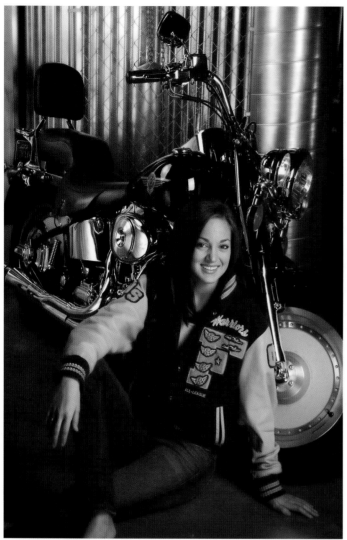

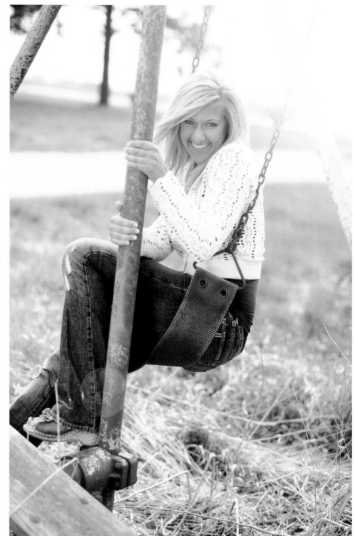

PLATE 439. PHOTOGRAPH BY JEFF SMITH.

PLATE 440. PHOTOGRAPH BY JEFFREY AND JULIA WOODS.

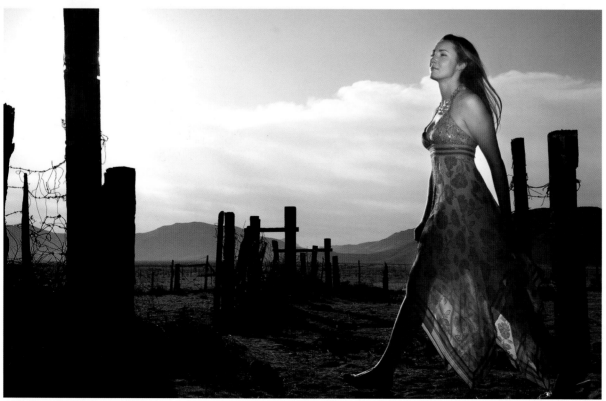

PLATE 441. PHOTOGRAPH BY BILLY PEGRAM.

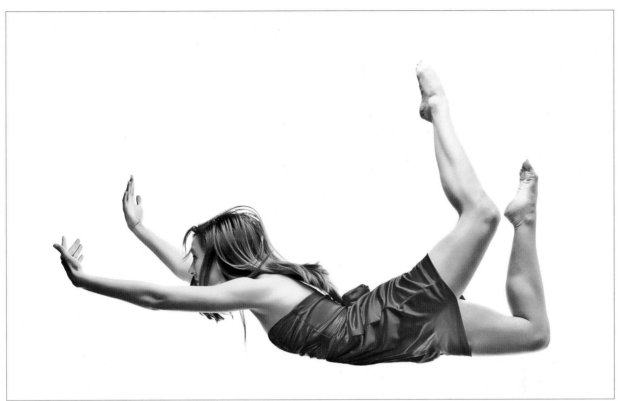

PLATE 442. PHOTOGRAPH BY WES KRONINGER.

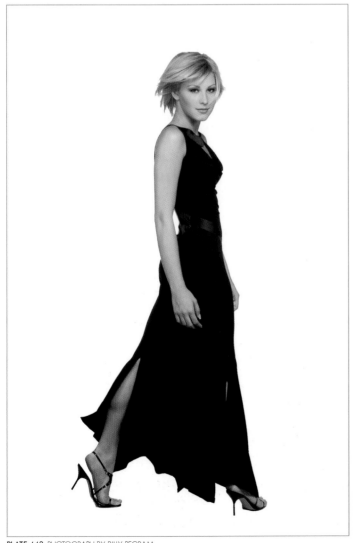

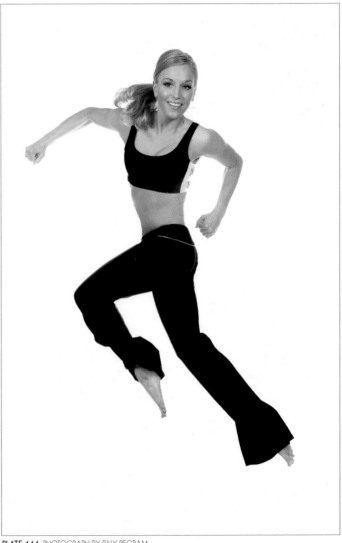

PLATE 443. PHOTOGRAPH BY BILLY PEGRAM.

PLATE 444. PHOTOGRAPH BY BILLY PEGRAM.

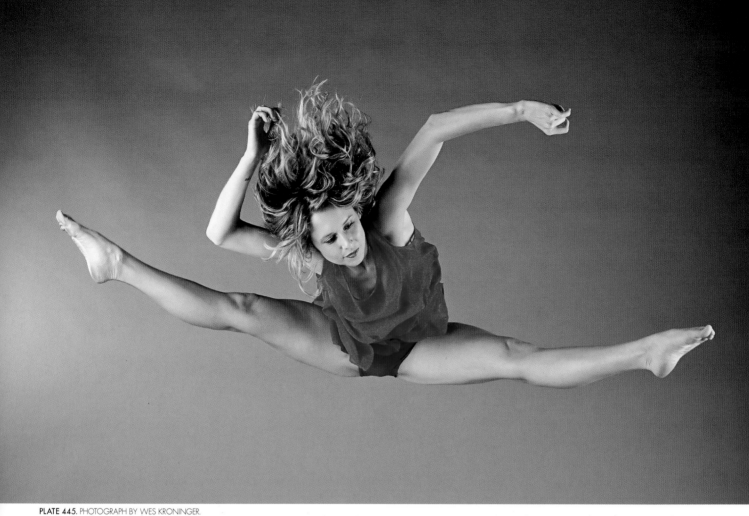

PLATE 445. PHOTOGRAPH BY WES KRONINGER.

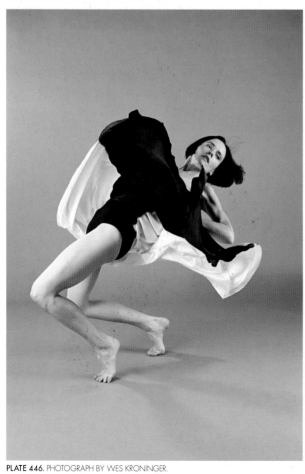

PLATE 446. PHOTOGRAPH BY WES KRONINGER.

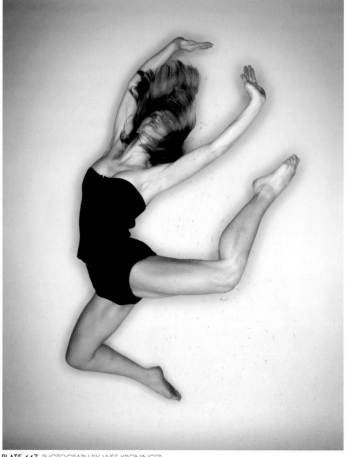

PLATE 447. PHOTOGRAPH BY WES KRONINGER.

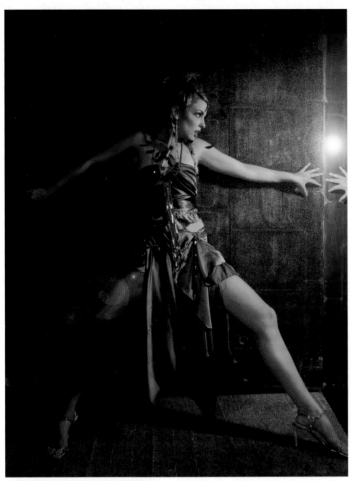

PLATE 448. PHOTOGRAPH BY BILLY PEGRAM.

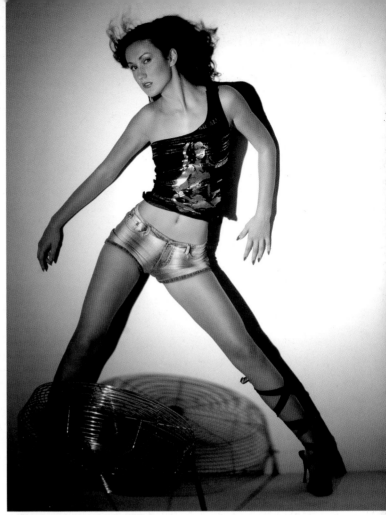

PLATE 449. PHOTOGRAPH BY BILLY PEGRAM.

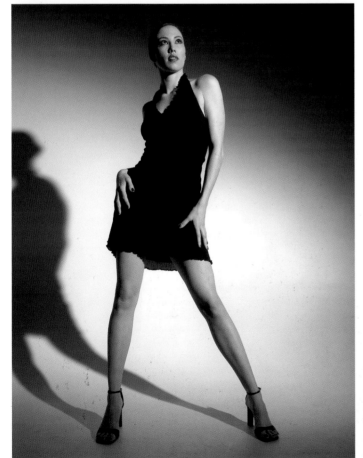

PLATE 450. PHOTOGRAPH BY BILLY PEGRAM.

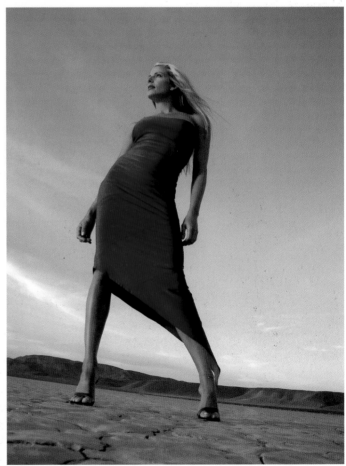

PLATE 451. PHOTOGRAPH BY BILLY PEGRAM.

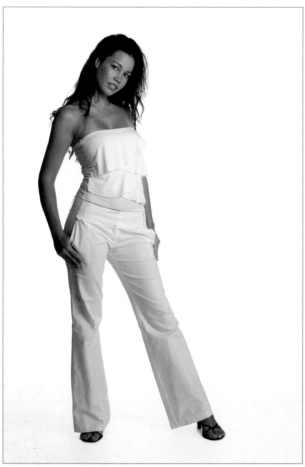

PLATE 452. PHOTOGRAPH BY STEPHEN DANTZIG.

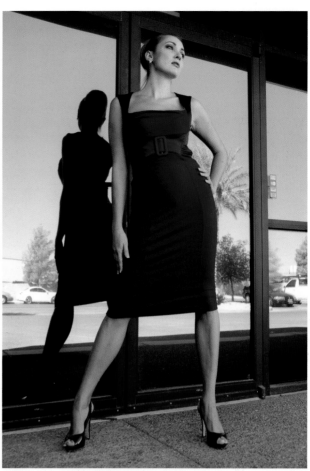

PLATE 453. PHOTOGRAPH BY BILLY PEGRAM.

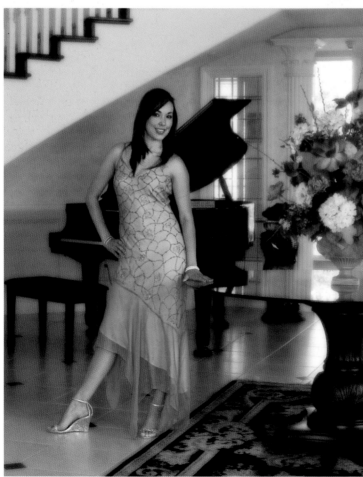

PLATE 454. PHOTOGRAPH BY JEFF SMITH.

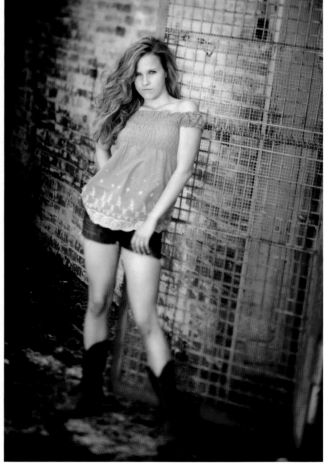

PLATE 455. PHOTOGRAPH BY JEFFREY AND JULIA WOODS.

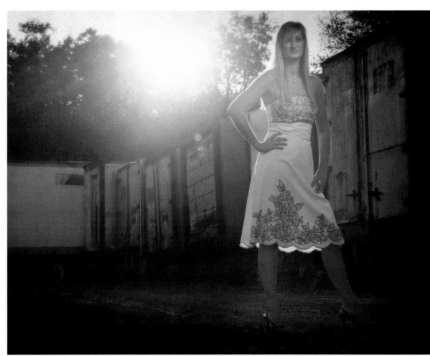

PLATE 457. PHOTOGRAPH BY JEFFREY AND JULIA WOODS.

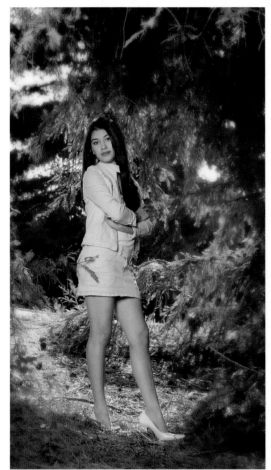

PLATE 456. PHOTOGRAPH BY JEFF SMITH.

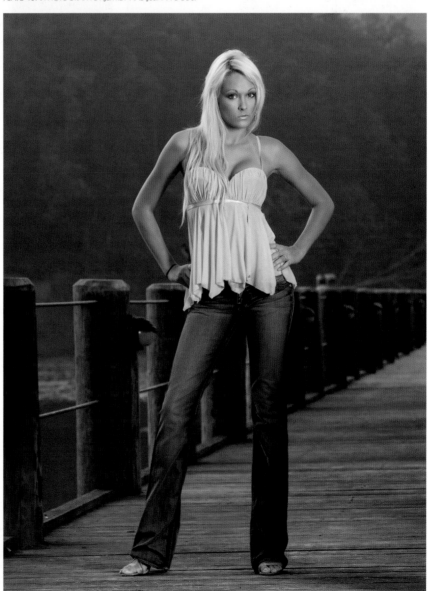

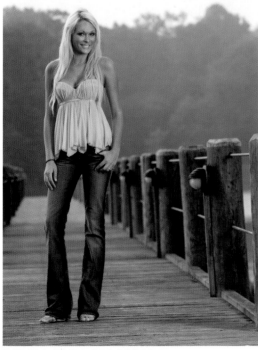

PLATE 458. PHOTOGRAPH BY ROLANDO GOMEZ.

PLATE 459. PHOTOGRAPH BY ROLANDO GOMEZ.

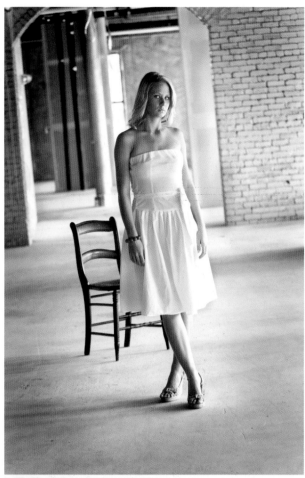

PLATE 460. PHOTOGRAPH BY DAN BROUILLETTE.

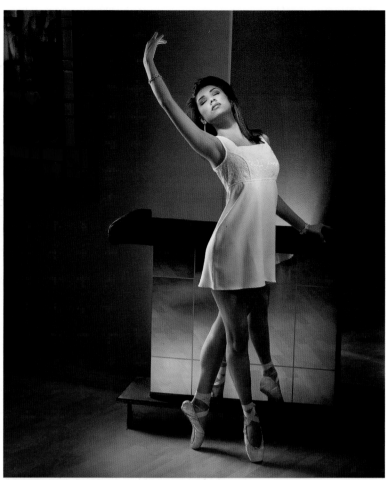

PLATE 461. PHOTOGRAPH BY HERNAN RODRIGUEZ.

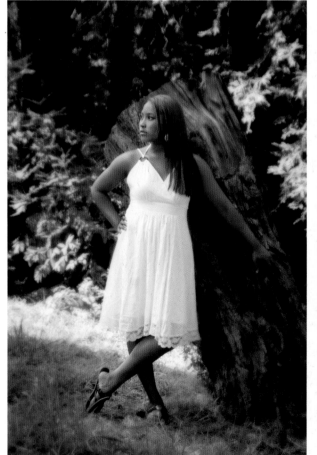

PLATE 462. PHOTOGRAPH BY JEFF SMITH.

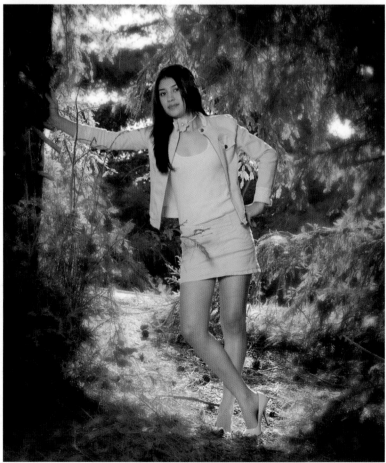

PLATE 463. PHOTOGRAPH BY JEFF SMITH.

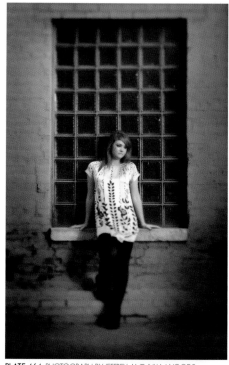

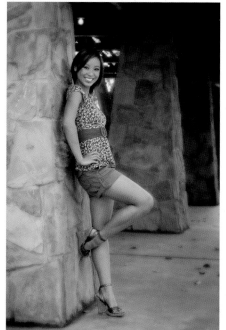

PLATE 465. PHOTOGRAPH BY JEFF SMITH.

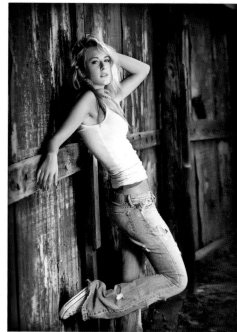

PLATE 466. PHOTOGRAPH BY TIM SCHOOLER.

PLATE 464. PHOTOGRAPH BY JEFFREY AND JULIA WOODS.

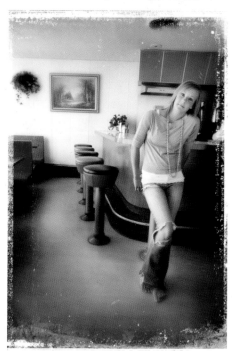

PLATE 467. PHOTOGRAPH BY JEFFREY AND JULIA WOODS.

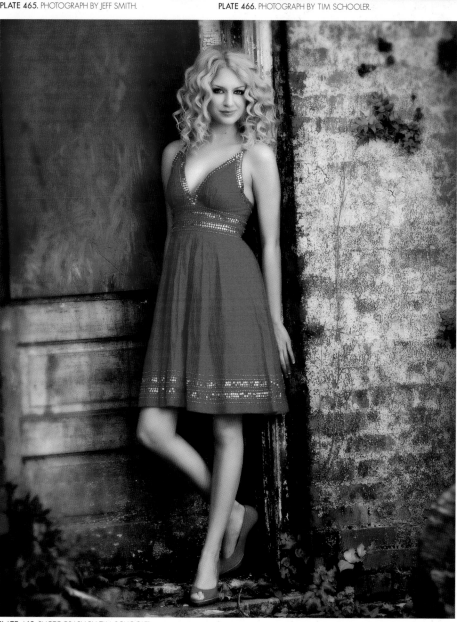

PLATE 468. PHOTOGRAPH BY TIM SCHOOLER.

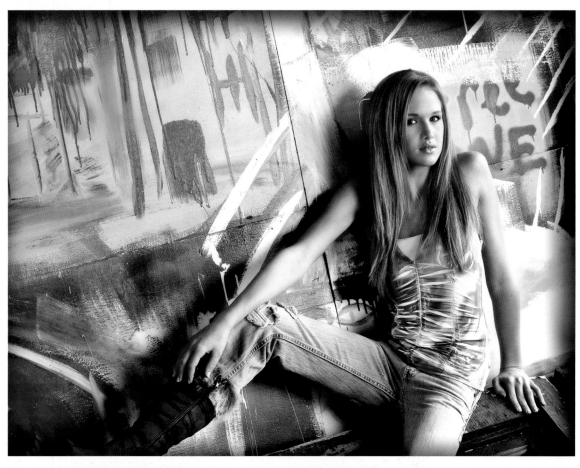

PLATE 469 (LEFT).
PHOTOGRAPH
BY TIM SCHOOLER.

PLATE 470 (BELOW).
PHOTOGRAPH BY
WES KRONINGER.

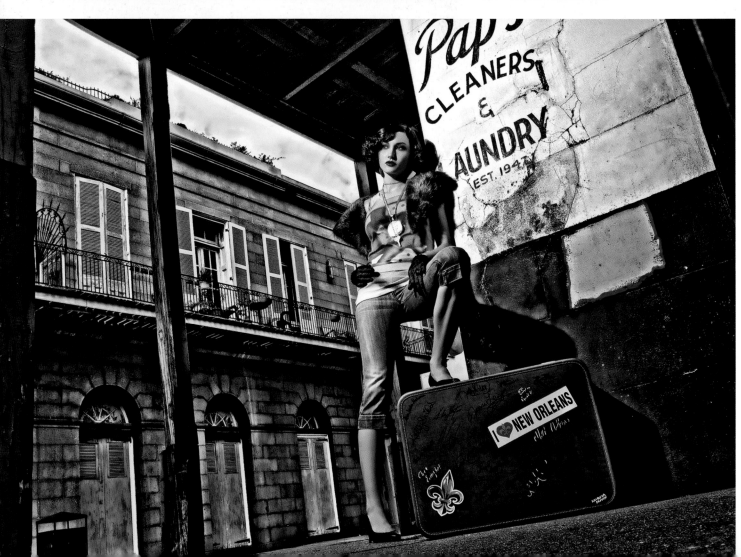

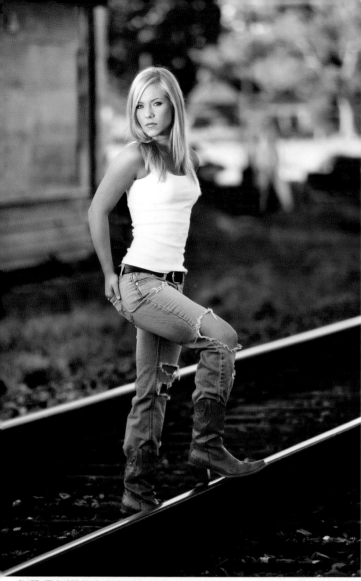

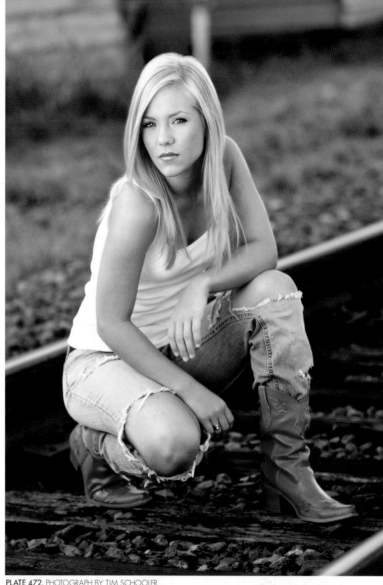

PLATE 471. PHOTOGRAPH BY TIM SCHOOLER.

PLATE 472. PHOTOGRAPH BY TIM SCHOOLER.

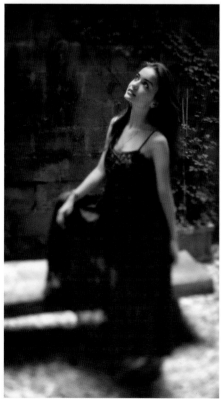

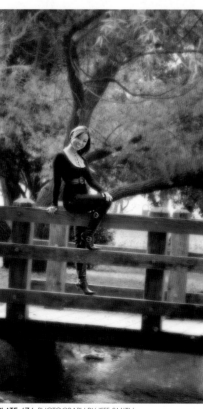

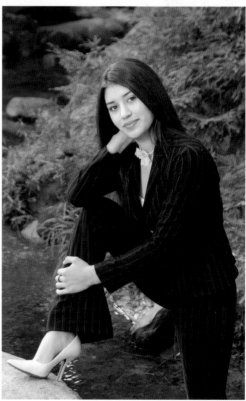

PLATE 473. PHOTOGRAPH BY VICKI TAUFER.

PLATE 474. PHOTOGRAPH BY JEFF SMITH.

PLATE 475. PHOTOGRAPH BY JEFF SMITH.

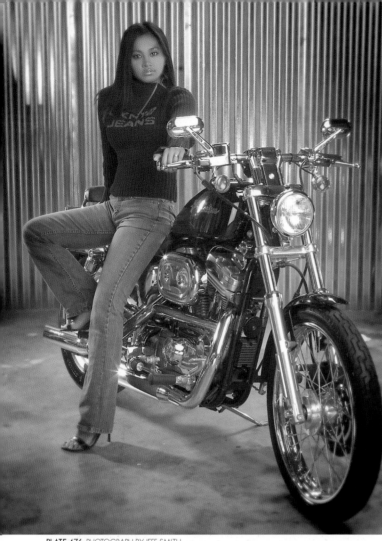

PLATE 476. PHOTOGRAPH BY JEFF SMITH.

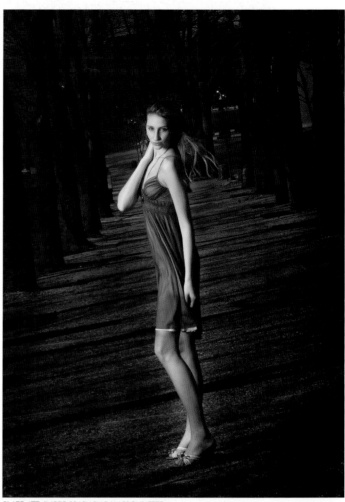

PLATE 477. PHOTOGRAPH BY DAN BROUILLETTE.

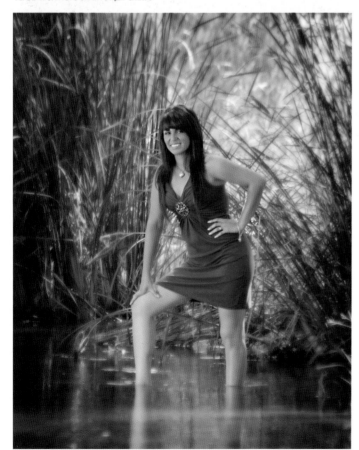

PLATE 478. PHOTOGRAPH BY JEFF SMITH.

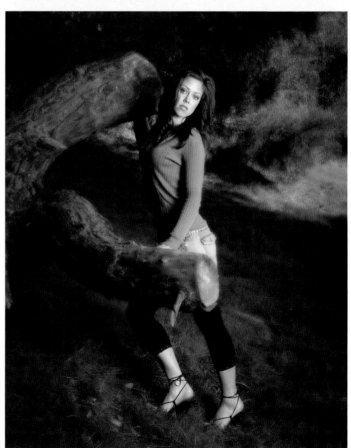

PLATE 479. PHOTOGRAPH BY JEFF SMITH.

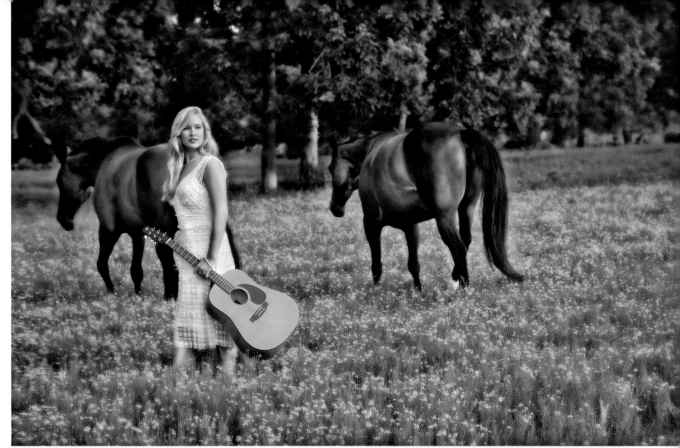

PLATE 480. PHOTOGRAPH BY TIM SCHOOLER.

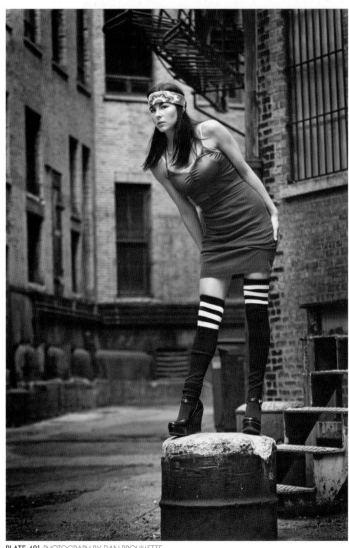

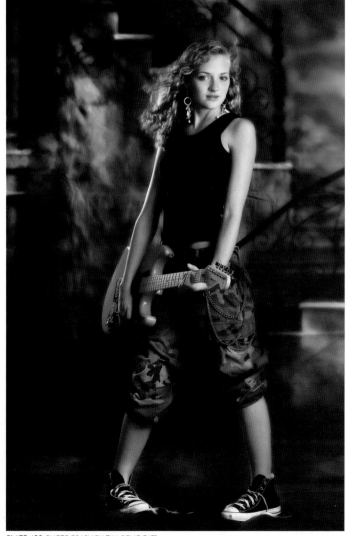

PLATE 481. PHOTOGRAPH BY DAN BROUILLETTE.

PLATE 482. PHOTOGRAPH BY TIM SCHOOLER.

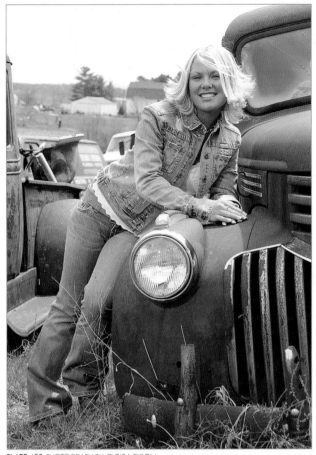

PLATE 483. PHOTOGRAPH BY CHRIS NELSON.

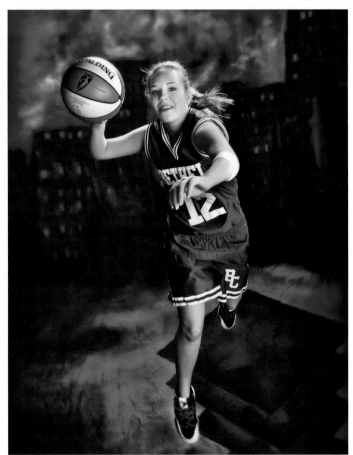

PLATE 484. PHOTOGRAPH BY TIM SCHOOLER.

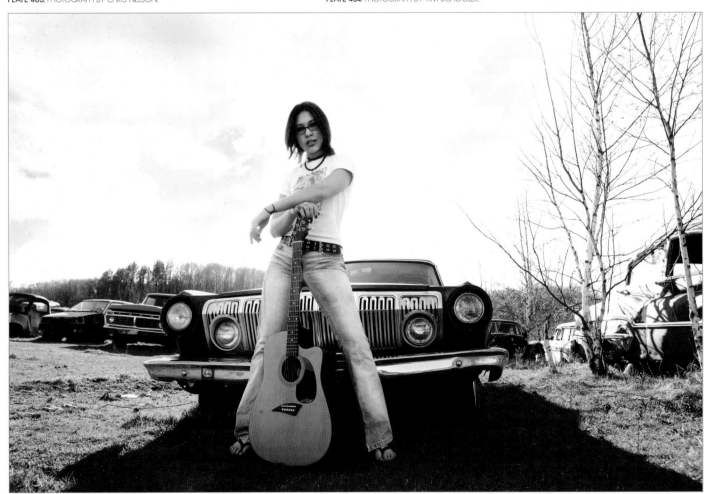

PLATE 485. PHOTOGRAPH BY CHRIS NELSON.

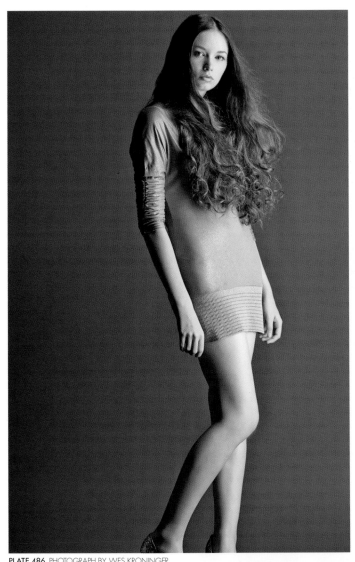

PLATE 486. PHOTOGRAPH BY WES KRONINGER.

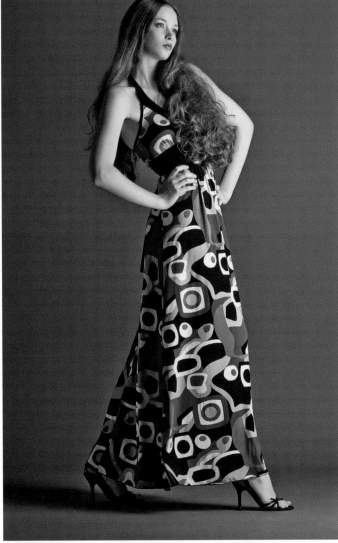

PLATE 487. PHOTOGRAPH BY WES KRONINGER.

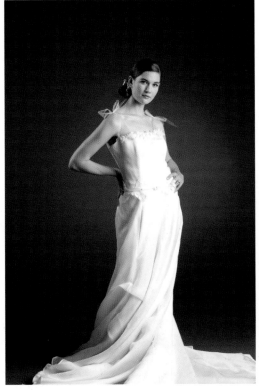
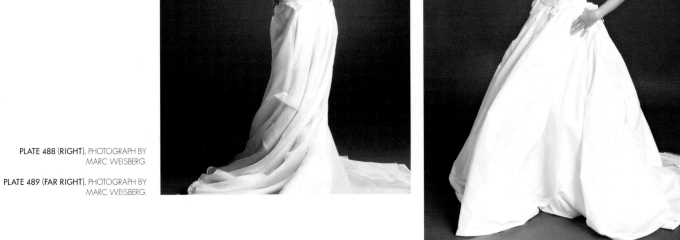

PLATE 488 (RIGHT). PHOTOGRAPH BY
MARC WEISBERG.

PLATE 489 (FAR RIGHT). PHOTOGRAPH BY
MARC WEISBERG.

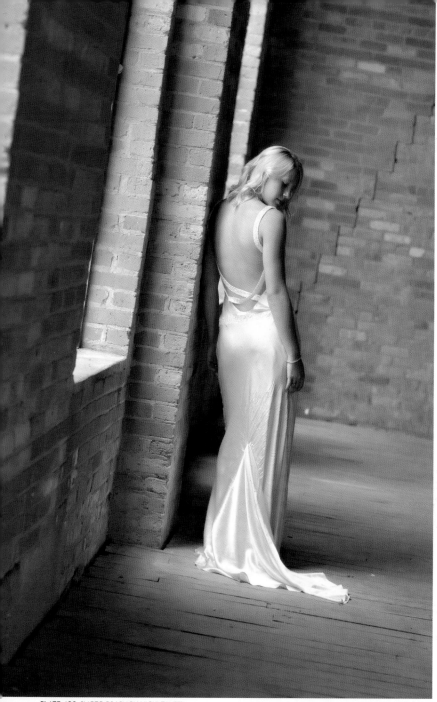

PLATE 490. PHOTOGRAPH BY VICKI TAUFER.

PLATE 491. PHOTOGRAPH BY VICKI TAUFER.

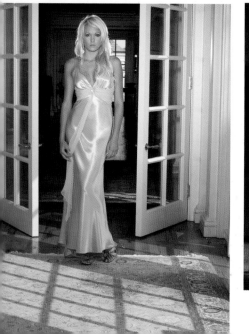

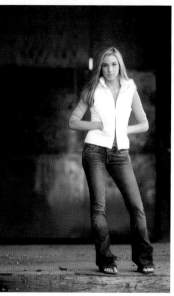

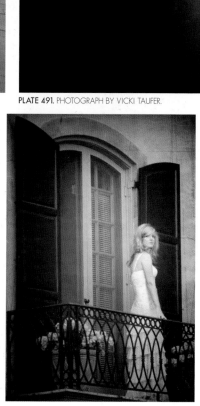

PLATE 492 (FAR LEFT).
PHOTOGRAPH BY ROLANDO
GOMEZ.

PLATE 493 (CENTER).
PHOTOGRAPH BY JEFFREY
AND JULIA WOODS.

PLATE 494 (RIGHT).
PHOTOGRAPH BY JEFFREY
AND JULIA WOODS..

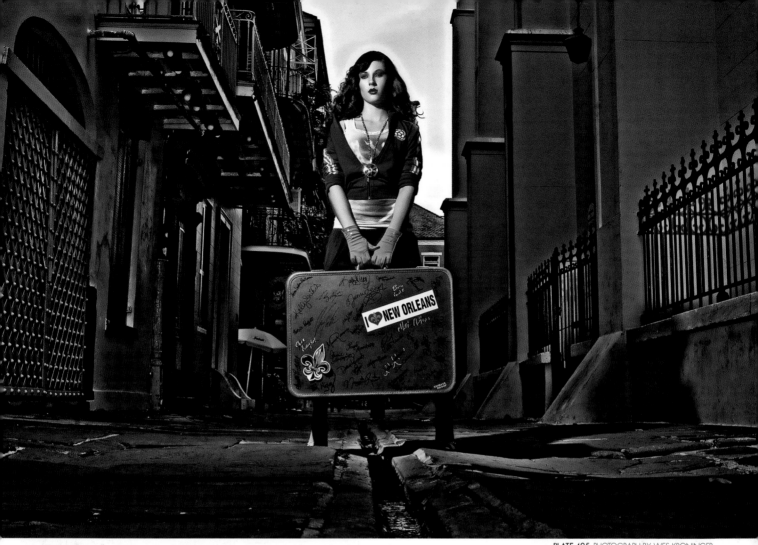

PLATE 495. PHOTOGRAPH BY WES KRONINGER.

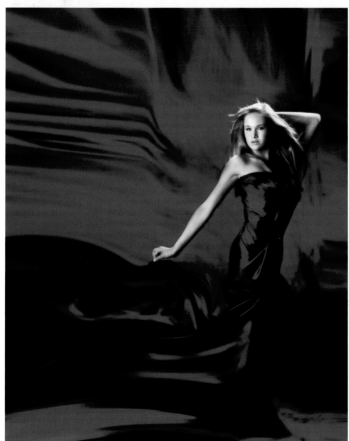

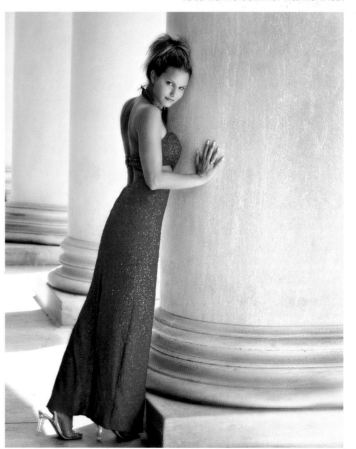

PLATE 496. PHOTOGRAPH BY TIM SCHOOLER.

PLATE 497. PHOTOGRAPH BY TIM SCHOOLER.

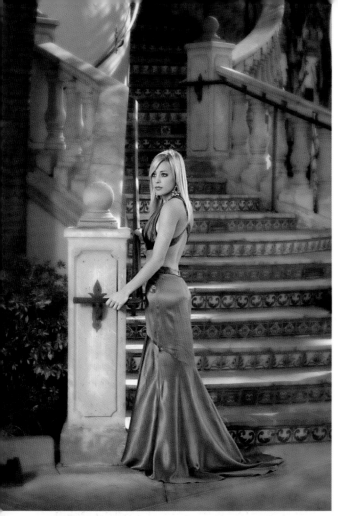

PLATE 498. PHOTOGRAPH BY JEFF SMITH.

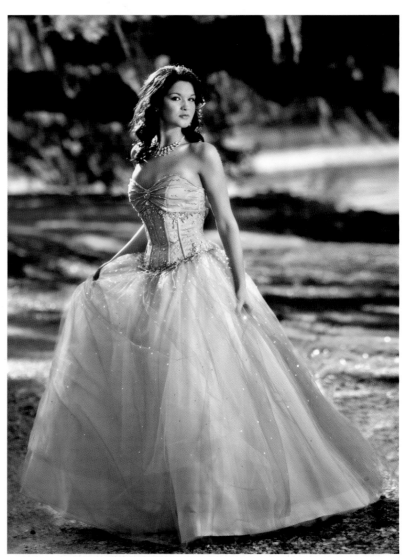

PLATE 499. PHOTOGRAPH BY TIM SCHOOLER.

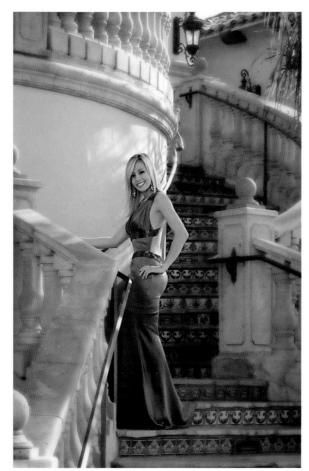

PLATE 500. PHOTOGRAPH BY JEFF SMITH.

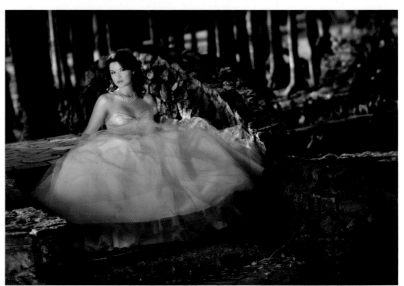

PLATE 501. PHOTOGRAPH BY TIM SCHOOLER.

Posing Basics

This section covers the fundamental rules of traditional posing—techniques that are illustrated in many of the images in this book. While these rules are often intentionally broken by contemporary photographers, most are cornerstones for presenting the human form in a flattering way.

Types

There are three basic types of poses, each defined by how much of the length of the subject's body is included in the image. When including less than the full body in the frame, it is recommended that you avoid cropping at a joint (such as the knee or elbow); this creates an amputated look. Instead, crop between joints.

Head and Shoulders Portraits (or Headshots). Portraits that show the subject's head and shoulders. If the hands are lifted to a position near the face, these may also be included.

Waist-Up Portraits. Portraits that include the subject's head and shoulders along with at least some of the torso. In portraits of women, these images are often cropped just below the bustline or at the waist. Waist-up portraits are sometimes considered a type of headshot.

Three-Quarter-Length Portraits. Portraits that show the subject from the head down to the mid-thigh or mid-calf. In some cases, one foot may be visible.

Full-Length Portraits. Portraits that show the subject from the head down to the feet (or at least the ankles). In some cases, only one foot may be visible.

Facial Views

Full Face View. The subject's nose is pointed at the camera.

Seven-Eighths View. The subject's face is turned slightly away from the camera, but both ears are still visible.

Three-Quarters or Two-Thirds View. The subject's face is angled enough that the far ear is hidden from the camera's view. In this pose, the far eye will appear smaller because it is farther away from the camera than the other eye.

The head should not be turned so far that the tip of the nose extends past the line of the cheek or the bridge of the nose obscures the far eye.

Profile View. The subject's head is turned 90 degrees to the camera so that only one eye is visible.

The Shoulders

Especially in portraits of women, the subject's shoulders should be turned at an angle to the camera. Having the shoulders face the camera directly makes the person look wider than he or she really is and can yield a static composition. In women's portraits, squaring the shoulders to the camera can give the image a less feminine look (which is sometimes done intentionally to create an assertive mood).

The Head

Tilting the Head. Tilting the head slightly produces diagonal lines that can help a pose feel more dynamic. In women's portraits, the head is traditionally tilted toward the near or high shoulder, but this rule is often broken. Most photographers agree that the best practice is to tilt the subject's head in the direction that best suits the overall image and most flatters the subject.

Chin Height. A medium chin height is desirable. If the chin is too high, the subject may look conceited and her neck may appear elongated. If the person's chin is too low, she may look timid and appear to have a double chin or no neck.

Eyes. In almost all portraits, the eyes are the most important part of the face. Typically, eyes look best when the eyelids border the iris. Turning the face slightly away from the camera and directing the subject's eyes back toward the camera reveals more of the white of the eye, making the eyes look larger.

Arms

The subject's arms should be separated at least slightly from the waist. This creates a space that slims the appearance of

the upper body. It also creates a triangular base for the composition, leading the viewer's eye up to the subject's face.

Arms should always be articulated and never allowed to simply hang at the subject's sides. Simply bending the elbows creates appealing diagonal lines in your composition—and placing these carefully can help direct the viewer of the image to the subject's face.

Most portrait photographers request that the subject wear long-sleeved tops; even if the subject is thin, bare upper arms rarely render attractively in portraits.

Hands

Keep the hands at an angle to the lens to avoid distorting their size and shape. Photographing the outer edge of the hand produces a more appealing look than showing the back of the hand or the palm, which may look unnaturally large (especially when close to the face). Additionally, it is usually advised that the hands should be at different heights in the image. This creates a diagonal line that makes the pose more dynamic.

Wrist. Bending the wrists slightly by lifting the hand (not allowing it to flop down) creates an appealing curve that is particularly flattering in women's portraits.

Fingers. Fingers look best when separated slightly. This gives them form and definition.

Props. Hands are often easiest to pose when they have something to do—either a prop to hold or something to rest upon.

Chest

In portraits of women, properly rendering this area is critical. Selecting a pose that places the torso at an angle to the camera emphasizes the shape of the chest and, depending on the position of the main light, enhances the form-revealing shadows on the cleavage. Turning the shoulders square to the camera tends to flatten and de-emphasize this area. Good posture, with the chest lifted and shoulders dropped, is also critical to a flattering rendition.

Waist and Stomach

Separating the arms from the torso helps to slim the waist. In seated poses, a very upright posture (almost to the point of arching the back) will help to flatten the stomach area, as will selecting a standing pose rather than a seated one. It is also generally recommended that the body be angled away from the main light. This allows the far side of the body to fall into shadow for a slimming effect.

Legs

Whether the subject is standing or seated, the legs should be posed independently rather than identically. Typically, one leg is straighter and used to support the body (or in a seated pose, to connect the subject to the floor). The other leg is bent to create a more interesting line in the composition.

Standing. Having the subject put her weight on her back foot shifts the body slightly away from the camera for a more flattering appearance than having the weight distributed evenly on both feet. Having a slight bend in the front knee helps create a less static look.

Seated. When the subject is sitting, her legs should be at an angle to the camera. Allowing for a small space between the legs and the chair will slim the thighs and calves.

One Leg in Profile. In portraits of women where the legs are bare, it is desirable to show the side of at least one leg. This better reveals the shape of the ankle and calf.

Hips and Thighs

Most female subjects are concerned about this area. For the slimmest appearance in a standing pose, turn the hips at an angle to the camera and away from the main light. In a seated pose, have the subject shift her weight onto one hip so that more of her rear is turned away from the camera.

Feet

Feet often look distorted when the toes are pointed directly at the camera. It is best to show the feet from an angle. In portraits of women, the toes are often pointed (or the heels elevated, as they would be in high-heeled shoes). This flexes the calf muscles, creating a slimmer appearance and lengthening the visual line of the subject's legs.

The Photographers

Steven Begleiter (www.begleiter.com). Steven Begleiter is an award-winning freelance photographer and studio owner based in Missoula, MT, who began his career as a photo assitant to Annie Leibowitz and Mary Ellen Mark. Before moving to Montana, Steven operated a successful commercial photography businesses in New York City and Philadephia, winning assignments from international magazines, Fortune 500 companies, and national advertising campaigns. Steven is the author of *Fathers and Sons: Photographs* (Abbeville Press), *The Art of Color Infrared Photography, The Portrait Book,* and *50 Lighting Setups for Portrait Photographers* (all from Amherst Media) and currently teaches at the Rocky Mountain School of Photography.

Dan Brouillette (www.danbrouillette.com). A native of Soiux City, IA, Dan Brouillette became interested in photography as a student at Iowa State University, where the imaging software on his roommate's computer held much more intrigue than his own biology textbooks. When a family friend asked him to take her senior portraits, he was eager to give it a try—and the results were so good that each subsequent year he received increasing numbers of calls from other seniors looking for his unique images. Four years later, Dan has opened a complete photo studio and is quickly catching the attention of photo editors and art directors with his fresh editorial/commercial style.

Stephen Dantzig (www.dantzigphotography.com). Stephen Dantzig, who specializes in fashion, beauty, and corporate photography, is a nationally renowned lighting expert and author of *Lighting Techniques for Fashion and Glamour Photography, Mastering Lighting Techniques for Outdoor and Location Digital Portrait Photography,* and *Softbox Lighting Techniques for Professional Photographers* (all from Amherst Media). He has written more than fifty magazine articles on photographic lighting and ethics for *Rangefinder, Professional Photographer, PC Photo, Studio Photography & Design,* and *www.prophotoresource.com.* He resides in Honolulu, HI.

Rick Ferro and Deborah Lynn Ferro (www.rickferro.com). Rick Ferro and Deborah Lynn Ferro operate Signature Studio, a full-service studio that provides complete photography services for families, portraits, children, high-school seniors, and weddings. In addition to the acclaim they have received for their images, Rick and Deborah are also popular photography instructors who tour nationally, presenting workshops to standing-room-only audiences (for more on this, visit www.ferrophotographyschool.com). Rick and Deborah have also authored numerous books, including *Wedding Photography: Creative Techniques for Lighting, Posing, and Marketing* and *Artistic Techniques with Adobe Photoshop and Corel Painter,* both from Amherst Media.

Rolando Gomez (www.rolandogomez.com). Rolando Gomez is a highly published photojournalist who was selected in 1994 by the Department of Defense as one of the top five military photographers worldwide. After nearly a decade of high-level employment with the Air Force News Agency, Rolando left to pursue his passion: glamour photography. He is the founder of www.GarageGlamour.com, which is visited by over half a million people each month. This has led to a successful career conducting international glamour workshops and three popular books: *Garage Glamour: Digital Nude and Beauty Photography Made Simple, Rolando Gomez's Glamour Photography,* and *Rolando Gomez's Posing Techniques for Glamour Photography,* all from Amherst Media.

Wes Kroninger (www.weskroninger.com). Wes Kroninger is a professional photographer who established his career in Baton Rouge, LA, until relocating to Los Angeles in 2008. Kroninger, who specializes in commercial beauty photography, describes himself as an "MTV and Atari kid" and feels that this is reflected in how he pairs classic photographic skills with an edgy, contemporary sensibility. Kroninger's fresh and bold imagery has been featured in *American Salon, Rolling Stone,* and *Rangefinder.* His images have also won numerous awards for him and his clients.

Chris Nelson (www.fallcreekphoto.com). A former photojournalist and reporter, Chris Nelson used to supplement his small-market wages shooting weddings, advertis-

ing images, and senior portraits—until he enjoyed his sideline more than his main job. Today, he operates Fall Creek Portrait Design, located in Fall Creek, WI. He has won numerous awards for his portrait photography and is the author of *Master Guide for Glamour Photography*, from Amherst Media.

Billy Pegram (www.billypegram.com). Fashion, editorial, and commercial photographer Billy Pegram is known as a shooter who pays attention to detail and always captures amazing results. In addition to photographing assignments for FILA, Lord of the Dance, and celebrities like John Nordstrom and Booth Gardiner, Billy has directed and produced over a hundred videos for American College of Sports Medicine in conjunction with major sponsors such as Reebok, Gatorade, YMCA Corporation, and Stairmaster. He is also the author of *Professional Model Portfolios, Posing Techniques for Photographing Model Portfolios,* and *Fashion Model Photography: Professional Techniques and Images,* all from Amherst Media.

Hernan Rodriguez (www.hernanphotography.com). The recipient of over twenty international photography awards in the past three years alone, Hernan Rodriguez operates a successful studio in the heart of Los Angeles' San Fernando Valley. There, he juggles a steady roster of commercial, product, and celebrity photography, along with portraiture for families, children, and graduates. He has art directed and photographed advertising campaigns for Guess Clothing, Tanline CA, Comfort Zone, and Corona (to name just a few). He has also been featured in *Rangefinder, Studio Photography,* and *Photoshop User* magazines.

Tim Schooler (www.timschooler.com). Tim Schooler Photography is an award-winning studio, located in Lafayette, LA, that specializes in cutting-edge high-school senior photography. Tim's bold and dynamic images are so popular that his sessions book solid almost instantly—in fact, he often has several hundred seniors on his waiting list! Tim's work has been published internationally and he has been the subject of numerous profiles in *Rangefinder* magazine. His signature images and techniques have also been featured prominently in numerous books on professional portrait photography.

Jeff Smith (www.jeffsmithphoto.com). Jeff Smith is an award-winning senior photographer from Fresno, CA. He owns and operates two studios in Central California and is well recognized as a speaker on lighting and senior photography. He is the author of many books, including *Corrective Lighting, Posing, and Retouching for Digital Photographers* and *Jeff Smith's Lighting for Outdoor & Location Portrait Photography* (both from Amherst Media), and *Senior Contracts* (self-published).

Cherie Steinberg Cote (www.cheriefoto.com). Cherie Steinberg Cote began her photography career as a photojournalist at the *Toronto Sun,* where she had the distinction of being the first female freelance photographer. She currently lives in Los Angeles and has been published in *Grace Ormonde, Los Angeles Magazine,* and *Town & Country.* She is also a Getty Image stock photographer and an acclaimed instructor who has presented seminars to professional photographers from around the country.

Vicki Taufer (www.vgallery.net). Vicki Taufer, with her husband Jed, is the co-owner of V Gallery, a prestigious portrait studio in Morton, IL. In just three years, the studio has grown from the cramped basement of the couple's house to its current home in a 4,000-square-foot space with eight employees. Vicki has received national recognition for her portraits and is an award winner in WPPI (Wedding and Portrait Photographers International) print competitions. She is also a popular photography instructor, who has led workshops both nationally and internationally—including a trip to South Korea.

Marc Weisberg (www.mwphoto.net). Marc holds a degree in fine art and photography from UC–Irvine and also attended the School of Visual Arts in New York City. His studio, located in Newport Beach, CA, specializes in wedding, portrait, and commercial photography but also photographs editorial and fashion work on a regular basis. Marc's images have earned over fourteen national and international awards and have been featured in numerous magazines, including *Riviera, Los Angeles Confidential, The Knot, Ceremony,* and *Rangefinder.* His work had also appeared in four books from Amherst Media.

Jeffrey and Julia Woods (www.portraitlife.com). Jeffrey and Julia Woods are award-winning wedding and portrait photographers who work as a team. They operate a successful wedding and portrait studio that specializes in highly personalized images that reflect the tastes and experiences that make each client unique. Their elegant images have been featured in *Rangefinder* magazine and in numerous photography books. In addition, their acclaimed marketing strategies have become the basis for a successful educational program for professional photographers, which they run out of their studio in Washington, IL. They were awarded WPPI's Best Wedding Album of the Year for 2002 and 2003, eight Fuji Masterpiece Awards, six Kodak Gallery Awards, and two Kodak Gallery Elite Awards.

By the Same Author . . .

ILLUSTRATED DICTIONARY OF PHOTOGRAPHY

Barbara A. Lynch-Johnt & Michelle Perkins

Gain insight into camera and lighting equipment, accessories, technological advances, film and historic processes, famous photographers, artistic movements, and more with the concise descriptions in this illustrated book. $34.95 list, 8.5x11, 144p, 150 color images, order no. 1857.

PROFESSIONAL PORTRAIT POSING

TECHNIQUES AND IMAGES FROM MASTER PHOTOGRAPHERS

Michelle Perkins

Learn how master photographers pose subjects to create unforgettable images. $34.95 list, 8.5x11, 128p, 175 color images, index, order no. 2002.

PROFESSIONAL PORTRAIT LIGHTING

TECHNIQUES AND IMAGES FROM MASTER PHOTOGRAPHERS

Michelle Perkins

Get a behind-the-scenes look at the lighting techniques employed by the world's top portrait photographers. $34.95 list, 8.5x11, 128p, 200 color photos, index, order no. 2000.

BEGINNER'S GUIDE TO ADOBE® PHOTOSHOP®, 3rd Ed.

Michelle Perkins

Enhance your photos or add unique effects to any image. Short, easy-to-digest lessons will boost your confidence and ensure outstanding images. $34.95 list, 8.5x11, 128p, 80 color images, 120 screen shots, order no. 1823.

POSING TECHNIQUES FOR PHOTOGRAPHING MODEL PORTFOLIOS

Billy Pegram

Learn to evaluate your model and create flattering poses for fashion photos, catalog and editorial images, and more. $34.95 list, 8.5x11, 128p, 200 color images, index, order no. 1848.

ROLANDO GOMEZ'S GLAMOUR PHOTOGRAPHY

PROFESSIONAL TECHNIQUES AND IMAGES

Learn how to create classy glamour portraits your clients will adore. Rolando Gomez takes you behind the scenes, offering invaluable technical and professional insights. $34.95 list, 8.5x11, 128p, 150 color images, index, order no. 1842.

JEFF SMITH'S LIGHTING FOR OUTDOOR AND LOCATION PORTRAIT PHOTOGRAPHY

Learn how to use light throughout the day—indoors and out—and make location portraits a highly profitable venture for your studio. $34.95 list, 8.5x11, 128p, 170 color images, index, order no. 1841.

MASTER GUIDE FOR GLAMOUR PHOTOGRAPHY

Chris Nelson

Establish a rapport with your model, ensure a successful shoot, and master the essential digital fixes your clients demand. Includes lingerie, semi-nude, and nude images. $34.95 list, 8.5x11, 128p, 200 color photos, index, order no. 1836.

SOFTBOX LIGHTING TECHNIQUES

FOR PROFESSIONAL PHOTOGRAPHERS

Stephen A. Dantzig

Use one of photography's most popular devices to produce soft and flawless effects for portraits, product shots, and more. $34.95 list, 8.5x11, 128p, 260 color images, index, order no. 1839.

GARAGE GLAMOUR™

DIGITAL NUDE AND BEAUTY PHOTOGRAPHY MADE SIMPLE

Rolando Gomez

This book will show you how to produce sultry, creative glamour images with a minimum of equipment. $34.95 list, 8.5x11, 128p, 150 color photos, index, order no. 1820.

MASTER LIGHTING TECHNIQUES

FOR OUTDOOR AND LOCATION DIGITAL PORTRAIT PHOTOGRAPHY

Stephen A. Dantzig

Use natural light alone or with flash fill, barebulb, and strobes to shoot perfect portraits all day long. $34.95 list, 8.5x11, 128p, 175 color photos, diagrams, index, order no. 1821.

CORRECTIVE LIGHTING, POSING & RETOUCHING FOR
DIGITAL PORTRAIT PHOTOGRAPHERS, 2nd Ed.

Jeff Smith

Learn to make every client look his or her best by using lighting and posing to conceal real or imagined flaws—from baldness, to acne, to figure flaws. $34.95 list, 8.5x11, 120p, 150 color photos, order no. 1711.

LIGHTING TECHNIQUES FOR **FASHION AND GLAMOUR PHOTOGRAPHY**

Stephen A. Dantzig, PsyD.

In fashion and glamour photography, light is the key to producing images with impact. With these techniques, you'll be primed for success! $29.95 list, 8.5x11, 128p, over 200 color images, index, order no. 1795.

WEDDING PHOTOGRAPHY WITH ADOBE® PHOTOSHOP®

Rick Ferro and Deborah Lynn Ferro

Get the skills you need to make your images look their best, add artistic effects, and boost your wedding photography sales with savvy marketing ideas. $34.95 list, 8.5x11, 128p, 100 color images, index, order no. 1753.

POSING FOR PORTRAIT PHOTOGRAPHY
A HEAD-TO-TOE GUIDE

Jeff Smith

Author Jeff Smith teaches surefire techniques for fine-tuning every aspect of the pose for the most flattering results. $34.95 list, 8.5x11, 128p, 150 color photos, index, order no. 1786.

PROFESSIONAL MODEL PORTFOLIOS
A STEP-BY-STEP GUIDE FOR PHOTOGRAPHERS

Billy Pegram

Learn to create portfolios that will get your clients noticed—and hired! $34.95 list, 8.5x11, 128p, 100 color images, index, order no. 1789.

PROFITABLE PORTRAITS
THE PHOTOGRAPHER'S GUIDE TO CREATING PORTRAITS THAT SELL

Jeff Smith

Learn how to design images that are precisely tailored to your clients' tastes—portraits that will practically sell themselves! $29.95 list, 8.5x11, 128p, 100 color photos, index, order no. 1797.

ARTISTIC TECHNIQUES WITH ADOBE® PHOTOSHOP® AND COREL® PAINTER®

Deborah Lynn Ferro

Flex your creativity and learn how to transform photographs into fine-art masterpieces. Step-by-step techniques make it easy! $34.95 list, 8.5x11, 128p, 200 color images, index, order no. 1806.

THE PORTRAIT BOOK
A GUIDE FOR PHOTOGRAPHERS

Steven Begleiter

A comprehensive textbook for those getting started in professional portrait photography. Covers every aspect from designing an image to executing the shoot. $29.95 list, 8.5x11, 128p, 130 color images, index, order no. 1767.

50 LIGHTING SETUPS FOR PORTRAIT PHOTOGRAPHERS

Steven Begleiter

Review the basics of portrait lighting, then follow along as the author takes you through fifty photo shoots, from developing the lighting concept to executing it flawlessly. $34.95 list, 8.5x11, 128p, over 100 color images/diagrams, index, order no. 1872.

ROLANDO GOMEZ'S
POSING TECHNIQUES FOR GLAMOUR PHOTOGRAPHY

Learn how to tailor a pose precisely to your client, accentuating her best features and downplaying any problem areas. The results are more flattering images that your subjects will love. $34.95 list, 8.5x11, 128p, 150 color images, index, order no. 1869.